# Ancient Art and Its Historiography

This book treats the historiography of ancient Near Eastern and Classical art, examining the social, intellectual, and institutional contexts that have shaped the way that the history of ancient art has been and continues to be written. It demonstrates how, from the Renaissance to the present, the study and interpretation of ancient art reflect contemporary ideas and practices. Among the subjects considered are the classical tradition in the post-antique West; the emergence of academic disciplines; the role of collections in the evaluation of ancient art; and issues of race, gender, and cultural authority in the interpretation of ancient civilizations.

A. A. Donohue, Associate Professor of Classical and Near Eastern Archaeology at Bryn Mawr College, is the author of *Xoana and the Origins of Greek Sculpture* and articles on the history and historiography of classical art that have appeared in the *American Journal of Archaeology*, *Archäologischer Anzeiger*, and *Hephaistos*.

Mark D. Fullerton is Professor and Chair in the Department of History of Art at the Ohio State University. He is the author of *The Archaistic Style in Roman Statuary*, *Greek Art*, and articles on Greek, Roman, and Etruscan art published in a variety of publications, including the *American Journal of Archaeology*, *Journal of Roman Archaeology*, and *Römische Mitteilungen*, among others.

# Ancient Art and Its Historiography

Edited by

**A. A. Donohue**
Bryn Mawr College

**Mark D. Fullerton**
The Ohio State University

CAMBRIDGE
UNIVERSITY PRESS

PUBLISHED BY THE PRESS SYNDICATE OF THE UNIVERSITY OF CAMBRIDGE
The Pitt Building, Trumpington Street, Cambridge, United Kingdom

CAMBRIDGE UNIVERSITY PRESS
The Edinburgh Building, Cambridge CB2 2RU, UK
40 West 20th Street, New York, NY 10011-4211, USA
477 Williamstown Road, Port Melbourne, VIC 3207, Australia
Ruiz de Alarcón 13, 28014 Madrid, Spain
Dock House, The Waterfront, Cape Town 8001, South Africa

http://www.cambridge.org

First published 2003

Printed in the United States of America

*Typeface* Minion 10.5/14.5 pt      *System* LᴬTEX 2$_\varepsilon$   [TB]

*A catalogue record for this book is available from the British Library*

*Library of Congress Cataloging in Publication Data*
Ancient art and its historiography / edited by A. A. Donohue, Mark D. Fullerton.
p.   cm.
Includes bibliographical references and index.
ISBN 0-521-81567-3
I. Art, Ancient – Historiography.   I. Donohue, A. A. (Alice A.)   II. Fullerton, Mark D.
N5329 .A53   2003
709'.3 – dc21      2002074197

ISBN 0 521 81567 3   hardback

# Contents

# Contents

# Illustrations

## From Whores to Hierodules
### JULIA ASSANTE

## The Fate of Plate
### KENNETH LAPATIN

# Illustrations

## A Brief Historiography of Stylistic Retrospection
MARK D. FULLERTON

## The *Peplos* and the "Dorian Question"
MIREILLE M. LEE

## Jargon, Authenticity, and the Nature of Cultural History-Writing
JOANNE MONTEAGLE STEARNS

# Contributors

Julia Assante has written articles on sexuality, magic, and women in the arts and texts of ancient Mesopotamia and is currently preparing *The Erotic Reliefs of Ancient Mesopotamia* for publication. She occasionally teaches classes in ancient Near Eastern archaeology at the Westfälische Wilhelms-Universität (University of Münster).

Mary Beard is Reader in Classics, University of Cambridge, where she is a Fellow of Newnham College. She is the author of *A Very Short Introduction to Classics* (with J. Henderson; Oxford, 1985); *Religions of Rome* (with J. North and S. Price; Cambridge, 1998); *The Invention of Jane Harrison* (Cambridge, Mass., 2000); *Classical Art: from Greece to Rome* (with J. Henderson; Oxford, 2001); and *The Parthenon* (London, 2002).

A. A. Donohue is Associate Professor of Classical and Near Eastern Archaeology at Bryn Mawr College and the author of *Xoana and the Origins of Greek Sculpture* (Atlanta, 1988) and articles on Greek art and its historiography.

Mark D. Fullerton is Professor of History of Art at the Ohio State University and the author of *The Archaistic Style in Roman Statuary* (*Mnemosyne* Suppl. 110; Leiden, 1990): *Greek Art* (Cambridge, 2000); and *Roman Art* (London, in preparation).

Jacob Isager is Associate Professor in the Department of Greek and Roman Studies at the University of Southern Denmark and the author of *Forum Romanum og Palatin* (Odense, 1976); *Pliny on Art and Society. The Elder Pliny's Chapters on the History of Art* (London and New York, 1991; Odense, 1991; repr.

Contributors

1998) and the editor of *Imperium Romanum, Realitet, Idé, Ideal* (with O.S. Due; Aarhus, 1993); *Peter Oluf Brøndsted. Interviews with Ali Pacha of Joanina in the Autumn of 1812; with Some Particulars of Epirus, and the Albanians of the Present Day* (Athens, 1999); and *Foundation and Destruction. Nikopolis and Northwestern Greece* (Monographs of the Danish Institute at Athens 3, Aarhus 2001).

**Kenneth Lapatin** is Assistant Curator of Antiquities at the J. Paul Getty Museum and the author of *Chryselephantine Statuary in the Ancient Mediterranean World* (*Oxford Monographs on Classical Archaeology*; Oxford, 2001); *Mysteries of the Snake Goddess: Art, Desire, and the Forging of History* (Boston, 2002); and *Luxus. The Sumptuous Arts of Greece and Rome* (in preparation).

**Mireille M. Lee** is Visiting Assistant Professor of Classics at Macalester College. She has written on the history and historiography of costume and gender in Bronze Age and classical Greece.

**Joanne Monteagle Stearns** is a Ph.D. candidate in the history of art at Bryn Mawr College. The title of her dissertation is "History at a Standstill: Jacob Burckhardt's 'State as a Work of Art' in the Light of Critical Theory."

# 1

# Introduction

A. A. DONOHUE

"May you live in interesting times."
Apocryphal Chinese curse

The essays in this volume examine a broad range of historiographic issues relating to the visual arts of the ancient Near East, Greece, and Rome. In the study of ancient art, historiographic topics have usually been narrowly construed in terms of disciplinary or institutional history or the biography of scholars; in consequence, historiography tends to be regarded as of marginal interest and, however interesting and informative it may be, as having only limited relevance for the solution of current problems. The present essays demonstrate that historiographic concerns can in fact have direct bearing on the treatment of specific questions in the field of ancient art and can contribute significantly to current praxis. In other words, subjects such as the development of a particular style or the interpretation of a particular category of artifact benefit from considering the way in which the history of art has been and continues to be written.

The last quarter of the twentieth century saw changes in the humanistic disciplines that have led, depending on one's point of view, either to their reinvigoration or to their imminent extinction. The changes involved both new thematic concerns and new methodologies. Gender, ethnicity, and power emerged as major topics, and the theory and practice of interpretation became a central focus of investigation. If there is a common denominator among the new approaches, it is arguably the willingness of scholars to question the nature and capacity of our means

of understanding. Seen in this light, the innovations are neither completely new nor utterly malign or beneficial; rather, they represent the latest episode in the cycle of confidence and doubt in human abilities that is a fundamental characteristic of the Western intellectual tradition.

The study of ancient art occupies a position within current academic structures that may be characterized as interesting, in the sardonic sense of that word as it appears in the apocryphal Chinese curse.[1] The subject occupies no consistent or secure place in the disciplinary and institutional frameworks that shape teaching and research. One might imagine that the study of ancient art provides an obvious opportunity for useful communication between art history and other disciplines, but too often it is effectively relegated to academic isolation.

Although many standard art-historical textbooks take ancient art into account, some departments of art history exclude the subject from their curricula, seeing it as the province of fields such as archaeology or classical studies. The exclusion is curious in view of the growing commitment of art historians to the inclusion of non-Western art in the discipline, to the critical scrutiny of Western culture, and to multicultural issues in a wide sense. The study of ancient art has much to contribute to all these areas of concern. It is not restricted to the cultures of ancient Greece and Rome: Egypt and the ancient Near East have long been and continue to be important subjects in the field. They offer the opportunity to study cultures that not only are emphatically non-Western but also had a decisive effect on the Greeks and Romans. The latter cultures are the foundation of the "Classical tradition" that is a central concern of both well-established and new approaches to the study of post-antique Western art and would therefore seem to call for formal curricular recognition.

The particular difficulties inherent in the study of ancient art have surely contributed to its estrangement from art history in the larger sense. That the fundamental elements of these civilizations – social organization, religious beliefs, and the like – are often manifestly alien to or subtly different from those of modern cultures makes it difficult to pursue the level of analysis that is customarily undertaken in the history of the art of more familiar and accessible eras and societies. Furthermore, the fragmentary and often poorly documented condition of the monumental

and textual record of ancient cultures makes interpretation on any level difficult for all but specialists. Despite the growing emphasis on contextual approaches in the history of art, the combination of fragmentation and strangeness has encouraged the perception that the major contributions to be made by the study of ancient art are limited to disciplines focussed on the specific cultures in question.

The fault does not lie completely on the side of art history. The institutional structures and intellectual convictions of related fields often contribute to isolating the study of ancient art. The subject is frequently taught in departments dedicated to the language and literature of specific cultures. A student in such a program who chooses to specialize in the art of a particular ancient culture might never be asked to undertake work in other fields of art beyond a superficial level, if at all. Another source of intellectual isolation is the failure fully to integrate art history within the disciplines involved in the study of particular ancient cultures. Art history is not inevitably part of the training in such fields at either the undergraduate or the graduate level. While the expectation that students of ancient culture will be able to approach the subject from a broad understanding is reflected in the existence of programs that draw faculty from several fields or departments, the current bricolage of academic structures has not been entirely successful in providing an adequate basis for the kind of interdisciplinary work that has emerged as the desired standard for research in the humanities. A student of ancient art is customarily expected to attain competence in the relevant languages and literatures, but a student specializing in Assyriology or Greek literature might never be required to take a course in art. Despite the commitment to crossing disciplinary boundaries, it has yet to be widely recognized within fields dedicated to the cultures of antiquity that the study of art merits more than casual attention. Even now, the legacy of certain nineteenth-century models of "Philologie" can be detected in the persistence of the attitude expressed by E. R. Curtius: "Pindars Gedichte zu verstehen, kostet Kopfzerbrechen; der Parthenonfries nicht." ("To understand Pindar's poems requires severe mental effort – to understand the Parthenon frieze does not.")[2]

The problems attaching to what might be called the disciplinary dignity of the study of ancient art similarly emerge in its relationship to

archaeology, another common institutional base for the subject. The rubric "archaeology" that is applied to the study of the physical remains of ancient civilizations includes approaches that are far from hospitable to the study of art. A wide gulf separates those whose work is grounded in the tradition of classical archaeology and those whose conception of the field (often orthographically distinguished as "archeology") derives from anthropology.[3] The gulf has not significantly diminished since Anthony Snodgrass addressed the situation in 1987.[4] It is "art" as a concept that is problematic.[5] For many anthropologically based archaeologists, the category of "art" has no place in the scientific study of social processes through material culture. The category of "art" also presents problems for classical archaeology: the privileging of certain categories of artifacts as "art" is widely recognized as the basis for the destruction of archaeological contexts through looting to feed both private and public collections, and the study of such "art" is seen as compromised by its long involvement with the exploitation of cultural heritage.[6]

For all these reasons, the study of ancient art exists uneasily in a disciplinary no-man's-land. Within art history it holds a marginal position; within textually based disciplines it is seen as irrelevant; and within many forms of archaeology it is variously condemned as effete, exclusive, destructive, or simply lacking validity.

The unenviable isolation of ancient art is ironic in light of the history of the field. The kind of *"Altertumswissenschaft"* conceived and developed by scholars such as Friedrich August Wolf and August Böckh in the early nineteenth century was deliberately inclusive in terms of evidence and method, designed to achieve an integrated understanding of the phenomena of classical antiquity – interdisciplinary, it might be said, before its time.[7] Although the model was not universally accepted and was adversely affected by institutional pressures toward ever-narrowing specialization, the need to deploy every available scrap of evidence, textual or material, to begin to make sense of the shattered remains of ancient cultures imposed a certain degree of readiness to cross disciplinary boundaries. That the study of ancient art has reflected destructive aspects of its social and intellectual matrices such as nationalism, imperialism, and racism is beyond doubt. It is also clear, however, that the wholesale condemnation

of the scholarship rests on shaky ground and, furthermore, that much of the foundation for the current scholarly appreciation of diverse cultures is owed to this field of inquiry.[8] The study of art has been fundamental to some of the most profound interpretations and reinterpretations of ancient cultures, and in some traditions of archaeology – the Italian tradition is particularly striking in this respect – art remains a central concern.[9]

The question of the relationship between past and current scholarship is especially pressing in the study of ancient art, a field in which primary sources such as excavation reports and catalogues never lose their documentary value and in which the exhaustive review of secondary scholarship is still widely considered to be a sine qua non of any new study. The insistence on extensive accounts of the "state of the problem" as part of the apparatus of scholarship might give the impression that historiographic awareness within the field is acute, but such is not the case. The convention of surveying the history of specific problems encourages the evaluation of previous scholarship in terms of progress (or lack of it) toward a single "correct" solution; it is not designed to take account of the profound differences in historical, cultural, and intellectual contexts that made particular approaches or conclusions possible. There is, of course, no shortage of synthetic histories of scholarship that do consider such issues, often with considerable sophistication, but only rarely are they directly useful in treatments of specific questions.[10] There is room for better integration of historiographic and general concerns; that is to say, the study of ancient art needs to be approached as part of intellectual history. That it is desirable to understand why we think as we do about ancient art, why we frame the questions we ask in the way we do, and why we adopt the methods we use is a modest assertion, but it can lead to surprising and productive consequences.

The idea for this collection of essays arose from two panels organized by the editors for the annual meetings of the College Art Association in 1997 and 2000 and from the responses to those sessions.[11] The contributions treat topics ranging from Mesopotamia to contemporary cultural theory. They have in common the principle that the study of ancient art cannot be satisfactorily undertaken without consideration of the historical, cultural, institutional, and intellectual contexts that underlie past

and present approaches. The collection is far from comprehensive in terms of geography, chronology, or methodology, but it is intended not to bring the consideration of historiographic issues to a close, but rather to encourage discussion.

In her essay "From Whores to Hierodules: The Historiographic Invention of Mesopotamian Female Sex Professionals," Julia Assante examines Mesopotamian reliefs with erotic scenes that have long been interpreted in terms of sacred prostitution. She shows that there is no evidence to support the existence of such a practice in antiquity and demonstrates the origin of the idea in nineteenth-century social and anthropological thought. Her study does more than correct a long-standing misapprehension. By clarifying the roots of this sensational episode in the long history of misinterpretation of the ancient Near East, she illustrates the bond between scholarship and its social context. The myth of the sacred prostitute is no less revealing of the situation in which it arose than Winckelmann's wishful invention of an ancient Greece naked and gay; in both cases, the interpretation of antiquity was also a means of formulating social commentary that resonated even into popular culture. Behind the Mesopotamia evoked by J. G. Frazer in *The Golden Bough* loomed contemporary English realities such as child prostitution, the subject of a notorious exposé in 1885 by W. T. Stead, "The Maiden Tribute of Modern Babylon."[12] Assante shows how a complex of nineteenth-century moral preoccupations has had lasting consequences for modern interpretations of ancient Mesopotamia.

Jacob Isager continues his groundbreaking analyses of Pliny the Elder, whose *Natural History* became in the Renaissance the model for historical treatments of art. It is thanks to Isager's research that we have come to understand that Pliny's treatment of the visual arts, far from being a "transparent" documentary source, is in fact a complex social and moral commentary on his own society. Nonetheless, Pliny's categories and analytic structures, together with the facts he gives about artists and their works, were taken over by post-antique writers on art and have continued to shape even present-day histories of Western art. In "*Humanissima ars*: Evaluation and Devaluation in Pliny, Vasari, and Baden," Isager explores the accumulated traditions of ancient, Renaissance, and post-Renaissance

# Introduction

European scholarship in the study of classical art. He offers as a case study the history of ancient Greek painting produced in 1825 by Torkel Baden, a Danish professor of fine arts, who used Pliny as a direct model. Baden's work is especially interesting because, despite its pedigree as a product of the Danish Academy of Fine Arts, it does not belong to the first rank of significant scholarship but offers instead an opportunity to examine levels of art-historical praxis that are often lost to view.

The complexity of the post-antique adoption of Pliny's conceptual structures is explored in Kenneth Lapatin's essay "The Fate of Plate and Other Precious Materials: Toward a Historiography of Ancient Greek Minor (?) Arts." The title alludes to the controversial reevaluation by Michael Vickers and David Gill of the high value assigned to Greek pottery since the eighteenth century at the expense of vessels executed in precious metals.[13] Lapatin focusses on the problematic concept of "minor arts," examining the contrast between the great value placed on luxury production in antiquity and the contrastingly deflating treatment it has received in consequence of its modern scholarly status as "Kleinkunst." He explains the discrepancy in terms of historiographic conventions going back to the Renaissance adoption of particular Plinian structures: the treatment of the visual arts by medium, and the dominant theme of the evolution of naturalistic representation. The mythologization of the Greeks as "pure and simple" also encouraged disrespect for sumptuous work, and the archaeological provenance of a great deal of such production outside the Greek heartland further contributed to its modern devaluation. The discoveries in recent years of spectacular artifacts in precious materials thus lack an adequate basis for interpretation – hence the proliferation of essentially interchangeable museum blockbusters that showcase ancient "treasures." Lapatin examines both the material and textual evidence for luxury production and suggests ways in which it might better be integrated into the history of classical art.

The history of Greek art has long been written on the model, again derived from Pliny, of an organic, linear stylistic evolution that culminates in the achievement of classical naturalism, only to collapse as the Hellenistic era begins a long period in which the earlier styles were mixed, matched, and manipulated in a way that was castigated as artistic

7

"decline." In "'*Der Stil der Nachahmer*': A Brief Historiography of Stylistic Retrospection," Mark D. Fullerton offers a critique of the organic model of stylistic development and its attendant categories and terminology. He points to the employment already in the fifth century B.C. of specific styles in connection with specific subjects, questioning the conception of such appropriations as "retrospection" and suggesting new ways to approach them. He recognizes the persistence of analytic models that are clearly inadequate to the monumental corpus as a serious problem for the field of ancient art.

The study of Greek clothing is generally approached as a purely archaeological problem restricted to identifying the types of garments that are represented and matching them with textual evidence for their ancient designations. Mireille M. Lee, in "The *Peplos* and the 'Dorian Question'," shows here that one of the most familiar garments in the scholarly repertory, the "peplos," was not so much discovered as brought into existence in connection with attempts to define the "Dorian" element of Greek culture. The distinction between Doric and Ionic styles of dress was initiated by Carl August Böttiger at the end of the eighteenth century and adopted by Karl Otfried Müller, whose work on the Dorians opened the door to what Eduard Will called the "deformation" of German historical thought toward racist principles.[14] Franz Studniczka in 1886 produced what has remained the standard definition of the "peplos" as the "Dorian chiton," a formulation grounded in his conception of Indo-European culture and significantly at odds with archaeological and textual evidence. Lee demonstrates the way in which overarching theories can affect ostensibly positivist approaches.

Mary Beard brings to life the atmosphere of British classical studies in the late nineteenth and early twentieth centuries in her essay "Mrs. Arthur Strong, Morelli, and the Troopers of Cortés." Vivid contemporary sources illuminate institutional history and the personalities of leading figures in the emergence of classical archaeology as a modern scholarly discipline. She focusses on the contributions made by Eugénie Sellers Strong to the study of ancient art, which have been overshadowed by the productions of her contemporaries. Strong was, however, formidable in her own right, and her work was particularly significant for introducing continental,

especially German, scholarship to the English-speaking world. Although her activities in the Roman sphere are now better remembered, her work also had an important effect on the study of Greek art. Beard shows that the introduction of Morellian method, regularly assigned in histories of the field to J. D. Beazley, should instead be credited to Strong. The essay sheds new light on the culture of scholarship and asks important questions about the intellectual pedigrees that are the foundation of its history.

Joanne Monteagle Stearns examines the controversy over Martin Bernal's *Black Athena*, which continues, more than a decade after the first volume appeared, to generate opposing claims about the moral and epistemological position of classical studies. In "Jargon, Authenticity, and the Nature of Cultural History-Writing: *Not Out of Africa* and the *Black Athena* Debate," Stearns addresses the fundamental historiographic issues that underlie the controversy. Classical antiquity, as recovered through the practice of writing history, holds a normative position in Western culture; its centrality demands that we continually examine both the means by which it is interpreted and the use that is made of it. Beginning with Leopold von Ranke's endlessly debated proposition that the task of the historian is to tell "what actually happened," Stearns examines how thinkers ranging from Adorno to DuBois have wrestled with the problems of authority and authenticity in the historical enterprise. In place of the accusatory polemic that has characterized much of the present controversy, she proposes constructive ways to explore the contested position of classical culture in the contemporary world.

We do indeed live in interesting times, and there is no reason to exclude from our specialized studies the intellectual challenges that surround us. A century ago the pioneering and now classic studies of ancient art had much in common with the wider intellectual agendas of their time; the investigations of artistic form pursued by Franz Wickhoff, Alois Riegl, Julius Lange, Alexander Conze, and Emanuel Löwy were no less concerned with uncovering fundamental principles than was contemporary work in physics on the structure of matter, and studies of ancient art made full, even extravagant, use of the discoveries of anthropology and psychology that promised to elucidate the basic processes of human experience.[15]

A. A. Donohue

At the start of the new millennium, we are no longer so optimistic that we can reach such comprehensive understanding, or even so willing to see such a goal as valid. The search for irreducible truths about human experience continues in new forms like the Human Genome Project, but it is balanced by a widespread distrust of the very concept of such universals that finds scholarly expression in the investigation of cultural forms and norms as contingent rather than inevitable. Our view of ancient art is further shaped by our awareness that the interpretation of the past has been implicated in the establishment and abuse of social authority; our specialized scholarship finds itself challenged by questions of who has the right to undertake such interpretation when the stakes are so high. In this book we express the conviction that the study of ancient art is not an isolated pursuit, but a vital part of intellectual history that is not without consequence for the present and the future.

NOTES

1. For the probable origin of the saying – not ancient, not Chinese, and not a curse – in Duncan H. Munro (Eric Frank Russell), "U-Turn," *Astounding Science Fiction* (April, 1950) 137, see Stephen E. DeLong, http://hawk.fab2.albany.edu/sidebar/sidebar.htm.

2. E. R. Curtius, *Europäische Literatur und lateinisches Mittelalter* (Bern, 1948) 23; trans. W. R. Trask, *European Literature and the Latin Middle Ages* (Bollingen Series 36; New York, 1953) 15. Part of the context of the remark is a methodological debate over *Wissenschaft* and *Geschichte*. Curtius continues: "Dasselbe Verhältnis besteht zwischen Dante und den Kathedralen usw. Die Bilderwissenschaft ist mühelos, verglichen mit der Bücherwissenschaft." ("The same relation obtains between Dante and the cathedrals, and so on. Knowing pictures is easy compared with knowing books.") Noting the offense taken by art historians at these remarks (which appeared first in 1947 in the journal *Merkur*), Curtius (1948, 24 n. 1; 1953, 16 n. 11) clarifies his position: "[W]ären Platons Schriften verloren, so könnte man aus der griechischen Plastik nicht rekonstruieren. Der Logos kann sich nur im Wort aussprechen." ("Were Plato's writings lost, we could not reconstruct them from Greek plastic art. The Logos can express itself only in words.") He calls (1948, 24 n. 1) for the reconsideration of the position of art history within the humanities ("Die Stellung der Kunstgeschichte innerhalb der Geisteswissenschaften scheint mir einer Revision zu bedürfen.") For the nineteenth-century situation, see infra n. 7.

3. See, e.g., P. Courbin, *Qu'est-ce que l'archéologie? Essai sur la nature de la recherche archéologique* (Paris, 1982); trans. P. Bahn, *What is Archaeology? An*

# Introduction

*Essay on the Nature of Archaeological Research* (Chicago and London, 1988) passim.

4. A. M. Snodgrass, *An Archeology of Greece. The Present State and Future Scope of a Discipline* (*Sather Classical Lectures* 53; Berkeley, Los Angeles, and Oxford, 1987) 132–134. See also B. S. Ridgway, "The Study of Classical Sculpture at the End of the 20th Century," *American Journal of Archaeology* 98 (1994) 759–760.

5. A classic examination of the emergence of "art," "fine arts," and related concepts is P. O. Kristeller, "The Modern System of the Arts: A Study in the History of Aesthetics," *Journal of the History of Ideas* 12 (1951) 496–527 and 13 (1952) 17–46.

6. See, e.g., M. Vickers and D. Gill, *Artful Crafts. Ancient Greek Silverware and Pottery* (Oxford, 1994; new ed., 1996) 192–193 for the effects of the concept of "Art (with a capital 'A')" on the study of Greek pottery and Cycladic figurines. For the latter, see D. W. J. Gill and C. Chippindale, "Material and Intellectual Consequences of Esteem for Cycladic Figures," *American Journal of Archaeology* 97 (1993) 601–602: "Connoisseurship we define as esteem for, and appreciation of, beautiful artifacts, especially those that seem to fall into the domain of the fine and decorative arts. Archaeology we define as the study of past societies by means of their surviving material remains.... For the most part the two concerns have gone harmoniously together in the hybrid discipline of Classical art history (so often effectively equated with Classical archaeology), which has been central to Classical learning over the last centuries. But they are distinct studies, and their distinct concerns and priorities have distinct consequences."

7. H. Funke, "F. A. Wolf," in W. W. Briggs and W. M. Calder III, eds., *Classical Scholarship. A Biographical Encyclopedia* (New York and London, 1990) 523–528; S. L. Marchand, *Down from Olympus. Archaeology and Philhellenism in Germany, 1750–1970* (Princeton, 1996) 16–24; B. Schneider, *August Boeckh: Altertumsforscher, Universitätslehrer und Wissenschaftsorganisator im Berlin des 19. Jahrhunderts. Ausstellung zum 200. Geburtstag 22. November 1985–18. Januar 1986* (Staatsbibliothek Preußischer Kulturbesitz, Ausstellungskataloge 26; Berlin, 1985); J. Irmscher, *Die griechisch-römische Altertumswissenschaft am Übergang von Klassizismus zum Historismus. Zur 200. Wiederkehr der Geburtstage von I. Bekker und A. Boeckh im Jahre 1985* (*Sitzungsberichte der Akademie der Wissenschaften der DDR. Gesellschaftswissenschaften* 1986 Nr. 4/G; Berlin, 1986); *Der Neue Pauly* 13 (Stuttgart and Weimar, 1999) 523–527 s.v. "Böckh-Hermann-Auseinandersetzung (C. Ungefehr-Kortus).

8. See, e.g., the essays in W. M. J. van Binsbergen, ed., *Black Athena: Ten Years After* (*Talanta. Proceedings of the Dutch Archaeological and Historical Society* 28–29, 1996–1997).

9. B. S. Ridgway has further reminded me of the important place of sculpture in Ranuccio Bianchi Bandinelli's Marxist analysis of ancient societies. See Mark D. Fullerton's essay in this volume for Bianchi Bandinelli's contribution to the study of style.

10. E.g., W. Schiering, "Zur Geschichte der Kunstgeschichte," in U. Hausmann, ed., *Allgemeine Grundlagen der Archäologie* (*Handbuch der Archäologie*; Munich, 1969) 11–161; A. H. Borbein, "Klassische Archäologie," in T. Buddensieg,

K. Düwell, and K.-J. Sembach, eds., *Wissenschaften in Berlin* (Berlin, 1987) I, 103–107; H. Sichtermann, *Kulturgeschichte der klassischen Archäologie* (Munich, 1996).

11. "Ripeness is All: Metaphors of the Classical Norm in Ancient Art" (1997); "Same As It Never Was: Issues in the Historiography of Ancient Art" (2000).

12. For the scandal provoked by Stead's exposé and its consequences, see R. L. Schults, *Crusader in Babylon: W. T. Stead and the Pall Mall Gazette* (Lincoln, 1972); J. R. Walkowitz, *City of Dreadful Delight: Narratives of Sexual Danger in Late-Victorian London* (Chicago, 1992) 81–134; for the conception of London as Babylon, see L. Nead, *Victorian Babylon: People, Streets and Images in Nineteenth-Century London* (New Haven and London, 2000) 3–10.

13. Vickers and Gill, *Artful Crafts* (supra n. 6) 77, chapter 3: "The Fate of Plate."

14. E. Will, *Doriens et Ioniens. Essai sur la valeur du critère ethnique appliqué à l'étude de l'histoire et de la civilisation grecques* (*Publications de la Faculté des lettres de l'Université de Strasbourg* 132; Paris, 1956) 12.

15. Wickhoff in W. von Härtel and F. Wickhoff, eds., *Der Wiener Genesis* (*Jahrbuch der Kunstsammlungen des Allerhöchsten Kaiserhauses;* Vienna, 1895); A. Riegl, *Stilfragen. Grundlegungen zu einer Geschichte der Ornamentik* (Berlin, 1893); trans. E. Kain, *Problems of Style. Foundations for a History of Ornament* (Princeton, 1992); idem, *Die spätrömische Kunstindustrie nach den Funden in Österreich-Ungarn* I (Vienna, 1901); republished as *Spätrömische Kunstindustrie* (Vienna, 1927); trans. R. Winkes, *A. Riegl. Late Roman Art Industry* (Rome, 1985); J. Lange, *Billedkunstens Fremstilling af Menneskeskikkelsen i dens ældeste Periode indtil Højdepunktet af den græske Kunst* (*Studier i de fra Perioden efterladte Kunstværker, Dansk Videnskabernes Selskab, Historisk-Filologiske Meddelelser*, 5th ser., 5.4 (Copenhagen, 1892) 177–466; repr. 1903; idem, *Billedkunstens Fremstilling af Menneskikkelsen i den græske Kunsts første Storhedstid* (*Studier i de fra Perioden efterladte Kunstværker, Dansk Videnskabernes Selskab, Historisk-Filologiske Meddelelser*, 6th ser., 4.4 (Copenhagen, 1898) 161–287; trans. M. Mann, ed. C. Jörgensen, *Darstellung des Menschen in der älteren griechischen Kunst* (Strassburg, 1899); A. Conze, "Zur Geschichte der Anfänge griechischer Kunst," *Sitzungsberichte der philosophisch-historischen Classe der Kaiserlichen Akademie der Wissenschaften* 64.2 (Vienna, 1870) 505–534; II, vol. 73.1 (Vienna, 1873) 221–250; idem, "Über den Ursprung der bildenden Kunst," *Sitzungsberichte der königlich preussischen Akademie der Wissenschaften zu Berlin* 1897, 98–109; E. Löwy, *Die Naturwiedergabe in der älteren griechischen Kunst* (Rome, 1900); E. Loewy, trans. J. Fothergill, *The Rendering of Nature in Early Greek Art* (London, 1907); F. Brein, ed., *Emanuel Löwy. Ein vergessener Pionier* (*Katalog der Archäologischen Sammlung der Universität Wien. Sonderheft* 1; Vienna, 1998). For "a new atmosphere in scholarship which brought people and ideas together on a scale and in a spirit hitherto unknown" that prevailed in the years before World War I, see W. S. Heckscher, "The Genesis of Iconology," in *Stil und Überlieferung in der Kunst des Abendlandes. Akten des 21. Internationalen Kongresses für Kunstgeschichte in Bonn 1964* III. *Theorien und Probleme* (Berlin, 1967) 250–257.

# From Whores to Hierodules: The Historiographic Invention of Mesopotamian Female Sex Professionals

JULIA ASSANTE

Since the end of the nineteenth century, scholars have fashioned a monument of exotic Eastern profligacy out of the Mesopotamian female body.[1] Art historians worked alongside classicists, theologians, social anthropologists, and especially philologists to create a discourse of prostitution and sexual rites that is still developing. According to most, harlots fornicated with strangers in the shadows of the city wall, in so-called tavern brothels, and in the urban thoroughfares; priestesses performed in lavish "orgiastic cults" within temple compounds, and "hierodules" ritually copulated with kings, some believe on couches placed at the summits of ziggurats (i.e., the Towers of Babel).[2] These three ranks of females – the common harlot, the temple prostitute, and the hierodule – became the hallmarks of ancient Near Eastern sexual and religious aberrancy. As they were constructed against a nineteenth-century idealization of Western women (envisioned as modest, even sexless, pious, and faithfully married), the ancient counterpoints were contrived opposites, suspiciously alike. They were all unmarried, sexually unrestrained professionals, and rather than obediently submitting to a male god who could at least approximate the god of nineteenth-century Christianity, they were closely affiliated with a thoroughly heathen goddess, Inanna/Ishtar, whose domain was sex and war.[3] As the "Divine Harlot," she fostered prostitution in her secular daughters.[4] As a high deity she imposed sexual duties on her priestesses and forced the hierodule, her human surrogate and the highest ranked of the three, to fornicate with kings.[5] This celestial Cleopatra, beautiful,

powerful, exotic, seductive, and above all, dangerous, became the feminine face of oriental despotism.[6]

The academic discourse of fertility magic, sexual rites, and prostitution has amassed authority by sheer repetition, the extent of which has turned fabrication into fact. Mesopotamia is believed to have been the home of "the oldest profession" and to have originated sacred marriage rites and cult prostitution that later diffused to other cultures. This form of academic sensationalism is reiterated in scholarly and popular works alike, especially in those that include religion, sexuality, or women in antiquity.[7] Although biblical and classical sources appear to give these notions historical weight, they are ultimately the products of Victorian anthropology. Scholars so consistently read Mesopotamian arts and texts through the thick lens of nineteenth-century social theory that their original meaning is nearly imperceptible in the secondary literature.

Art historians colluded in creating this standard discourse. Without critical evaluation, they distorted the meaning of Mesopotamia's erotic art to fit already existing labels. For instance, they regarded images of nude women and sexual intercourse from all places and periods as fertility amulets. They saw universal rituals performed to promote fertility in any scene of human copulation. These rituals were generally given two forms: sacred marriage, in which a king copulates with Inanna's mortal stand-in, and rituals performed by sacred prostitutes. Sacred marriage between male and female deities was an early, less favored reading. A more recent interpretation is that images of intercourse depict common female prostitutes with their clients, although some view any female sexual activity as an offertory rite to Ishtar.[8] The monotony of available interpretations caused considerable frustration in interpreting erotica, as voiced by André Parrot: "Sacred Marriage rite, scene of sacred prostitution, a purely profane act, one cannot know how to choose for certain. . . . At any rate, the deeper meaning is overlooked."[9]

Despite the evident disparities in time, place, and iconography, scenes of copulation that appear intermittently on stamp and cylinder seals from the mid-fifth millennium B.C. on were usually dubbed "sacred marriage." Although the true meaning of each seal scene is not yet known, some are more likely to portray exorcism (Fig. 1) than divine union.[10] Similarly,

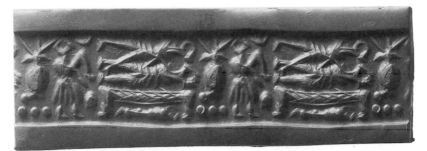

Fig. 1. Modern impression of an Early Dynastic limestone cylinder seal featuring a man and a woman in intercourse on a bed. An attendant manipulates the woman's feet. Behind him stands a large beer vessel with straws protruding from its mouth. A scorpion is under the bed. From Tell Asmar (As 32934). 2 × 1.2 cm. (Photo courtesy of the Oriental Institute of the University of Chicago.)

Old Babylonian terracotta plaques with sexual scenes (ca. 2000–1650 B.C.), according to the current reasoning, depict sacred marriage, sacred prostitution, or just plain harlotry (Figs. 2 and 3). They do not. Like thousands of other Old Babylonian terracotta plaques without sexual content, they are complex tools of domestic magic whose images are grounded in Sumerian folk traditions. They functioned primarily to protect the house and its occupants.[11] Women in Middle Assyrian lead erotica (1240–1207 B.C.), occasionally in ménages à trois, must be female temple officiants offering themselves on altars in Ishtar's orgiastic cult.[12] Mistakenly assumed to have come from the Ishtar Temple at Assur, one erotic relief (Fig. 4) appeared in 1992 as an illustration for "prostitution and ritual sex," an entry in a popularizing Mesopotamian dictionary.[13] The truth is, such lead reliefs show foreign captives performing bizarre sexual acts for Assyrian viewers and thus carry strong political messages that equate sex and visual possession with territorial conquest.[14] They are the only examples of pornography known from Mesopotamia.[15] These few examples amply demonstrate how the facile application of standard interpretations obscured (far more interesting) indigenous purposes and precluded meaningful art-historical investigation. The concept of fertility cults was and still is integral to any discussion of artifacts that involves female nudity, "vulva" signs (i.e., triangles), or female sexual activity.

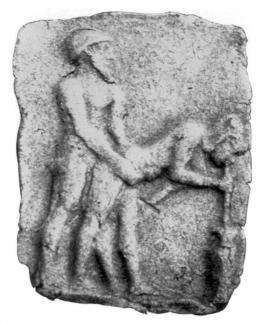

**Fig. 2.** Old Babylonian terracotta plaque of a man and a woman in intercourse. The woman bends over to drink beer through a straw. From Warka. Vorderasiatisches Museum, Berlin VA 6214. Ht. 7.2 cm. (Photo: author. Reproduced courtesy of the museum.)

The application of such ideas to texts is correspondingly wide. Until recently, philologists across the board mistook literary descriptions of sexual encounters as examples of ritual. Thus, any love ditty between Inanna and Dumuzi took on the immense dimensions of temple liturgy performed to ensure the fertility of the land. Similarly, royal hymns of praise that involved a king's imaginary bedding of Inanna were regarded as written records of enacted sacred marriage rites, again to ensure fertility. Female temple personnel and many female professionals mentioned in lexical, judicial, economic, or literary texts were at one time or another thought to officiate in these cults. According to Mayer Gruber, scholars were "unable to imagine any cultic role for women in antiquity that did not involve sexual intercourse."[16] Even those who recognized that primary sources do not connect these female functionaries with sexual activity still viewed them as officiants in fertility cults.[17] The vagueness of the fertility concept gave rise to a considerable amount of

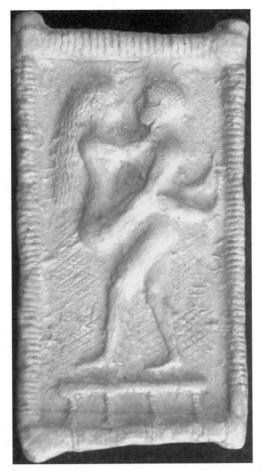

Fig. 3. Modern plaque made from an Old Babylonian terracotta mold of a man and a woman in intercourse on a bed. Unprovenienced. Vorderasiatisches Museum, Berlin VA 14514. Ht. 14 cm. (Photo: author. Reproduced courtesy of the museum.)

slippage and tangled contradiction between presumed rites and their celebrants.[18]

Fertility in the most expanded sense of the term is inextricable from any principle of growth or abundance. As a modern label, not ancient Mesopotamia's, it is an undifferentiated mass loaded with sexual connotations, the habitual application of which obliterates Mesopotamian distinctions. When eminent scholars, such as Henri Frankfort, Thorkild Jacobsen, and Samuel Noah Kramer, identify rites and hymns performed

Julia Assante

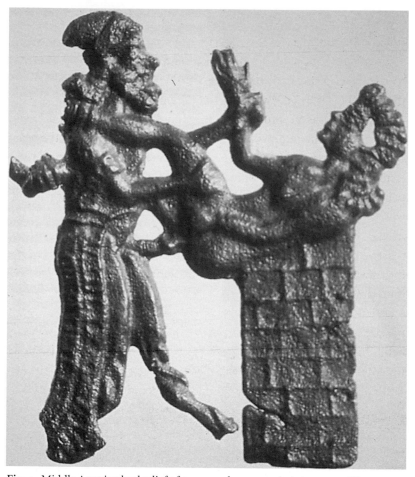

**Fig. 4.** Middle Assyrian lead relief of a man and a woman in intercourse. The woman lies on a mudbrick structure. From Assur. Vorderasiatisches Museum, Berlin VA 4244). Ht. 7.2 cm. (Photo courtesy of the Vorderasiatisches Museum, Berlin.)

to secure divine favor (and all its attendant boons) as fertility rituals, they are significantly altering native meaning. Divine favor does not equate to fertility. Divine favor, not fertility, brings luck. Divine favor, for the commoner, means an individual is gaining ground in the battle against illness, poverty, and loneliness. For the king in sacred marriage texts, it means absolute power, wealth, and long life. Fertility conveys none of these things.

18

## The Formative Environment of the Nineteenth Century

What were the social factors that led to the academic production of women's aberrant sexuality in Mesopotamia? And why did it become so entrenched? Art historians and other orientalists[19] were subject to the complex emotional and intellectual climate of the late nineteenth and early twentieth centuries that structured models of sexual behavior according to contemporary attitudes about gender and class. In the realm of visuality certain ideals about women and female sexuality were projected in exaggerated forms onto "oriental" women in nineteenth-century paintings. One was the fantasy of feminine sexual passivity and male control, translated pictorially in J.-L. Gérôme's *The Slave Market* (Fig. 5). In addition to portraits of slaves for sale are curvaceous women put up on the marriage market and plump odalisques idling in harems.[20] These paintings of what Linda Nochlin calls "The Imaginary Orient" show women – invariably luscious – waiting to be taken as passive commodities or owned flesh.[21] As such, they do not display themselves openly or willingly but are inspected or spied upon by a presumably male eye. The visual habits that enabled modern viewers to assimilate images of female nudity were strong, unconscious influences in the interpretations of ancient Near Eastern female nudes. The women in Mesopotamian sexual scenes exhibit neither passivity nor modesty. They instead cavort with two men at once, fornicate while being watched by attendants, indulge in autoeroticism with outsized disembodied phalli, and bend over to copulate while sucking beer from straws. The disruption of visual habits was so jarring that scholars simply labeled the artifacts – with occasional bowdlerizing – and put them away.[22] Mesopotamian erotica could not be assimilated.

Nevertheless, scholars did identify the females in these scenes as professionals in the midst of performance because of the figures' alarmingly wanton display and non-missionary positions, just as they identified similar figures in the arts of ancient Greece and nineteenth-century Paris.[23] And, of course, sex professionalism always involves performance to some degree. Many set non-missionary positions against missionary positions and put them in a dualistic structure of abnormal/public versus normal/private that usually took the shape of cultic sphere in contrast to

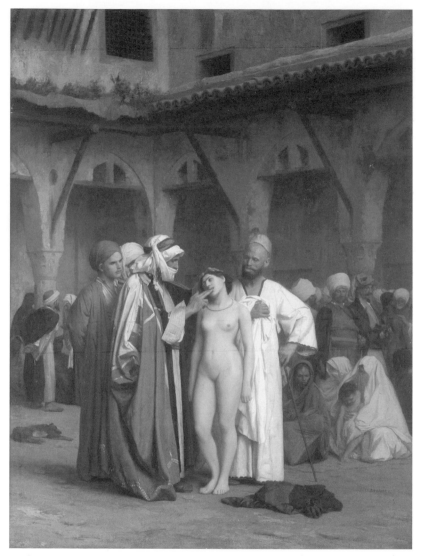

**Fig. 5.** Jean-Léon Gérôme, *The Slave Market.* (Early 1860s). Oil on canvas. 84.3 × 63 cm. Sterling and Francine Clark Art Gallery, Williamstown. (Photo courtesy of the museum.)

domestic sphere.[24] As long as nudity was involved, art historians barely distinguished female dancers and musicians from professionals in so-called orgiastic cults or hierogamous rites. Behind the making of this muddle were specific oriental character types already secured in the

nineteenth century, such as Flaubert's *ameh*, the Egyptian Kuchuk Hanem, part dancer and part prostitute – the prototype for his Salomé, Salammbô, and Tanit.[25] These were exotic adaptations of the nineteenth century's fallen woman. The Mesopotamian version is refreshingly brazen and robust, no doubt because she inhabited a primitive domain of naïve paganism (it could be reasoned), uninhibited by the concepts of sin and sexual shame that weighed heavily on her modern counterpart.

Orientalists' attitudes toward single women and patriarchy in general supported the construction of female waywardness. The Western scholar of the nineteenth century already lived in a moral milieu that divided the female populace into respectable and not respectable, legitimate and not legitimate – in other words, married and not married. It is the latter category, i.e., the "other woman," who was unfailingly sexualized as a prostitute or kept woman and rigorously alienated from the domestic sphere.[26] The fallen woman was a blight on the moral vigor inherent in patriarchy, a social system underwritten by the Bible. Orientalists, trained in biblical Greek and Hebrew, adopted from the Bible a belief in a coldly righteous form of ancient Near Eastern patriarchy.[27] Genesis claims that patriarchy originated in Mesopotamia and that Abraham, the supreme patriarch, took it from the ancient city of Ur and brought it west in its pristine state. The monotheism of later Palestine – so unlike the pantheon of Mesopotamia – was a spiritual reflection of an idealized patriarchy. It indisputably set the right of rule on male shoulders and made obedience to male authority a moral imperative. Orientalists shaped a monolithic and absolute patriarchy out of this ideological material. The way they perceived contemporary Moslem village life and the Ottoman Empire confirmed their version, and no classical source contradicted it. It is safe to say that at one time or another scholars suspected all women in antiquity who did not conform to their imagined social precepts – that is, who neither were owned as slaves or concubines, nor were legally controlled as wives – of sex professionalism.

According to orientalists' translations of cuneiform texts, Mesopotamia teemed with the whorish "daughters of Ishtar,"[28] a view reinforced by the books of the Old Testament and Herodotus.[29] Moral biases eclipsed the recognition of biblical sexual imagery as political metaphors.

Rather than describing profligate females – adulterers if married, harlots if single – such imagery described apostasy and idolatrous practices.[30] Hebrew writers and prophets personified disobedience to their male god-hood as a degenerate, unfaithful woman.[31] Even the nation of Judah became Yahweh's adulterous wife. To the prophets, the aging country to the east was the most licentious of all not just because it was thoroughly pagan but because it captured and corrupted Hebrews.[32] Together, the misunderstood accounts and modern attitudes led orientalists to condemn all single women as defiant of natural patriarchal order; like Inanna/Ishtar, these women were neither faithful nor obedient to any man.

Such women were also projections of a longing for a different kind of sex, a less burdened, freer sex, enticingly laced with danger. As Edward Said puts it:

> We may as well recognize that for nineteenth-century Europe, with its increasing *embourgeoisement*, sex had been institutionalized to a very considerable degree. On the one hand, there was no such thing as "free" sex, and on the other, sex in society entailed a web of legal, moral, even political and economic obligations of a detailed and certainly encumbering sort. . . . [S]o the Orient was a place where one could look for sexual experience unobtainable in Europe.[33]

Scholars of the ancient Near East not only looked for the unobtainable – and what could be more unobtainable to the modern male than sex with a sacred prostitute! – but, as spokesmen for Mesopotamia, they also had the authority to insert it into history. Nevertheless, they could not imagine women altogether free of dominion, and certainly they saw despotism in general as the natural course for baser, un-Greek societies. They therefore placed women outside male control under one mistress, Inanna/Ishtar, the ultimate renegade deity – she who happily exhausts sixty times sixty men in a public square, the ultimate verbal flasher, who praises her vulva and its wetness and frequently wonders aloud, "Who will plow it?"

How did scholars come to this point? First, they were accustomed to images of sexy, tyrannical females from biblical and classical sources – portraits they accepted as historical truth. The women of biblical and classical stories often became the notorious subjects, the femmes fatales,

of nineteenth-century historical fictions.[34] Mesopotamia as the Great Whore who brings her people to corruption and ruin appears in both the Old and New Testaments[35] alongside her mortal correlates, the Jezebels, Salomés, and Delilahs. Herodotus gave them the Babylonian Aphrodite, presumably Ishtar, who made her income by pimping her female virgin citizens. Her demand of their virginity as a temple offering must have appeared as an extreme corruption of patriarchal order to Herodotus's Greek audience:

> The foulest Babylonian custom is that which compels every woman of the land once in her life to sit in the temple of Aphrodite and have intercourse with some stranger . . . with crowns of cord on their heads; there is a great multitude of women coming and going; passages marked by line run every way through the crowd, by which the stranger men pass and make their choice. When a woman has once taken her place there she goes not away to her home before some stranger has cast money into her lap and had intercourse with her outside the temple; but while he casts the money he must say, "I demand thee in the name of Mylitta" (that is the Assyrian name for Aphrodite). It matters not what be the sum of the money; the woman will never refuse, for that were a sin, the money being by this act made sacred. So she follows the first man who casts it and rejects none. After their intercourse she has made herself holy in the goddess's sight and goes away to her home; and thereafter there is no bribe however great that will get her. So then the women that are fair and tall are soon free to depart, but the uncomely have long to wait because they cannot fulfil the law; for some of them remain for three years, or four. There is a custom like to this in some parts of Cyprus.[36]

It was not until the turn of the century, when the classicist Sir James Frazer developed the theory of fertility cults, that this perverse feminine despot-cum-evil temptress of ancient sources was softened and given a scientific rationale. Within this frame, Ishtar was transformed into the great Mother Goddess,[37] which allowed post-Frazerian (and post-Darwinian) scholars to read in (what they asserted were) her institutions an altruistic response to her people's drive for the survival of the species. It is Frazer who must be held accountable for his damaging re-make of Herodotus's passage on temple prostitution. Whereas Herodotus

regarded these women as amateurs forced to prostitute themselves only once in their lives, Frazer envisioned them as full-time "religious prostitutes," thereby giving birth to the ancient Near Eastern institution of sacred prostitution. And while Herodotus implies that this singular act was a means by which the temple gained income, without exalting it with religious purpose,[38] Frazer charged the ancient world with mystical sexual fervor and an irrepressible desire to reproduce that sought expression in rite.[39]

Although the first edition of Frazer's monumental *Golden Bough* appeared in 1890, it was the abridged, single-volume edition of 1922 that circulated the theories that infiltrated scholarship without critical resistance.[40] It was then that his impact on scholars of the ancient Near East, including biblical scholars, was first felt. Before the 1922 edition, for instance, art historians simply labeled Mesopotamian erotic scenes as "pornographic" or "obscene," suggesting acts committed by mere secular prostitutes. But by the 1930s, the images had acquired their glamorous status as depictions of institutionalized religious rite. Just as cultic connotations were absent from readings of Mesopotamian erotica prior to Frazer, there were no cult prostitutes in the Bible before 1927. The Hebrew *q$^e$dēšā*, a cognate for Akkadian *qadištu*, formerly translated as "prostitute" or "strumpet" and the like, became a cult or temple prostitute in subsequent English-language Bibles.[41] Frazer's cool "scientific" survey legitimized ritual sex as a field of study. Its officiants popped up everywhere from sources, once unyielding, that seemed at last unlocked. More than any other, it was this classicist who naturalized ancient sexual fertility rites and gave them the forms of sacred marriage and sacred prostitution in currency today.

## The Question of Fertility Cults: Be Fruitful and Multiply?

Scholars have applied and still do apply essentialized notions about fertility cults and mother goddesses to ancient societies – no matter how dissimilar – from East to West, from the Pleistocene to historical periods.[42] Prominent orientalists, such as the philologists Beatrice Brooks, Thorkild Jacobsen, and Samuel Noah Kramer and the art historians Henri

Frankfort, E. Douglas van Buren, and Anton Moortgat, set the standards for the ancient Near East by asserting fertility rites as central to Mesopotamian religion. Brooks's "Fertility Cult Functionaries in the Old Testament" describes the cultural diffusion of fertility cults throughout the ancient Middle East. The author enlists "thousands" of nude female figurines of widely divergent periods, places, and styles as paraphernalia of the cult. The "hundreds of liturgical texts and legal codes" – almost entirely from ancient Mesopotamia – indicate a common origin for the "Isis-Osiris, Ininni-Dumuzi, Ishtar-Tammuz, and Astarte-Adonis [fertility] cults," grounded in sacred marriage. The lists of female clerical titles from Mesopotamia become lists of celebrants in the "licentious rites of sympathetic magic described by various Greek historians," i.e., Herodotus.[43] Not atypically, the individual intentions of images, literary works, laws, and lexical lists are all subsumed in one cult. Even in more current studies, fertility is claimed as the underlying raison d'être for all ecclesiastical women, despite the fact that female cult functionaries were usually forbidden to bear children and some, such as certain *nadītu*s, were probably chaste.[44]

There are no internal features in the objects assumed to be fertility amulets that suggest animal or agricultural fertility. Nor have images of women pregnant or giving birth yet emerged from the soils of Mesopotamia. Although sexual intercourse in love literature is commonly rendered in agricultural metaphors, such as "plowing" or "watering" a field, the fact that no words are spent on impregnation or progeny undermines the interpretation of these images as expressions of human fecundity.[45] In fact, Inanna/Ishtar – the icon of female sexuality – remained in almost all her traditions childless.[46] Nonetheless, the spoken promise of material abundance as an aftermath of sexual ecstasy is such a common theme in these works that one is tempted to read the proffering of presents as an aphrodisiac ploy. The gifts can flow from man to woman or woman to man. But whether jewelry, the staff of rulership, or sweet cream and white cheeses should be interpreted as evidence of fertility is dubious at best. The gifts reflect what we know from marriage contracts and dowry agreements – that mating should be calculated to increase economic security. Instances of impregnation only appear in those myths in which a male deity is the focus.[47] These stories, usually rendered as rapes,

highlight the Herculean potency of the divine male member. They have never been interpreted as liturgies for rite. Their textual imagery (e.g., the gigantic, engorged member of the god Enki poking through reedy swamps) does not appear in the visual art that remains to us. There is little to glean from other sources about Mesopotamian attitudes toward procreation.

One of the chief reasons the theory of fertility magic survives inherent contradiction and the absence of evidence is its seeming confirmation in religion and science. Yahweh's command to be fruitful and multiply and the Bible's emphasis on progeny in general represent the peoples of antiquity as morally driven to reproduce as much and as often as possible. Certainly, Darwin's scientific corroboration seemed to underscore the eternal wisdom of that command. But as far as we know, no Mesopotamian god ever commanded people to multiply. Quite the contrary. As Anne Kilmer shows, the gods of pre-biblical flood myths did not destroy mankind because they sinned but because they overpopulated and made too much noise.[48] Atra-ḫasīs, the Mesopotamian Noah, escaped the divine massacre only to initiate a species that overpopulated all over again. The gods Nintu and Enki created several types of humans who could not reproduce to keep the population in check; to these were added plagues and pestilence.[49] Historically, we know that many types of female cult functionaries were forbidden to have children. From Atra-ḫasīs (III vii 6–9), the same work from which the main Flood Story comes, the *ugbabtu*, the *entu*, and the *egiṣtu* are singled out. The *nadītu*'s enforced childlessness is well known from a variety of other sources.[50] Such myths were probably understood as historical.[51] Kilmer concludes: "It seems very clear to me that the condition set by the gods for man's continuance on earth was that overpopulation – and the ills that were seen to go with it – is forever to be avoided, and that population control is to be achieved by nature and the gods on the one hand, and deliberately, by man, on the other" through celibacy or contraceptive sexual techniques.[52]

Altogether, it is difficult to accept a consistent ideology of "be fruitful and multiply" for Mesopotamia. This is not to suggest that human fertility was never a concern. Laws indicate that a certain pressure was put on a woman to provide her husband with a child, but only one child.

If she could not, she was a good candidate for divorce or for having her status reduced to the rare second wife. For these and other, potentially personal, reasons, a childless woman might seek the help of fertility magic, but her situation would be the exception rather than the norm. Finally, the resource-poor lands of ancient Sumer, the threats of drought and salination, and the small amount of available irrigated land that was divided and subdivided ad infinitum (as were houses among competing sons), all indicate an economic necessity to keep families small. Some estimate two to four children as typical.[53] In short, there is no evidence that the promotion of human fertility was a major cultural force in Mesopotamia, at least not in historical periods.[54] The terms "fertility" and "fertility magic" are misleading and too broad for critical use. They reinforce untested socio-biological assumptions that all cultures possess an inherent drive to maximize procreation. They also advance the belief that ancient patriarchies perceived women's sexuality solely as a vehicle of reproduction.[55]

## Sacred Marriage: Story, Symbol, or Rite?

The term "sacred marriage," from the Greek *hieròs gámos*, originally referred to the marriage of Zeus and Hera. Although Frazer expanded its meaning to include any symbolic marriage or sexual ritual that promoted fertility, scholars of the ancient Near East apply the term to three types of union: between two deities, between a king and Inanna, and between Inanna and Dumuzi.

Marriages between deities were spottily recorded for the god Ningirsu and his wife Baba in the last quarter of the third millennium B.C. and again in the mid-first millennium B.C. for the god Nabû and either Nanâ or Tashmetu. There are occasional allusions to other divine couples in most historical periods.[56] Even though the textual references are localized and surprisingly few, early art historians, such as Frankfort, Moortgat, and van Buren, all active members of the myth and ritual school, interpreted sexual motifs of all periods and places as commemorating divine union.[57] Their interpretations often involved conflation and unlikely permutations,[58] and ignored the absence of the horned headdress, the divine

insignia worn by all deities.[59] In 1934, Frankfort went so far as to outline a religion based on a trilogy of a fertility god, the great mother goddess, and the sun god. The image (Fig. 1) from which he drew his inspiration appeared at least 500 years earlier than the first known sacred marriage texts and 200 kilometers away.[60] For almost four decades, few challenged Frankfort's reading of images of sexual congress as sacred marriage.[61] Oddly, no one has so far suggested that these literary instances of marriages between two deities are the remnants of rituals once acted out by male and female human surrogates.

Of a ritual marriage between a king and Inanna, the earliest "evidence" comes from the court literature of Shulgi (*Shulgi X*, ll. 1–73), the deified Ur III king (2095–2048 B.C.). Added to this text is part of another royal poem for Iddin-Dagan (*Iddin-Dagan A*), the later king of Isin (ca. 1974–1954 B.C.). There are also allusions in *Enmerkar and Ensuḫkeshdanna*, a tale of two legendary rulers who both boast of intimate relations with Inanna.[62] A handful of allusions in myths, royal hymns, and non-literary texts refers to some early kings as "spouse of Inanna" or "spouse of the nu.gig," but such titles are not likely to indicate ritual marriages.[63] Indisputably, some early kings identified themselves as Inanna's mates, a symbolic alliance to be sure. Circulating stories of their supernormal copulation with Mesopotamia's most popular goddess was one way they legitimated their claims of divine status in the eyes of their people.[64] Tellingly, when the tradition of deified kingship ceases, hymns of this type disappear.

Does any of these texts speak of a sexual rite enacted by a king and a hierodule? That scholars have been unable to discover anything about the hierodule's identity speaks volumes.[65] Her existence remains merely speculation. Some have argued that the rite was invoked to beget an heir to the throne.[66] Very few kings, however, claimed to be the son of Inanna. Furthermore, if such a rite were enacted, the goddess's royal son would eventually have to bed his mother. Ronald Sweet, who believes that the rite never really took place, compares the scholarly responses to hymns of praise that do not involve the king's sexual exploits with responses to similar hymns that do so.[67] In *Shulgi A*, for example, the king performs a number of astonishing acts – all in one day! He runs 320 kilometers, offers sacrifices, celebrates at a festival, banquets with the sun god Utu,

and receives a royal crown from the god An. Sweet remarks: "No one, to the best of my knowledge, has been so wooden-minded as to propose that human actors played the roles of Utu and An at the banquet."[68] If we do not read the lines in question as liturgy but as kingly hyperbole, then why do we read stories of kings copulating with Inanna as liturgy? And if we do not insist that males stood in for male gods in non-sexual hymns of praise (or for that matter in marriages between two deities), why should we insist that a woman substituted for the goddess in ritual sex? Sweet's logic exposes the double standards at work.

Such hymns might be elaborated commemorations of royal visits to Inanna's temples.[69] Oddly, the idea that sacred marriage between a king and the goddess might have been performed symbolically or as a dramatization has not arisen. A king may have ritually passed the night in her temple with her statue. Statues of deities were regarded as fully alive. They were washed, fed, adorned, given gifts, and prayed to; they paid visits to each other, according to festival itineraries. When the king goes proudly "with lifted head" to Inanna's bedchamber, he may well be expecting to meet wood, ivory, and gold rather than flesh and blood.

In the philological world of the 1950s and 1960s, amidst a flurry of general scholarly interest in sacred marriage cults and fertility, a large body of Sumerian love songs and erotic hymns, mostly devoted to Inanna, began to come out in translation.[70] Jacobsen and Kramer gathered the various works under the title "The Inanna-Dumuzi Cycle" in which the drama of the couple's wooing and wedding ends with Dumuzi's death.[71] Together with Adam Falkenstein, they put the spotlight on Inanna and Dumuzi as the prototypical couple in the rite of sacred marriage, where it still remains.[72] The first critical treatment of scholarship on sacred marriage appeared in the mid-1970s. Johannes Renger critiqued the textual material scholars associated with sacred marriage and concluded that the rite was overdetermined.[73] Jerrold Cooper, in a landmark essay, showed that images of men and women in intercourse cannot portray official rites, for they lack iconography that would indicate divine or high-ranking celebrants.[74] Both Renger and Cooper argued that the perception of sacred marriage as fertility magic exceeds the evidence, although neither questioned the existence of an enacted sexual rite.

Do the Dumuzi-Inanna texts describe ritual practice or even sacred marriage? The goddess usually appears as the archetypal girl on the verge of marriage. In one hymn, she and Dumuzi scheme to arrange a premarital tryst. In another, Dumuzi promises her that she will not have to do housework if she marries him. Any girl might identify with such themes and with Inanna's youthful flirtation and innocent yearning for "the honey man" who "sweetens [her] ever."[75] Obviously, the love songs had wide popular appeal.[76] Their literary images even crossed a cultural and temporal gulf from the Babylonian south to the Assyrian north of later centuries.[77] Such cultural impact could hardly have been caused by an elite temple rite that had been defunct by then for hundreds of years.

Currently, a different approach to Inanna-Dumuzi texts is gaining ground. Bendt Alster was the first to challenge Kramer's claim that all the Inanna-Dumuzi love songs are religious, ritual, and elite in character.[78] He notes traces of popular rather than ecclesiastical or courtly origin in some and suggests that certain hymns might depict common courting and weddings.[79] Cooper removes them one step further from ritual by suggesting that they were also sung in the privacy of the home.[80] Nevertheless, both Alster and Cooper see the hymns as scribal creations. The findspots of the tablets, however, and the fact that written versions appear when Sumerian was dying as a spoken language, combined with the internal structure and repetitiousness of most songs, point to oral folk material recorded, not written, by scribes.[81]

I would further propose that Sumerian love poetry has performative functions in that it teaches gendered response to sexual arousal. Cooper notes the expression of adolescent innocence and the couching of sex talk in metaphors, such as plowing a field or watering a garden, that imply long-lasting activity.[82] To me, the graphic metaphorical displacement composed of such familiar elements gives room for the novice to visualize only what is comfortable. Yet the wording is sufficiently explicit to convey important information about how the organs should respond. Through Inanna's own words, women learn about their bodies in sexual arousal, and men become acquainted with the depth of female sexual experience. Both learn procedures for heightening desire. The objective is entirely one of positive magic. Courtship and coupling are devoid of fear. Fears

of impotency – of which we have many examples in cuneiform texts – are ignored, as are fears of pain or pregnancy. Contrary to what we know was custom, it is desire that makes the match, rather than parents. Material wealth is the expected issue. Many songs probably eased anxieties about sex and marriage and thus played a valuable role in Mesopotamia, where marriages were normally arranged and the bride and groom had little or no previous contact. In addition, some hymns worked as magical analogues against the deadly embraces of evil forces who "marry" their victims.[83] Related sexual images on terracotta plaques, also from the Old Babylonian period, operated in the same tradition (Fig. 3). Rather than being depictions of sexual rites, they are amulets that were used to prevent malevolent agents from slipping into the house through doorways and windows; at the same time, they attracted the auspicious to enter.

## Making Sacred and Secular Prostitutes for History

To date, no evidence for sacred prostitution has ever been uncovered from Mesopotamian soil. We can no longer argue that its absence is an accident of archaeological discovery. In the archives from the Inanna Temple of the holy city of Nippur, to cite one case, out of more than 2000 tablets and fragments retrieved – more than half of which (1163) were economic documents from one period (Ur III) – none suggests such an institution.[84] If temple prostitutes brought in revenue, as scholars assert, some records, especially from the temples of Inanna/Ishtar, should have survived. Why does this delusion persist as if it were historical reality? Certainly the impressive list of ancient historiographers – Herodotus, the Hebrew prophets,[85] Strabo, Eusebius, and so forth – is largely at fault.[86] Out of their ostensibly authoritative works, Frazer composed an irresistible montage, a widespread panoply of activity that took a variety of astonishing forms.[87] The age-old formula of paganism and frenzied sexual abandon is quite plainly too enticing to relinquish. And although many scholars have dismissed Herodotus's account as propagandistic fabrication – impractical, anachronistic, and too lurid to be real – there is a distinct unwillingness in the same literature to give up sexualizing Mesopotamian women.[88] The issue of sacred prostitution

remains heatedly debated, and, like the fertility cult label with which it is often identified, riddled with contradictions, conflations, and unfounded assumptions. A growing number of scholars, however, is demonstrating that today's notions of sacred prostitution in ancient Mesopotamia do not stand up to textual scrutiny. United, their contributions form compelling testimony, although the acceptance of their conclusions has been disappointingly limited.[89]

Part of the resistance lies in the misinterpretation of the terms kar.kid in Sumerian and its Akkadian equivalent, *ḫarimtu*, which were wrongly thought to signify the common prostitute.[90] If the kar.kid/*ḫarimtu* is in any way connected to a temple, in particular a temple of Inanna/Ishtar's, she becomes a sacred prostitute. The proximity of the terms kar.kid or *ḫarimtu* to a priestess title in a lexical list, for example, is taken to confirm temple prostitution for that title. Many believe that the *qadištu*, a functionary frequently connected to midwifery, is the quintessential sacred prostitute, partly because she is associated in a few documents with the *ḫarimtu*.[91] Since her Sumerian equivalent, nu.gig, is usually translated as "hierodule," philologists often imbricate hierodule with sacred prostitute in their translations. Certain secular or descriptive categories of females, such as the *kezertu* and the *šamḫatu*, whose exact definitions elude us, were associated in ancient texts with the *ḫarimtu*, and thus are translated as sacred or secular prostitutes.[92] By extension, any female connected with the *kezertu, šamḫatu,* or *qadištu* becomes suspect.[93]

If we look at the primary textual sources without nineteenth-century blinders, their readings are clear. Kar.kid and *ḫarimtu* are not terms for prostitutes, harlots, whores, and the like, but terms designating a legal category of women – a female adult who does not live with her father and is not married. Loosely, the terms denote the Mesopotamian single woman. The cuneiform associations with female occupations and cult functions were not about sex professionalism but about a legal status shared among unmarried women. Should a kar.kid/*ḫarimtu* engage in sexual activity, it is inevitably extramarital. Unlike a married woman, the kar.kid/*ḫarimtu* was not limited by law to intercourse with one man. She thus became in the literary imagination the emblem of *l'amour libre*, the woman "who knows the penis" (i.e., who was not a virgin) and got

around, so to speak. Considering the moral environment outlined above, it is easy to see how scholars confused such sexy literary representations, rare as they are, with prostitutes.

The mistranslation of kar.kid and *ḫarimtu* and subsequent misinterpretations of laws and judicial documents, lexical lists, ration lists, adoption contracts, economic documents, magical texts, and popular and sacred literature have peopled Mesopotamia with hordes of streetwalkers, bordello whores, and madams who run taverns to traffic in women. These assumed but fictitious deviants distorted art-historical interpretations as well.[94] Obviously, whatever place the kar.kid/*ḫarimtu* frequents becomes the locus of lust. But when we encounter the common phrase "the *ḫarimtu* of the streets," it does not mean a street hooker. It is legal terminology for a single woman who does not live in an ancestral or matrimonial household; in other words, her home has no patriarchal status.[95] When poets call Ishtar a *ḫarimtu*, they do not mean, Ishtar, the Divine Harlot, the archetypal whore; they refer, rather, to the goddess's aspect as an unmarried woman. As another of her chief aspects is the bride-to-be, the goddess embodies women's fundamental life routes – to marry or remain single.[96] This pervasive production has created moral distinctions between those who are not associated with the *ḫarimtu* (i.e., the faithful wife, the good daughter, the occasional pious ecclesiastic, etc.) and those who share her harlotry. Circular reasoning has put most unmarried women of Mesopotamia at the fringes of mainstream society, along with female outcasts of the Bible. The misconception of the kar.kid/*ḫarimtu* has wreaked havoc on our understanding of ancient Mesopotamian society, its women, its most popular deity, and its patriarchal systems. It has been used to validate sacred prostitution and conveys the idea that common prostitution was the wellspring that fed all other forms of sex professionalism.

Like the ancient languages of Egypt, Sumerian and Akkadian had no specific words for prostitution. Possibly the ancients of Mesopotamia and Egypt did not set prostitutes apart from other types of women (and men) or distinguish people strictly on the basis of their sexual activity. Some form of prostitution must have existed.[97] In a world before currency, however, the definition of paid-for sex blurs. Furthermore, gifting in

33

return for pleasurable sex is a common literary theme in Mesopotamia, so that exchanging food, clothing, jewelry, shelter, and so on for sex may not have been regarded as socially dissonant.[98] Whatever prostitution did take place was no doubt bartered, and individual small-scale barter of any kind was almost never recorded. There are cultural factors at work, too. Mesopotamians probably did not regard prostitution as a profession because sex was not considered to be a learned or specialized skill. "The art of sex" as well as "the art of kissing the phallus" were among the "me," the foundations of civilization given to *all* mortals by the gods. What is more, the sexual availability of slaves (male or female) – a topic that deserves careful scrutiny – may have interrupted the laws of supply and demand for free bodies as commodity.[99]

## Conclusion

I have presented only in brief a very complex topic: how and why the historiography of the ancient Near East produced the female sex professional. The standard discourse of sexual rites and prostitution is a collusion of texts drafted by nineteenth-century moral dualisms and visual habits. Its insistent reproduction over the last century and a half has transformed Mesopotamia's imaginary pageant of sexual exotica into ineradicable historical fact. Today, we cannot picture the ancient "land between the rivers" without this spectacle, and we have none as vivid and interesting to put in its place. It serves to highlight differences between East and West, between Old and New. Nineteenth-century scholars initiated the accepted view of the Fertile Crescent as the land of origins, the locus of the mother culture that gave birth to the dueling twins of sexual aberrancy and the austere patriarchy of later West Asian antiquity. Frazer painted Inanna/Ishtar as a totem of paganism whose rites and cults were rooted in an innocent, socially unstratified precivilization and the socio-biological conditions of Early Man. Removing the sexual spectacle imposed on "the first civilization" forces each antique culture to answer for its own *bizarreries* without blaming Mesopotamia as the source. When the unexamined essentialized notions of "experts" are continually written into "scientific" texts on origins and produced as history, they greatly affect the

modern world. Such notions – fertility as a biological imperative; female prostitution as "the oldest profession in the world," which at best naturalizes Man as helplessly wayward and Woman as manipulative; and the oppressive hierarchies of absolute patriarchy as morally authorized by god and the prophets – must be thoroughly dismantled, or they will stubbornly remain problematic baselines in the reconstruction of social life.

### NOTES

1. This essay is adapted from research presented in J. Assante, "The Erotic Reliefs of Ancient Mesopotamia" (diss. Columbia University, 2000) 19–73, henceforth abbreviated as Assante, "Erotic Reliefs." Abbreviations for other frequently cited works are: Assante, "kar.kid/*ḫarimtu*": J. Assante, "The kar.kid/*ḫarimtu*, Prostitute or Single Woman? A Reconsideration of the Evidence," *Ugarit-Forschungen* 30 (1998) 5–96; Fisher, "Cultic Prostitution?": E. Fisher, "Cultic Prostitution in the Ancient Near East? A Reassessment," *Biblical Theology Bulletin* 6 (1976) 225–236; Gruber, "*QEDĒŠĀH* ": M. Gruber, "Hebrew *QEDĒŠĀH* and Her Canaanite and Akkadian Cognates," *Ugarit-Forschungen* 18 (1986) 133–148; Henshaw, *Female and Male: The Cultic Personnel*: R. Henshaw, *Female and Male: The Cultic Personnel, the Bible and the Rest of the Ancient Near East* (*Princeton Theological Monograph Series* 31; Alison Park, 1994); and Sefati, *Love Songs*: Y. Sefati, *Love Songs in Sumerian Literature* (*Bar-Ilan Studies in Near Eastern Languages and Culture*; Ramat Gan, 1998).
2. The scholars involved in this production easily number in the hundreds. For the most comprehensive critique of secondary literature that misconstrues Mesopotamian legal and social terminology for unmarried women as terms for prostitutes, see Assante, "kar.kid/*ḫarimtu*." For sacred prostitution, see J. Renger, "Heilige Hochzeit. A. Philologisch," *Reallexikon der Assyriologie* 4 (1972–1975) 251–259 and especially Henshaw, *Female and Male: The Cultic Personnel* 220–233. The notion of sacred marriage taking place at the top of a ziggurat is based primarily on J. G. Frazer's interpretation of Herodotus 1.179 (J. G. Frazer, *The Golden Bough. A Study in Magic and Religion* [abridged ed., London, 1922; repr. London, New York, Victoria, Toronto, and Auckland, 1996] 171). This rite is unknown from Mesopotamian sources.
3. The goddess's name was Inanna in Sumerian and Ishtar in Akkadian. Written Sumerian first appeared during the fourth millennium B.C. The language seems to have died out around the end of the nineteenth century B.C. Akkadian began appearing in the last quarter of the third millennium and survived the fall of the Assyrian and Babylonian empires (seventh and sixth centuries B.C., respectively).
4. See Assante, "kar.kid/*ḫarimtu*" 13–14, 39–43, 55–59, and 73–82 for analyses of textual misinterpretations that have led to this vision of Ishtar.
5. "Hierodule" is often given for the Sumerian term nu.gig, a high-status cult functionary in early periods. See A. Zgoll, "Inana als nugig," *Zeitschrift für*

35

*Assyriologie und vorderasiatische Archäologie* 87 (1997) 181–195. Its Akkadian equivalent, *qadištu*, however, is commonly translated as "sacred prostitute."

6. This conceptualization of the goddess is founded in Herodotus' view of the so-called barbarian Aphrodite. However, Ishtar as a debauched, castrating seductress appears in the first-millennium version of the *Gilgamesh Epic* in a passage whose political motivations I discuss in Assante "kar.kid/*ḫarimtu*" 55–59.

7. Especially, V. Bullough, "Attitudes Toward Deviant Sex in Ancient Mesopotamia," *The Journal of Sex Research* 17.3 (1971) 184–203; K. van der Toorn, trans. S. Denning-Bolle, *From Her Cradle to Her Grave. The Role of Religion in the Life of the Israelite and the Babylonian Woman* (Sheffield, 1994); G. Leick, *Sex and Eroticism in Mesopotamian Literature* (London and New York, 1994); M. Stol, "Women in Mesopotamia," *Journal of the Economic and Social History of the Orient* 32 (1995) 121–144; K. R. Nemet-Nejat, "Women in Ancient Mesopotamia," in B. Vivante, ed., *Women's Roles in Ancient Civilizations: A Reference Guide* (Westport and London, 1999) 85–114; as well as many seminal works and innumerable encyclopedia entries on ancient history. In turn, the fictions presented in these scholarly works have been repeated ad infinitum in popular literature, for instance, in R. Tannahil, *Sex in History* (New York 1980), among others cited below. More continue to appear.

8. E.g., W. G. Lambert, "Prostitution," in V. Haas, ed., *Außenseiter und Randgruppen* V (*Xenia: Konstanzer althistorische Vorträge und Forschungen* 32; Konstanz, 1992) 135.

9. A. Parrot, *Tello: Vingt Campagnes de fouilles (1877–1933)* (Paris, 1948) 262: "Rite d'hiérogamie, scène de prostitution sacrée, acte purement profane, on ne saurait faire un choix certain. . . . De toutes façon, le sens profond échappe."

10. In a future article I discuss cylinder seals and other art that features exorcisms performed on beds. Some scenes display a single patient on a bed with a scorpion under the bed and one or more attendants (e.g., fig. 593 in J. Asher-Greve, *Frauen in altsumerischer Zeit* [*Bibliotheca Mesopotamica* 18; Malibu, 1985] pl. XXX). Similar seals that portray instead a couple in intercourse on a bed, but still the scorpion under the bed and an attendant or attendants at the head or feet of the lovers, are also depictions of exorcisms. Most examples come from the middle of the third millennium B.C. (e.g., fig. 2 in T. A. Madlum, "The Excavations at Tell al-Wilayah," *Sumer* 16 [1960], in Arabic).

11. For the magical function of Old Babylonian terracotta plaques in general, see J. Assante, "Style and Replication in 'Old Babylonian' Terracotta Plaques: Strategies for Entrapping the Power of Images," in O. Loretz, K. Metzler, and H. Schaudig, eds., *Ex Mesopotamia et Syria Lux; Festschrift für Manfried Dietrich* (*Alter Orient und Altes Testament* 281; Munster, 2002) 1–29. For the magical function of plaques with sexual images, see Assante, "Erotic Reliefs" 210–255 and J. Assante, "Sex, Magic and the Liminal Body in the Erotic Art and Texts of the Old Babylonian Period," in S. Parpola et al., eds., *XLVIIᵉ Comptes rendus de la Rencontre Assyriologique Internationale* (Helsinki, forthcoming).

12. This widely accepted yet mistaken notion generated from Walter Andrae's excavation report, *Die jüngeren Ištar-Tempel in Assur* (*Wissenschaftliche Veröf-*

*fentlichungen der Deutschen Orient-Gesellschaft* 58; Leipzig, 1935) 103. See also E. D. van Buren, "The Scorpion in Mesopotamian Art and Religion," *Archiv für Orientforschung* 12 (1937–1939) 1–28 and the following note.

13. J. Black and A. Green, *Gods, Demons and Symbols of Ancient Mesopotamia: An Illustrated Dictionary* (London, 1992) 152–153. See especially F. Pinnock, "Erotic Art in the Ancient Near East," in J. M. Sasson et al., eds., *Civilizations of the Ancient Near East* I (New York, 1995) 2521–2531; and Nemet-Nejat, "Women in Ancient Mesopotamia" (supra n. 7) for more secular yet equally erroneous readings. The belief that lead erotica came from the Ishtar Temple is widespread. In fact, most came from what I have identified as an industrial site at Assur on the New Palace Terrace (Assante, "Erotic Reliefs" 179–209 and for commentary, 46–47). For further commentary, see J. Scurlock, "Lead Plaques and Other Obscenities," *Nouvelles Assyriologiques brèves et utilitaires* (1/March, 1993) 15.

14. Assante, "Erotic Reliefs" 268–288.

15. As I show, the Middle Assyrian erotic reliefs are the only sexual images known from Mesopotamia that clearly violate social mores. For discussion see Assante, "Erotic Reliefs" 268–288. Formerly, pornographic art was considered unthinkable for Mesopotamia because, as one scholar explains, it is a type of *l'art pour l'art*, a concept not known in the ancient Near East (Asher-Greve, *Frauen in altsumerischer Zeit* [supra n. 10] 43).

16. Gruber, "*QEDĒŠĀH* " 138.

17. E.g., D. Arnaud, "La prostitution sacrée en Mésopotamie, un mythe historiographique?" *Revue de l'histoire des religions* 183 (1973) 111–115; Fisher, "Cultic Prostitution?"; Gruber "*QEDĒŠĀH.*" Henshaw, in *Female and Male: The Cultic Personnel*, gathers the lukur/*nadītu*, the *šugētu*, the *saḫiptu*, the *kezertu*, the *sekretu*, the *kulmašītu*, the nin.dingir/*ugbabtu* or en/*entu*, the nu.gig/*qadištu* or *ištarītu*, and the *amalītu* under the rubric "Officiants Who Interpret Fertility and Sexuality." In a few omens from the omen series *šumma ālu*, certain types of fornication of *entu*-priestesses are bad omens (Leick, *Sex and Eroticism* [supra n. 7] 219). As first-millennium B.C. omens appear long after the death of the *entu*-institution, the *entu*'s activity is imaginary.

18. Conflation, much of it inherited from Frazer (e.g., *Golden Bough* [supra n. 2] 399–401), is rife in secondary literature. Most notable is W. Kornfeld, "Prostitution sacrée," *Dictionnaire de la Bible*, Supplément viii (1972) cols. 1356–1374; also W. G. Lambert, "Morals in Ancient Mesopotamia," *Jaarbericht Ex Oriente Lux* 15 (1957–1958) 184–218; W. von Soden, "Kultische Prostitution," *Religion in Geschichte und Gegenwart* 5 (1961) 642–646; G. von Rad, *Old Testament Theology* (Edinburgh, 1962); M. C. Astour, "Tamar the Hierodule: An Essay in the Method of Vestigial Motifs," *Journal of Biblical Literature* 85 (1966) 185–196; E. Yamauchi, "Cultic Prostitution: A Case Study in Cultural Diffusion," in H. A. Hoffner, Jr., ed., *Orient and Occident: Essays Presented to Cyrus H. Gordon on the Occasion of his Sixty-Fifth Birthday* (*Alter Orient und Altes Testament* 22; Munster, 1973) 213–222; Fisher, "Cultic Prostitution?"; W. Fauth, "Sakrale Prostitution im Vorderen Orient und im Mittelmeerraum," *Jahrbuch für Antike und*

*Christentum* 31 (1988) 24–39; etc. For an extreme example from art history, see van Buren, "The Scorpion" (supra n. 12).

19. By orientalists I mean the art historians, archaeologists, and philologists studying the ancient Near East who identified themselves by this term. I do not intend a pejorative use.

20. See E. Long's *The Marriage Market at Babylon* (1875), which is based on a passage from Herodotus (1.196); the practice of buying wives is not attested in cuneiform sources. For harem scenes, see, for instance, J. A. D. Ingres' *La grande odalisque* (1814), *Odalisques avec esclave* (1839), *Le bain turc* (1862); L. Mussini's *Odalisque* (1862); T. Chassériau's *Femme sortant du bain* (1849) and *Femme mauresque sortant du bain au sérail* (1854); F. Cormon's *Jealousy in the Serail* (1874); P. A. Renoir's *Odalisque* (1870); and M. Bompard's *Harem Scene* (ca. 1900).

21. L. Nochlin, "The Imaginary Orient," *Art in America* 71.5 (1983) 118–131, 187, 189, and 191.

22. For example, L. Woolley describes a cylinder-seal scene showing a woman bent over, penetrated from behind by an ithyphallic male while another ithyphallic male stands in waiting and a third holds down her head, as "solar heroes and their enemy" (L. Woolley, *Ur Excavations* II. *The Royal Cemetry. A Report on the Predynastic and Sargonid Graves Excavated Between 1926 and 1931* [London, 1934] 355, fig. 272).

23. J. Asher-Greve states that when nude women on "amulets" or seals appear to invite sexual advances, they are showing sexual readiness and are therefore probably temple prostitutes (Asher-Greve, *Frauen in altsumerischer Zeit* [supra n. 10] 41 and 131–132). The notion of display is doubly intensified when the author suggests that such items were worn by temple prostitutes as personal vouchers (43). The same sort of reasoning led to the mistaken interpretation of "courtesan" attached to Titian's *Venus of Urbino* in the nineteenth century.

24. E.g., Andrae, *Ištar-Tempel* (supra n. 12) 103; B. Buchanan, "A Snake Goddess and Her Companion," *Iraq* 33 (1971) 4–5, and Buchanan, *Early Near Eastern Seals in the Yale Babylonian Collection* (New Haven and London, 1981) 200; J. Cooper, "Heilige Hochzeit. B. Archäologisch," *Reallexikon der Assyriologie* 4 (1972–1975) 265–266. See Scurlock, "Lead Plaques and Other Obscenities" (supra n. 13); J. Westenholz, "Heilige Hochzeit und kultische Prostitution im Alten Mesopotamien," *Wort und Dienst, Jahrbuch der Kirchlichen Hochschule Bethel*, n.s. 23 (1995) 61; and Assante, "Erotic Reliefs" 47–49 for commentary.

25. E. W. Said, *Orientalism* (New York, 1978; repr. 1994) 187.

26. Such notions are active in ancient Near Eastern historiography. For instance, Jean Bottéro discusses the attractions of "free love" from the male point of view; such love is only to be had with a prostitute. In the domestic sphere, sex was devoid of pleasure: "In marriage, love was seen as being used only for a preset goal, and as subservient to family life in a sense" (J. Bottéro, "'Free Love' and Its Disadvantages," in *Mesopotamia: Writing, Reasoning, and the Gods*, trans. Z. Bahrani and M. van de Mieroop [Chicago and London, 1992] 193). Yet the many hymns of Inanna and Dumuzi describe love in the domestic sphere, and it is steamy! In one hymn, "The Bed of Love," her whole body trembles from sexual

excitement (Sefati, *Love Songs* 151–153). Procreation is hardly a preset goal for this couple.

27. Early philologists approached the eastern Semitic language of Akkadian by way of their knowledge of later biblical Hebrew. Since Akkadian bilingual texts were used to gain access to the older, unrelated Sumerian language, the guiding force for both was biblical Hebrew. The study of Sumerian still suffers from Akkado-centrism and biblical comparison. The strong religious backgrounds of most philologists significantly colored their approaches to Mesopotamian material (see Assante, "Erotic Reliefs" 26, n. 22).

28. Beatrice Brooks was the first to note an anomaly. According to her, so many cuneiform terms were "arbitrarily" translated as "eunuch," "harlot," "whore," "hierodule," "prostitute," and the like, that is seems as though "an improbable percent of the population must have been either secular or religious prostitutes of some sort" ("Fertility Cult Functionaries in the Old Testament," *Journal of Biblical Literature* 60 [1941 ] 231).

29. According to Herodotus (1.196), after the fall of Babylonia, when the "admirable practice" of the marriage market was no longer in use, all lower-class Babylonian girls prostituted themselves to relieve their poverty.

30. Fisher, "Cultic Prostitution?"

31. As in Lev. 17.7, 20.5–6; Judg. 8.27–33; 1 Kings 14.24; Job 36.14; Isa. 23.16, 57.1–8; Jer. 2.20, 3.1–5, 4.30, 5.7; Hos. 4.10–15. Note that some scholars are currently questioning the translation of "(common) prostitute," "whore," or "harlot" for the Hebrew word *zônâh*. See, for instance, H. Schulte, "Beobachtungen zum Begriff der Zônâ im Alten Testament," *Zeitschrift für alttestamentliche Wissenschaft* 104 (1992) 255–262; and C. Friedl, *Polygynie in Mesopotamien und Israel* (*Alter Orient und Altes Testament* 277; Munster, 2000).

32. On Babylon: Jer. 50.38: "For it is the land of images, and they go mad over idols." Also see The Letter of Jeremiah, chapter 6 of the apocryphal Book of Baruch, dated anywhere from the fourth to first century B.C. (Henshaw, *Female and Male: The Cultic Personnel* 227). Purported to be a copy of the letter Jeremiah sent to those in exile, it exhorts Jews to remain faithful to Yahweh and to shun the abhorrent paganism of Babylonia. The epistle warns of the falseness of Babylonian gods, their priests, and the lewd prostitutes who work near the temple. For the Letter of Jeremiah, see *The Holy Bible. New Revised Standard Version with Apocrypha* (New York and Oxford, 1989) 145–147.

33. Said, *Orientalism* (supra n. 25) 190.

34. As in Théophile Gautier's *Une nuit de Cléopâtre* (1845); Phillippe-Auguste Villiers de l'Isle-Adam's *Isis* (1862); Algernon Swinburne's *Cleopatra* (1862); for Salomé, see Oscar Wilde's *Salomé*; Gustave Flaubert's *Salammbô* (1862) and *Hérodias* (1877), and for a variety of female dangers, his *La tentation de Saint-Antoine* (1874). For social historians and their visions of ancient female rule as "*tellurischen Hetärismus*," see K.-H. Kohl, "Cherchez la femme d'Orient," in G. Sievernich and H. Budde, eds., *Europa und der Orient 800–1900* (Gütersloh and Munich, 1989) 362–364. The author tracks Johann Jakob Bachofen's popular works (e.g., *Das Mutterrecht. Eine Untersuchung über die Gynaikokratie der alten*

*Welt nach ihrer religiösen und rechtlichen Natur* [Stuttgart, 1861]) as important in the formation of the nineteenth-century concept. These stereotypes originate in classical sources. Dante condemned the dangerously sexual Semiramis, Helen of Troy, Cleopatra, and Dido of Carthage to the third circle of hell.

35. See especially Revelation 19.2: "[The Lord] has judged the great whore who corrupted the earth with her fornication, and he has avenged on her the blood of his servants." Nahum (3.4–6) speaks about Nineveh (Assyria): "Because of the countless debaucheries of the prostitute, gracefully alluring, mistress of sorcery, who enslaves nations through her debaucheries, and peoples through her sorcery, (5) I am against you, says the Lord of hosts, and will lift up your skirts over your face; and I will let nations look on your nakedness and kingdoms on your shame. (6) I will throw filth at you and treat you with contempt, and make you a spectacle."

36. *Histories* 1.199. Trans. A. D. Godley, *Herodotus. Books I–II* (Cambridge, Mass. and London, 1920; repr. 1996).

37. See section XXIX, "The Myth of Adonis," in Frazer, *Golden Bough* (supra n. 2).

38. Despite scholarship's assumption that Herodotus 1.199 speaks of temple prostitution in which the woman's earnings from sex go directly to the temple, Herodotus does not openly state this. However, Herodotus does say that the money becomes "sacred," which means, in the parlance of antiquity, that is belongs to a deity. The word "sacred" in the ancient Near East did not imply purity, holiness, or even religion, as it often does in modern times; it merely indicates a relationship with a deity, in particular, divine ownership.

39. Frazer drew his ideas of the paramount importance of rite in "primitive" societies from the Semitist William Robertson Smith. Smith believed that disparate universal primal rites eventually cohered into mythology and systemized religion. Frazer broadened Smith's methodology and his concepts, adding the concept of cultural diffusionism and emphasis on fertility. The intellectual debt Frazer owed Smith is clear in the preface of the first edition of the *Golden Bough* of 1890. Later, Frazer retreated from his earlier position that rite spawned myth. See R. Ackerman, *The Myth and Ritual School: J. G. Frazer and the Cambridge Ritualists* (New York, 1991) 56–58; and R. Jones, "Robertson Smith and James Frazer on Religion: Two Traditions in British Social Anthropology," in G. W. Stocking, ed., *Functionalism Historicized: Essays on British Social Anthropology* (Madison, 1984) 31–58. Orientalists seem to have agreed with Smith, for they were actively on the search for ritual in myth, literature, art, or contemporary local customs.

40. See M. Beard, "Frazer, Leach, and Virgil: The Popularity (and Unpopularity) of the *Golden Bough,*" *Comparative Studies in Society and History* 34 (1992) 203–224. The first edition of the *Golden Bough* was a two-volume work, followed by a three-volume edition and, by 1915, a twelve-volume edition. For the publication history of the *Golden Bough,* see R. Ackerman, *J. G. Frazer. His Life and Work* (Cambridge, 1987; repr. 1990) 95–100.

41. See the compilation of translations in Henshaw, *Female and Male: The Cultic Personnel* 219.

42. Mother-goddess cults and "Venus" fertility figurines are increasingly coming under fire in studies of prehistory. See, for instance, J. A. Hackett, "Can a Sexist Model Liberate Us? Ancient Near Eastern 'Fertility' Goddesses," *Journal of Feminist Studies in Religion* 5 (1989) 65–76; M. Conkey and R. Tringham, "Archaeology and the Goddess: Exploring the Contours of Feminist Archaeology," in D. Stanton and A. Stewart, eds., *Feminism in the Academy* (Ann Arbor, 1995) 199–247; L. Meskell, "Goddesses, Gimbutas and 'New Age' Archaeology," *Antiquity* 69 (March 1995) 74–86; S. Nelson, *Gender in Archaeology; Analyzing Power and Prestige* (Walnut Creek, London, and New Delhi, 1997) 162–168; and R. Tringham and M. Conkey, "Rethinking Figurines: A Critical View from Archaeology of Gimbutas, the 'Goddess' and Popular Culture," in L. Goodison and C. Morris, eds., *Ancient Goddesses. The Myths and the Evidence* (London, 1998) 22–45.

43. Brooks, "Fertility Cult Functionaries" (supra n. 28) 232.

44. Certain kinds of *nadītu* were allowed to marry; others were not. For a brief overview of the *nadītu*, see R. Harris, "Independent Women in Ancient Mesopotamia?" in B. S. Lesko, ed., *Women's Earliest Records from Ancient Egypt and Western Asia. Proceedings of the Conference on Women in the Ancient Near East, Brown University, Providence, Rhode Island, November 5–7, 1987* (Atlanta, 1989) 141–144 and 145–166.

45. J. S. Cooper, "Enki's Member: Eros and Irrigation in Sumerian Literature," in H. Behrens, D. Loding, and M. T. Roth, eds., DUMU-E$_2$-DUB-BA-A: *Studies in Honor of Åke W. Sjöberg* (Philadelphia, 1989) 89.

46. In the standard version of the *Gilgamesh Epic* (first millennium B.C.), the poet draws a strong contrast between Ishtar and the good mother (R. Harris, "Images of Women in the *Gilgamesh Epic*," in T. Abusch, J. Huehnergard, and P. Steinkeller, eds., *Lingering over Words: Studies in Ancient Near Eastern Literature in Honor of William L. Moran* [*Harvard Semitic Studies* 37; Atlanta, 1990] 219–230; Assante, "kar.kid/ḫarimtu" 53–59). Yet, as she was the most popular female deity, many women may have called on her for help in conceiving or to ease and protect childbirth, although other goddesses, for example, Nin-Isina/Gula, would serve these purposes more directly.

47. See the works by J. Cooper: "Enki's Member" (supra n. 45) and "Gendered Sexuality in Sumerian Love Poetry," in I. J. Finkel and M. J. Geller, eds., *Sumerian Gods and their Representations* (*Cuneiform Monographs* 7; Groningen, 1997) 85–97.

48. A. D. Kilmer, "The Mesopotamian Concept of Overpopulation and Its Solution as Reflected in the Mythology," *Orientalia* n.s. 41 (1972) 160–177.

49. J. J. Finkelstein, "Late Old Babylonian Documents and Letters: Introduction," *Yale Oriental Series* 13 (1972) 10; Kilmer, "The Mesopotamian Concept of Overpopulation" (supra n. 48) 172.

50. See supra n. 44.

51. Kilmer, "The Mesopotamian Concept of Overpopulation" (supra n. 48) 160.

52. Kilmer, "The Mesopotamian Concept of Overpopulation" (supra n. 48) 172–173.

53. M. Stol, "Private Life in Ancient Mesopotamia," in Sasson et al., eds., *Civilizations of the Ancient Near East* I (supra n. 13) 488.

54. Kilmer divides Mesopotamian conceptual frames into a pre-Flood mentality, when fertility was thought to be limitless, and a post-Flood mentality, when fertility had to be controlled ("The Mesopotamian Concept of Overpopulation" [supra n. 48] 172).

55. Joan Westenholz criticizes Kramer's view of biology as the sole determinant in the destiny of women. She reminds readers that many childless women in Mesopotamia held powerful social positions ("Towards a New Conceptualization of the Female Role in Mesopotamian Society," *Journal of the American Oriental Society* 110 [1990] 511).

56. For Ningirsu and Bau, see R. Jestin, "Un rite sumérien de fécundité: Le mariage du dieu Nin-Gir-Su et de la déesse Ba-Ba," *Archiv Orientální* 17 (1949) 333–339. For later periods see the essays of E. Matsushima in *Acta Sumerologica*: "Le 'lit' de Šamaš et le rituel du mariage à l'Ebabbar," 7 (1985) 129–137; "Le ritual hiérogamie de Nabû," 9 (1987) 131–175; and "Les rituels du mariage divin dans les documents Accadiens," 10 (1998) 95–128. Also see A. Livingstone, *Mystical and Mythological Explanatory Works of Assyrian and Babylonian Scholars* (Oxford, 1986) 92–118; and *Court Poetry and Literary Miscellanea* (*State Archives of Assyria* 3; Helsinki, 1989). For a sprinkling of allusions in the time between the Old Babylonian and Neo-Babylonian periods, see Bottéro in S. N. Kramer, *Le mariage sacré à Sumer et à Babylone*, (rev. ed. of *The Sacred Marriage Rite* [Bloomington 1969], with translation and addenda by J. Bottéro) (Paris, 1983) 175–177.

57. Frankfort was well versed in theories of the myth and ritual school. From personal observations of a "rain-dance" in a village of Kurdistan, he saw features of the "Tammuz-Adonis-Osiris cult" ("A Tammuz Ritual in Kurdistan(?)" *Iraq* 1 [1934] 137–145). Later, he viewed ritual more as a dramatization of myth that helped "primitive man" participate in the workings of nature ("Myth and Reality," *The Intellectual Adventure of Ancient Man* [Chicago, 1946] 3–27). Moortgat wrote on sacred marriage and Sumerian art in *Tammuz: Der Unsterblichkeitsglaube in der altorientalischen Bildkunst* (Berlin, 1949), in which he suggests a Mesopotamian Easter festival when Dumuzi rises from the Underworld to unite with the great mother goddess to renew life and the state. Van Buren's views of fertility magic are prominent in many works; see especially "The Sacred Marriage Rite in Assyria and Babylonia," *Orientalia* n.s. 13 (1944) 1–72, but also *Clay Figurines of Babylonia and Assyria* (New Haven, 1930) lxv–lxvi and nos. 693–712, and "The Scorpion" (supra n. 12).

58. Discussed in Assante, "Erotic Reliefs" 32–34.

59. See Cooper, "Heilige Hochzeit. B. Archäologisch" (supra n. 24).

60. H. Frankfort, *The Iraq Excavations of the Oriental Institute 1932/33. Third Preliminary Report of the Iraq Expedition* (*Oriental Institute Communications* 17; Chicago, 1934) 45–51 and reiterated in *Cylinder Seals: A Documentary Essay on the Art and Religion of the Ancient Near East* (London, 1939) 75–76 and in *Stratified Cylinder Seals from the Diyala Region* (*Oriental Institute Publications* 72; Chicago, 1955) 38, figs. 340 and 599. Frankfort actually based his argument on two Early Dynastic artifacts from Eshnunna (Tell Asmar, mid-third millennium

B.C.), a cylinder seal (here Fig. 1) and a limestone plaque (*The Iraq Excavations* [supra] 45, fig. 40). However, he mistook the scene on the limestone plaque. It does not show intercourse but a lone woman lying on a bed (N. Cholidis, "Keine Darstellung der Heiligen Hochzeit auf der Weihplatte As 32:930/1178 aus Tell Asmar?" *Mitteilungen der Deutschen Orient-Gesellschaft* 120 [1988] 153–158). Both scenes are likely to show exorcism (supra n. 10), rather than sacred marriage.

61.  E.g., H. de Genouillac, *Fouilles de Telloh* II. *Époque d'Ur III<sup>e</sup> dynastie et de Larsa* (Paris, 1936) 40 n. 2; H. Seyrig, "Antiquités syriennes: 4. Scène d'hiérogamie," *Syria* 32(1955) 38–41; P. Amiet, *La glyptique mésopotamienne archaïque* (Paris, 1961) 119; Kramer, *The Sacred Marriage Rite* (supra n. 56); I. Seibert, *Die Frau im Alten Orient* (Leipzig, 1973) 38. The archaeologists D. McCown and R. C. Haines connect even model terracotta beds to sacred marriage or the "orgiastic rites" supposedly related to it: *Nippur* I. *Temple of Enlil, Scribal Quarters and Soundings* (*Oriental Institute Publications* 78; Chicago, 1967) 94.

62.  See Sefati, *Love Songs* 17–49 for discussion of all literary occurrences, including the texts mentioned here, that might relate to the sacred-marriage theme.

63.  E.g., Mes-Annepadda, king of Kish (ca. 2600–2550 B.C.) (J. Cooper, *Sumerian and Akkadian Royal Inscriptions* I: *Presargonic Inscriptions* [*American Oriental Society Translation Series* 1; New Haven, 1986] 98, Ur 5.3) and Eannatum of Lagash (ca. 2440 B.C.) from the "Stele of the Vultures." For others, see Sefati, *Love Songs* 36–38.

64.  Such texts are likely to have worked on a number of fronts, none of which has to do with fertility. See J. Cooper, "Sacred Marriage and Popular Cult in Early Mesopotamia," in E. Matsushima, ed., *Official Cult and Popular Religion in the Ancient Near East* (Heidelberg, 1993) 81–96. See also Westenholz, "Heilige Hochzeit und kultische Prostitution" (supra n. 24) and Assante, "Erotic Reliefs" 36–37. The abundance that issues from the king's pleasuring of the goddess is not dissimilar to the abundance that results from any other successful dealing with a deity. In a later Akkadian reconstruction of a sacred marriage hymn, no sex even occurs, but the king, Amiditana (ca. 1683–1647 B.C.), still receives his royal boons from Ishtar (F. Thureau-Dangin, "Un hymne à Ištar," *Revue d'assyriologie et d'archéologie orientale* 22 [1925] 169–177.

65.  E.g., Kramer, *The Sacred Marriage Rite* (supra n. 56) 79 and 93; Renger, "Heilige Hochzeit. A. Philologisch" (supra n. 2) 256; T. Jacobsen, *The Treasures of Darkness: A History of Mesopotamian Religion* (New Haven and London, 1976) 39; W. Römer, "Einige Überlegungen zur 'Heilige Hochzeit' nach altorientalischen Texten," in W. C. Delsman, J. T. Nelis, J. R. T. M. Peters et al., eds., *Von Kanaan bis Keral. Festschrift für J. P. M. van der Ploeg O.P.* (*Alter Orient und Altes Testament* 211; Munster, 1982) 421; D. Frayne, "Notes on the Sacred Marriage Rite," *Bibliotheca Orientalis* 42 (1985) 5–22; J. Klein, "Sacred Marriage," in D. N. Freedman et al., eds., *The Anchor Bible Dictionary* 5 (1995) 866–870; and Sefati, *Love Songs* 45.

66. E.g., W. Hallo, "The Birth of Kings," in J. H. Marks and R. M. Good, eds., *Love and Death in the Ancient Near East. Essays in Honor of Marvin H. Pope* (Guilford, Conn., 1987) 45–52.

67. R. Sweet, "A New Look at the 'Sacred Marriage' in Ancient Mesopotamia," in E. Robbins and S. Sandahl, eds., *Corolla Torontonensis. Studies in Honour of Ronald Morton Smith* (Toronto, 1994) 85–104. F. R. Kraus was the first to postulate that the royal marriage rite was purely a literary invention (Cooper, "Sacred Marriage and Popular Cult" [supra n. 64] 88–89).

68. Sweet, "A New Look at the 'Sacred Marriage' in Ancient Mesopotamia" (supra n. 67) 103.

69. Poetic memorializing of royal visits to temples can employ imaginary material that has little to do with the king's actual activities. For example, Rim-Sin's (1822–1763 B.C.) visit to the Ekišnugal of Ur was celebrated in a poem written in the guise of coronation. Despite the flattering imagery, the king did not go to the temple to legitimate his throne, but simply to perform devotions: D. Charpin, *Le clergé d'Ur au siècle d'Hammurabi (XIXᵉ–XVIIIᵉ siècles av. J.-C.)* (*Hautes Études Orientales* 22; Geneva and Paris, 1986) 302.

70. Renger, "Heilige Hochzeit. A. Philologisch" (supra n. 2) 251–253.

71. It is not sufficiently clear whether these various texts belong together; not all explicitly refer to Inanna or Dumuzi. In those that do name Inanna and Dumuzi, discrepancies, such as different genealogies, suggest that individual works came from different traditions.

72. They could not agree, however, on the exact nature of the rite or its participants. Jacobsen sees Dumuzi as a god of vegetation and the rite as largely metaphoric (*Towards the Image of Tamuz* [Cambridge, 1970] 73–75). Falkenstein believes him to be human with godly traits and their union to be central to Sumerian religion ("Tammuz," *Compte rendu de la troisième Rencontre Assyriologique Internationale* [1954] 41–65). Kramer views Dumuzi as a name given to a king who performed the rite with Inanna (or her stand-in) for the fertility of the land (*The Sacred Marriage Rite* [supra n. 56]), in a formulation similar to Frankfort's expressed in *Kingship and the Gods* (Chicago, 1948) 281–299.

73. Renger, "Heilige Hochzeit. A. Philologisch" (supra n. 2).

74. Cooper, "Heilige Hochzeit. B. Archäologisch" (supra n. 24).

75. Sefati, *Love Songs* 166, l. 5.

76. Cooper, "Sacred Marriage and Popular Cult" (supra n. 64)

77. See Middle Assyrian incipits in J. Black, "Babylonian Ballads: A New Genre," *Journal of the American Oriental Society* 103 [1983] 25–34; for instance, KAR 158: "O young man loving me/Come in, shepherd, Ishtar's lover."

78. B. Alster, "Sumerian Love Songs," *Revue d'assyriologie et d'archéologie orientale* 79 (1985) 127–128.

79. B. Alster, "Marriage and Love in the Sumerian Love Songs, with some notes on the Manchester Tammuz," in M. Cohen, D. Snell, and D. Weisberg, eds., *The Tablet and the Scroll. Near Eastern Studies in Honor of William H. Hallo* (Bethesda, 1993) 15–27.

80. Cooper, "Sacred Marriage and Popular Cult" (supra n. 64).

81. In Assante, "Erotic Reliefs" 219–223, I explore more reasons why some Inanna-Dumuzi love literature should be regarded as recorded oral folk songs.
82. J. Cooper, "Gendered Sexuality in Sumerian Love Poetry" (supra n. 47).
83. The existence of these magical analogues and how they worked in Old Babylonian erotic art and texts are demonstrated in Assante, "Erotic Reliefs" 210–255 and in Assante, "Sex, Magic and the Liminal Body" (supra n. 11).
84. R. Zettler, *The Ur III Temple of Inanna at Nippur. The Operation and Organization of Urban Religious Institutions in Mesopotamia in the Late Third Millennium B.C.* (*Berliner Beiträge zum Vorderen Orient* 11; Berlin, 1987) 197 n. 4.
85. Henshaw (*Female and Male: The Cultic Personnel* 226–227), drawing from other scholars, isolates Herodotus's influence in the Letter of Jeremiah 11 (Baruch 6.11) and Revelation 18 and 19. Also see the Testament of Judah 12.1 and 2 Macc. 6.4. W. Baumgartner adds to these Mic. 1. 7 and Deut. 23. 18–19 in "Herodots Babylonische und Assyrische Nachrichten," *Archiv Orientální* 18/1–2 (1950) 82.
86. See the comprehensive annotated bibliography of ancient sources in Henshaw, *Female and Male: The Cultic Personnel* 225–236.
87. Frazer ranges over ancient Western Asia, pointing out the highlights of various practices: supposedly there was a law of the Amorites that mandated all women about to marry to sit in fornication seven days by the gate, and at Byblus women who refused to sacrifice their hair in the annual mourning for "Adonis" (= Dumuzi) "had to give themselves up to strangers on a certain day of the festival and the money which they thus earned was devoted to the goddess" (Frazer, *Golden Bough* [supra n. 2] 399). No such practices are attested in cuneiform texts.
88. E.g., F. Delitzsch, "Zu Herodots babylonischen Nachrichten," in G. Weil, ed., *Festschrift für Eduard Sachau* (Berlin, 1915) 87–102; Arnaud, "La Prostitution sacrée en Mésopotamie, un mythe historiographique?" (supra n. 17); Fisher, "Cultic Prostitution?"; G. Wilhelm, "Marginalien zu Herodot, Klio 199," in T. Abusch, J. Huehnergard, and P. Steinkeller, eds., *Lingering over Words: Studies in Ancient Near Eastern Literature in Honor of William L. Moran* (*Harvard Semitic Studies* 37; Atlanta, 1990) 506–524; Henshaw, *Female and Male: The Cultic Personnel*; Pinnock, "Erotic Art in the Ancient Near East" (supra n. 13). M. Beard and J. Henderson ("With this Body I Thee Worship: Sacred Prostitution in Antiquity," *Gender and History* 9 [1997] 480–501) stand refreshingly apart; some of their ideas are incorporated in M. van de Mieroop, *Cuneiform Texts and the Writing of History* (London and New York, 1999) 151–154, with added emphasis on "Orientalist" attitudes. For bibliographic discussion, see Assante, "Erotic Reliefs" 64–69. Some of the scholars named above review the impact Herodotus had on later authors, including ancient ones and modern travel and fiction writers.
89. A few canvass sources for all female cultic personnel, e.g., S. Hooks, "Sacred Prostitution in Israel and the Ancient Near East," (diss. Hebrew Union College, 1985); R. Oden, *The Bible without Theology* (San Francisco, 1987); Henshaw, *Female and Male: The Cultic Personnel*. Others concentrate on specific professional or ecclesiastical terms: e.g., R. Harris, *Ancient Sippar: A Demographic Study of an Old Babylonian City 1894–1595 B.C.* (Istanbul, 1975) and

"Independent Women in Ancient Mesopotamia?" (supra n. 44) for the *nadītu*; Gruber, "*QEDĒŠĀḤ* "; J. Westenholz, "Tamar, *Qᵉ dēšā, Qadištu* and Sacred Prostitution in Mesopotamia," *Harvard Theological Review* 82 (1989) 245–265; and Zgoll, "Inana als nugig" (supra n. 5) for the nu.gig/*qadištu*; B. F. Batto, *Studies on Women at Mari* (Baltimore and London, 1974); F. Blocher, *Untersuchungen zum Motiv der nackten Frau in der altbabylonischen Zeit* (Munich, 1987) (with qualifications); J. Spaey, "Some Notes on ᴋᴜ₃.ʙᴀʙʙᴀʀ/ɴᴇʙɪʜ ᴋᴇᴢᴇʀ(ᴛ)ɪ(ᴍ)," *Akkadica* 67 (1990) 1–9; K. Van Lerberghe and G. Voet, *Sippar-Amnânum. The Ur-Utu Archive* 1 (*Mesopotamian History and Environment Series* 3; Ghent, 1991) 91–96 and pls. 39–40; M. Tanret and K. Van Lerberghe, "Rituals and Profits in the Ur-Utu Archive," in J. Quaegebeur, ed., *Ritual and Sacrifice in the Ancient Near East* (*Orientalia Lovaniensia Analecta* 55; Leuven, 1993) 435–449; and Assante, "kar.kid/ḫarimtu" 39–45, for the *kezertu*. For Assyrian temple personnel, see B. Menzel, *Assyrische Tempel* I. *Untersuchung zu Kult, Administration und Personal* II. *Anmerkungen, Textbuch, Tabellen und Indices* (*Studia Pohl* [*Series Major*] 10; Rome, 1981). See also Westenholz, "Heilige Hochzeit und kultische Prostitution" (supra n. 24).

90.  The following discussion on the kar.kid/*ḫarimtu* is drawn from Assante, "kar.kid/ḫarimtu."

91.  See Gruber, "*QEDĒŠĀḤ* " and Westenholz, "Tamar, *Qᵉ dēšā, Qadištu* and Sacred Prostitution" (supra n. 89).

92.  E. g., M. L. Gallery, "Service Obligations of the *kezertu*-Women," *Orientalia* n.s. 49 (1980) 333–338; I. M. Diakonoff, "Women in Old Babylonia Not under Patriarchal Authority," *Journal of the Economic and Social History of the Orient* 29 (1986) 225–238; F. Blocher, *Untersuchungen zum Motiv der nackten Frau* (supra n. 89); Bottéro, "Free Love" (supra n. 26) 187; Lambert, "Prostitution" (supra n. 8); Stol, "Women in Mesopotamia" (supra n. 7). The terms seem to describe no more than certain characteristics, i.e., "curly-headed one" for *kezertu* or "voluptuous one" for *šamḫatu*.

93.  The enormous slippage between sacred and secular prostitution and categories of professional and clerical females is especially evident in works that attempt to distinguish them: e.g., Gallery, "Service Obligations of the *kezertu*-Women" (supra n. 92); Diakonoff, "Women in Old Babylonia Not under Patriarchal Authority" (supra n. 92), G. Lerner, "The Origin of Prostitution in Ancient Mesopotamia," *Signs. Journal of Women in Culture and Society* 11/2 (1986) 236–254; Blocher, *Untersuchungen zum Motiv der nackten Frau* (supra n. 89); Fauth, "Sakrale Prostitution im Vorderen Orient und im Mittelmeerraum" (supra n. 18); Wilhelm, "Marginalien zu Herodot, Klio 199" (supra n. 88); Bottéro, "Free Love" (supra n. 26) 185–198; Lambert, "Prostitution" (supra n. 8); P.-A. Beaulieu, "Women in Neo-Babylonian Society," *Bulletin for the Canadian Society for Mesopotamian Studies* 26 (1993) 7–14; Leick, *Sex and Eroticism* (supra n. 7), Stol, "Women in Mesopotamia" (supra n. 7); and so forth.

94.  Two works seem to deliberately distort archaeological and philological evidence to insert harlotry, brothel taverns, and the like in their interpretations: L. Trümpelmann, "Eine Kneipe in Susa," *Iranica Antiqua* 16 (1981) 35–44; and

I. M. Diakonoff, "Old Babylonian Ur," *Journal of the Economic and Social History of the Orient* 38 (1981) 91–94. The arguments in Pinnock, "Erotic Art in the Ancient Near East" (supra n. 13) and Nemet-Nejat, "Women in Ancient Mesopotamia" (supra n. 7) draw a great deal from Trümpelmann as well as from other flawed secondary literature. For analyses of the above-mentioned secondary works, see Assante, "Erotic Reliefs" 49–51.

95. The same legal phrase, "of the street," was employed in contracts for men who were dismissed from the houses of their fathers. They thus no longer had patriarchal status. For discussion of this phrase, see Assante, "kar.kid/*ḫarimtu*" 45–53.

96. For discussion of these two aspects of Inanna/Ishtar and related art and texts, see Assante, "Sex, Magic and the Liminal Body" (supra n. 11).

97. For literary allusions, see the passage Enkidu's Blessing in the first-millennium *Gilgamesh Epic* and a hymn to the goddess Nanâ/Nanaya (*CBS* 8530 in Å. Sjöberg,"Miscellaneous Sumerian Texts, II," *Journal of Cuneiform Studies* 21 [1977] 3–45). For discussion of the *Gilgamesh* passage, see 57–59, and for the hymn, see 86 in Assante, "kar.kid/*ḫarimtu*."

98. Unexpectedly, it is often the female in the guise of Inanna who brings boons in reward for her sexual satisfaction. In other hymns Dumuzi competes with a farmer in what he can materially promise Inanna if she chooses him over the farmer for her bed. The frank and open dealings of bride price and dowry, abundantly attested in marriage laws and contracts, further indicate that Mesopotamians were accustomed to thinking about sex and wealth as interrelated.

99. The sexual availability of slaves is a thorny issue, and the current scholarship is problematic. For instance, M. A. Dandamaev discusses "the hire of slave women for use in brothels," without bothering with evidence: *Slavery in Babylonia. From Nabupolassar to Alexander the Great* (Dekalb, Ill., 1984) 132–135. The slave is confused with the so-called prostitute (i.e., kar.kid or *ḫarimtu*), and the temple slave is facilely identified with presumed temple prostitution.

# *Humanissima ars*: Evaluation and Devaluation in Pliny, Vasari, and Baden

JACOB ISAGER

The important role of selection in the transmission of texts in antiquity has left us with the Elder Pliny's chapters on various artistic media as almost the only ancient account of the history of Greek and Roman art. His endeavor to establish a methodology has therefore become the starting point for all subsequent attempts at the systematic treatment of art in antiquity and later periods. This essay discusses Pliny's concept of art and his contribution to the historiography of art, followed by two examples of Pliny's effect on attitudes toward art in later periods. One is the case of Giorgio Vasari, Pliny's Renaissance successor as father of art history; the other of a Danish art historian, Torkel Baden, who, in the beginning of the nineteenth century, followed in Pliny's footsteps in a most pedestrian way.

## *Humanissima ars* and the Evolution of Art

In the Elder Pliny's treatment of Greek and Roman sculpture in Book 34 of his *Naturalis Historia* (*Natural History*), we find the following story about the sculptor Perillus and the tyrant Phalaris in Akragas on Sicily (34.89):

> No one should praise Perillus, who was more cruel than the tyrant Phalaris, for whom he made a bull and promised that if a man was enclosed in it and a fire lit under it the man would do the bellowing. He himself became the first to suffer this torture – a very justified cruelty. To this debasement, far removed from all representations of gods and men, he had brought the highest human art. All those

who had contributed to this art had only exerted themselves so that it could end up being used as an instrument of torture. Therefore the works of Perillus are preserved for the sole reason that anyone seeing them must hate the hands that created them.[1]

*Humanissima ars*, "the highest human art" or "an art that is most worthy of Man," is the designation Pliny applies to the art of bronze, and it seems to me that Pliny condenses into this single expression what one might call his philosophy of art in the service of man.

In his efforts to organize his art-historical material, Pliny blends very different methods and approaches that are seemingly in conflict with each other. He has therefore often been said to be a rather uncritical and unsystematic compiler. In the following discussion I will try to sort out these methods and approaches, and I hope to show that the concept of *humanissima ars* serves as a main thread all through his chapters on art and that Pliny thereby made a personal and lasting contribution to the methodology of art.

A character sketch of the Elder Pliny is given in the letters of the Younger Pliny, his nephew (*Ep.* 3.5; 3.16; and 3.20). The Elder Pliny was of the Equestrian order and had a career as a Roman officer. He ended as an admiral of the fleet stationed at Misenum near Naples. The most famous of these letters, written to the historian Tacitus, describes the death of the uncle during the eruption of Vesuvius in A.D. 79. This letter (3.16) leaves the modern reader with the impression that the Elder Pliny was a somewhat comical and naive person. I strongly doubt that this was the impression the nephew intended to give, and I want to underline two qualities of character he mentions as contributing to the death of his uncle. The first was the Elder Pliny's desire to investigate the wonders of nature, in this case the eruption of Vesuvius. The second was his fervent desire to help his fellow man. Both these characteristics are fully displayed in the *Natural History*.

Pliny is represented by his nephew as a very prolific writer, but the *Natural History* is the only work that has survived from his hand. It is normally dated to the year A.D. 77. It is dedicated not to the ruling emperor Vespasian, but to his son, the later emperor Titus. It is intended to be a Mirror of Princes. Pliny declares that he wants to give a comprehensive

picture of the present knowledge of the world and the way the world is organized and to impart to his fellow authors what earlier writers, going back to Aristotle and the natural philosophers, have written about it. Pliny identifies his target group as the common people, the mass of peasants and artisans, and, finally, those who have the time to spare for studies (*Praef.* 6). Thus, Pliny presents himself as an author who – through his *Natural History* – tries to benefit the many people who do not have the possibility of acquiring deeper knowledge about the world around them. In learning, he says, a special position is held by those who prefer to be of assistance and use than to please and curry favor (*Praef.* 16).

Pliny's view of culture is found in his cosmology, the theme of Book 2. It is marked by the conceptions of several philosophers, but most dominant is that of the Stoics. The world, *mundus*, is considered to be the divinity, *numen*, and is eternal and infinite (section beginning at 2.1). It is a sign of folly to search for God's image and form (2.14). But Pliny does state his conception of God (2.18): "That a mortal helps another mortal is God; and this is the way to eternal fame."

In a further discussion of the concept of God (2.27) Pliny reaches the conclusion that the power of nature is that which we call God. Nature benefits and helps Man, and Man, who is part of Nature and thus of the divine, benefits and helps his fellow Man.

These beneficial relations are expressed throughout Pliny's work. Nature makes its products available to Man and gives certain people greater insight and the ability to process the products that are the results of this insight. Artists and scientists have this insight. He praises those who, through special insight into Nature, have benefited Mankind (2.54), but he stresses that Nature has the controlling role in studies of itself. Scientists or artists are not Nature's conquerors. They receive the knowledge that Nature wants to give them (2.141).

The material for art can be found in the mineral kingdom, and Pliny's treatment of minerals in the service of Man is permeated with a basic moral conception of Nature and Man's relationship to it. Works of art are the results of a special processing of nature's raw materials, and that is why it is important for Pliny to discuss the role of the artist in society

and Man's intercourse with art and architecture. Here as elsewhere in this work it becomes clear that what Pliny calls a Natural History might equally well be called a history of human activity.

Past and present, progress and retrogression are the themes found constantly in Pliny. In his view, the age of discovery is over (2.117–118). The Roman peace seems to preclude a need for broader horizons. Man seems to believe that he has achieved the optimum in knowledge. But the peace, created by the Emperor, is not to be blamed. Conditions have improved, but people neglect possibilities. Morality is failing, and peace nurtures greed and luxury, *avaritia* and *luxuria*. Pliny makes no attempt to hide the fact that Man, in his eagerness to satisfy personal needs, has long since transgressed the boundaries set by Nature. Thus, linked with the perception of material development is the idea that such development causes moral decay, a thought found in other authors such as Seneca and Lucretius,[2] and which in turn has Greek roots.

Pliny has been called a "proto-environmentalist,"[3] and his "green" attitudes are most obvious in his warning against altering the ecological balance of nature. The area that suffers most damage, according to Pliny, is the mineral kingdom, which is dealt with at the end of the *Natural History*. The increasing urbanization of Roman society and the increasing number of monumental buildings have led to a massive drain on nature's resources. This overtaxing and misuse is called *luxuria* by Pliny. *Luxuria* is against nature; it is exactly the opposite of living in accordance with nature. *Luxuria* is unnatural. Pliny's treatment of the mineral kingdom is not a description of stones and metals. It deals instead with the use – and abuse – of artifacts, the results of Man's efforts as artisan and artist. Within the realm of artifacts it is primarily urban phenomena such as works of art and buildings that interest Pliny. Therefore, rather unexpectedly, the mineralogy section ends up as an art history in which works of art are enumerated hierarchically. It starts with gold and silver; then follow works in bronze and marble. Painting is included, justified by the use of inorganic pigments. Because Pliny gives us the only art history preserved from antiquity, the influence of these chapters has been considerable.

The modern expectations of the sections on art have been high, and Pliny has often been criticized for not providing sufficient and more precise descriptions of the works of art he mentions. But it was not his intention to provide a complete art history. He is concerned with art in the service of Man, with Man's intercourse with art and architecture, and he often focusses on misuse. He also focusses on the city of Rome. In his lists of famous Greek sculptors and painters he constantly tells us where their works are displayed in Rome. He speaks of the great amount of art brought to Rome from all over the Greek world. These works, displayed in Rome, are thus presented as the result and symbol of Rome's conquest of the world. Rome reflects the whole world; it becomes a museum of the Roman empire (36.101). In the chapters on marble we find a list of the wonders of the world, and as a counterpart Pliny establishes a list of the marvels of Rome in stone.[4]

It is in this light we must see Pliny's demand that great art ought to be shown publicly, for the pleasure of the people, not hidden away in the country in the homes of wealthy men. Art is an urban phenomenon and should be seen as a part of urban culture.[5] When Nature gives certain individuals the ability to compete with itself in imitating its own works, then those works should be for the people and not reserved for just the few. Murals are criticized because they are private property. The painters of the past, who painted easel paintings, enjoyed well-deserved fame. All artists then worked for their cities, and a painter was owned by all (35.118).

Book 34 offers a good example of how Pliny handles the vast material available to him from earlier Greek and Roman authors. The materials treated in Book 34 are copper alloys (including bronze), iron, and lead. Following his hierarchical enumeration, Pliny opens this section by stating that because of their usefulness copper and bronze are to be treated after the chapters on gold and silver in Book 33. But he adds that in his day, Corinthian bronze is valued even more highly than silver and almost above gold. I shall not enter the ongoing debate over what constitutes Corinthian bronze.[6] But this special alloy, which is often referred to in Roman literature, becomes, in fact, a kind of heading for and a clue to all of Book 34. It furnishes an excuse for Pliny to enter on a discussion of the status of Corinthian bronzes in Rome, and for an excursus on the

function and uses of bronze in Roman society. These sections offer the only systematic ancient treatment of Roman art preserved today. They clearly voice an attitude toward the use of art in Rome, thus furnishing us with a unique opportunity to hear a Roman's own words on a subject that we mostly view from an archaeological or art-historical perspective. I shall not go further into Pliny's section on Roman bronze, but confine myself to referring to Pliny's own headings for these parts of Book 34. They are found in Book 1, which contains his index to all the books of the Natural History:

Temple decoration in bronze
The first bronze statue of a god in Rome
The origin and reputation of statues
Types and forms of statues
The ancient statues (of people) wearing togas without tunics
The first statues in Rome
The first statues publicly exhibited
The first statues on columns
The date of the Rostra
Foreigners for whom there are statues exhibited publicly
Women for whom statues are exhibited publicly
The first equestrian statue to be exhibited publicly
When were all privately raised statues removed from public display?
The first statue to be raised publicly by foreigners
From ancient times there have been bronze artists in Italy, too
Excessive prices of statues
The most famous colossal statues in Rome

The so-called connoisseurs' wrong opinion about what the designation "Corinthian bronze" means also gives Pliny a reason to proceed with a chronology of Greek artists and to expand on the development of Greek bronze art in a section bearing the heading, "366 principal bronze works and artists in bronze." The theme of Corinthian bronzes, in fact, introduces this section on Greek bronzes. Owners of the so-called Corinthians had such passion for them that some carried them around. When Nero travelled he brought with him an Amazon by Strongylion, famous for

its splendid legs. Brutus fell in love with a statue of a boy by the same artist.[7] Apart from being curious stories, these examples must be seen in connection with the concept of the lifelike. The artist copies Nature to such a degree that people fall in love with statues.[8]

The first presentation of Greek artists is a chronological one. Who were contemporaries and competitors, *aemuli*? Who were pupils of what artists, *discipuli*? Pliny stresses the competitive aspect in Greek art. The artists are classified according to their high point, their floruit (*flos*).

What may surprise us is that Pliny has Greek art in bronze commence with Pheidias in the 83rd Olympiad, which we are told corresponds to year 300 after the foundation of Rome, that is, the years 448–445 B.C., when the work on the Parthenon began. Likewise, in his section on Greek painting, he begins his list of Greek painters in the time of Pheidias. Nevertheless, Pliny criticizes those who do not go further back in the history of Greek painting, and he mentions examples of earlier painting in Greece (35.54–56).

Pliny lists artists from the period of Classical idealism to that of the realism of Late Classical, early Hellenistic times. Then, according to him, bronze art goes into decay. A revival follows in 156th Olympiad (156–153 B.C.). One may disagree with Pliny's chronology for certain artists, but recently efforts have been made to make it agree with our traditional dating of these artists.[9] It seems, however, that Pliny focusses on artistic development at the expense of chronology.

Having set up the chronological framework for the most famous artists, Pliny then presents several lists of artists, the greatest names followed by the lesser known. The artists are grouped according to various criteria. In 34.54–71 he examines the most famous artists and their best-known works. We are told about the places where these works can be found – in Greece and, whenever possible, in Rome – and finally of the individual artist's contribution to the development of art. This pattern is shown in the following excerpts:

> 34.54. Justly Pheidias is judged to be the first who opened the path for the art of sculpture in bronze (*toreutice*)[10] and showed its possibilities.

34.56. Polykleitos is thought to have brought this science to perfection and developed the art of making sculpture for which Pheidias had opened the way. The idea that a statue could rest on one leg is entirely his own, although Varro says that they are "squarely cut" and almost all built on the same model.

34.58. Myron seems to have been the first who expanded the realistic content in art. He was more varied in his compositions[11] than Polykleitos and more careful in the working out of the proper proportions. But he confined himself to a careful representation of the parts of the body and did not represent the inner feelings. He did not represent hair on the head and pubic hair with any more particular correctness than that which was attained in the primitive past.

34.59. Pythagoras was the first who represented tendons and veins and executed the hair more carefully.

34.65. Lysippos is said to have given the greatest contribution to the art of bronze (*statuaria ars*)[12] by his representation of hair, by making the head smaller than the older artists did, and by making the body more slender and firm, whereby the statues seem to be more straight and tall. He carefully observed the rules of mutually related right proportions, *symmetria*, for which we have no Latin word, by a novel and untried way of altering his predecessors' more squarely cut figures. He used to state that while his predecessors had represented men as they really were, he had made them as they appeared to be. A characteristic of his art was his attention to details, even the slightest.

Art in bronze reaches its height with Lysippos, and the artists who are mentioned after him are not placed in a developmental chart but assigned individual characteristics. Telephanes is singled out for having the problem of being a provincial artist in Thessaly, where his works remained unrecognized in spite of their merits (34.68). Praxiteles, though celebrated more for his marbles, is mentioned for his beautiful bronzes (34.69).

After this section comes an alphabetical presentation of thirty-three artists (34.72–83), starting with Alkamenes, a pupil of Pheidias. Reference is made to at least one work by each, and the whole is made entertaining

by anecdotes. This list has played an important role in our identification of Greek statues. Xenocrates is the last to be cited (34.83), "and he has written books about his art." The same Xenocrates (third century B.C.), who is also listed in Pliny's index of authors consulted for Book 35 and in 35.68, is normally considered the principal source for Pliny's account of the development of bronze art and for the features of art criticism that are connected with it.[13]

As already mentioned, Pliny lists works of the above-mentioned artists found in Rome, but the relevance of the subject for the Roman reader is emphasized in the following observation, which also picks up what Pliny, from either ignorance or forgetfulness, may have omitted. The political undertones are clearly audible (34.84):

> Of all the works that I have enumerated the most famous are to be found in Rome today, dedicated by the Emperor Vespasian in the *Templum Pacis* and in his other buildings. They were brought to Rome by Nero as plunder and were displayed throughout the intimate rooms of the *Domus Aurea*.

The moral is that great art ought to be publicly accessible! Another alphabetical list follows (34.85), which contains the names only of Greek artists who have in common the more humble uniformity of their talents. Then (34.86–90) comes a more extensive alphabetical list of those artists who worked within the same genre. The genres mentioned are the following: statues of philosophers, women adorning themselves, wrestlers, old women, and so on, but there are also somewhat more specialized subjects, such as "Child Who in a Pitiable Way Tries to Make an Impression on his Mother Who Lies Slain," or, "Person Counting on His Fingers." Pliny concludes the section on Greek artists by mentioning Kallimachos, who suffered from a never-ending assiduity (*diligentia*).

It becomes evident that with Lysippos, Greek art has reached its state of perfection. Pliny sees the history of bronze art in Greece as an evolution; from its origin it eventually reaches perfection through a development advanced by contributions from different artists. After this point, no

more seems to happen, or there is a period of decay. It is a scheme we find elsewhere, for example, in Cicero and Quintilian when they refer to the history of the visual arts,[14] and it can be followed back to Aristotle.[15] Yet, according to Quintilian, Greek sculpture had already reached perfection with Polykleitos. Quintilian prefers idealism, but Pliny wished to concentrate his description of the evolution of the arts on the development from the idealizing to the realistic, from *pulchritudo* to *similitudo*. After Lysippos no contributions seem to be left to make for the artists to come. They could choose whatever style or genre they wanted. In this respect, Pliny's way of listing works of art from the Hellenistic era according to genre seems to be the best way of handling the artistic material of this epoch, and many have since followed in his footsteps. That Pliny did not establish a chronology for the art of the Hellenistic period is a problem that still haunts us.

Thus, in Book 34 on bronzes, Pliny blends a chronological, evolutionary, and systematic Greek art history with a social history of Roman art to make his own moralistic version of the history of what he designates *humanissima ars*. Art reaches its perfection through the contributions of generations of artists, and when art is used properly to benefit mankind, it is an art worthy of Man.[16]

The following list contains the main concepts that governed Pliny in his disposition of the art-historical material:

*Greek art in bronze*
Pretext to write about Greek art in bronze: Corinthian bronze
Chronology; dating by
    Olympiads and the artist's floruit
    contemporaries
    competitors
    pupils
    death and revival of art in bronze
Evolution of art in bronze
    from idealism (*pulchritudo*) to realism (*similitudo*)
    artists' contributions to a development toward a zenith

artists as inventors and innovators
culmination of bronze art followed by a period with minor artists
artists as benefactors of mankind
slaves cannot be artists
Alphabetical lists of artists
with works and anecdotes
with names only, artists of more humble uniformity
according to their genre
Works of art as wonders, *mirabilia, miracula*; daring in art
Use and abuse of art
inamoration in art; realism
public versus private; art must be public, Vespasian versus Nero
Greek bronze art to be found in Rome
Plundered art as symbol of the Roman Empire; Rome as a museum

*Roman bronze art*
Formal reason to write about Roman bronze art: Corinthian bronze
Past glory versus present decadence
significance now lost
technique now lost
artists working for gain only
Use (and abuse) of bronze in Rome
public architecture
private architecture
utensils (luxury)
statues, according to types and employment (honorific)
gods, men, women
first examples
dressed, naked, standing, sitting, on horseback
on columns and arches
Immortality and transitoriness

The chapter on Roman bronzes displays neither art-historical nor aes-
thetic considerations.

## Giorgio Vasari

The attitude that artistic progress is measured by an ever-closer imitation of Nature is seen in the work of the founder of modern art history, Giorgio Vasari. With his *Lives of the Most Excellent Italian Painters, Sculptors and Architects*,[17] Vasari, like his predecessor Pliny, wished to be of service to art.[18] In the Preface to his work he immediately states that God, when creating Man, fashioned the first forms of painting and sculpture. Thus, Man became the perfect model for statues and pieces of sculpture and the challenges of pose and contour. As material to fashion the first man, God used a lump of clay. For the Divine Architect of time and of nature, being wholly perfect, wanted to show how to create by a process of removing from and adding to material in the same way that sculptors and painters strive to bring their rough models and sketches to the final perfection. He then added color to His model. Later on in his introduction, Vasari adds that art owes its origin to Nature herself, that the beautiful creation, which is the world, supplied the first model, that the original teacher was that divine intelligence, which not only has made man superior to other animals, but like God himself. Vasari suggests that the first men, being less removed from their divine origin, were more perfect and intelligent; with Nature as a guide, a pure intellect for a master, and a lovely world as a model, they originated the noble arts and by gradually improving them brought them at length, from smaller beginnings, to perfection. According to Vasari, art consists entirely of imitation, initially of Nature, and then – as it cannot rise so high by itself – of those things that are produced by the masters with the greatest reputation.

After a period of decadence in art in the late Roman and the post-Roman world,[19] Vasari places a rebirth of art in the fourteenth century, a period in which he finds an art that is, on the whole, an imitation of nature. From this first phase (*i primi lumi*), improvements are made (*augumento*) until art in Vasari's own time reaches its perfection (*perfezione*). He divides the development into three periods or styles, each introduced by prefatory remarks in which he outlines the contributions of the artist to this development.

Cimabue originated a new method of drawing and painting, and, together with Giotto and others, he represents the first period, the age of childhood. With regard to the artists of the second period, Vasari, in the preface to this section, states that notable improvements may be seen in everything, and little is wanting in complete perfection. The truth of Nature is exactly imitated. The works of the artists of the second period showed more grace, nature, order, design, and proportion than earlier works, and the statues begin to appear almost like living persons and not mere statues. In fact, little was left for the third period to complete. Examples of Vasari's accounts of the artists' contributions show – in both style and wording – his debts to Pliny (Preface to Part Two; *Lives* I, 208–209):

> [T]he figures of Jacopo dalla Quercia of Siena possess more movement, grace, design and diligence, those of Filippo a better knowledge of the muscles, better proportions and more judgment, and those of their pupils exhibit the same qualities. But Lorenzo Ghiberti added yet more in his production of the doors of S. Giovanni, in which he displayed his invention, order, style and design so that his figures seem to move and breathe. . . . He [Donato] imparted to his figures a movement, life and reality which make them worthy to rank with modern works, and even with those of antiquity. . . . [The artists showed] a constant endeavour to get nearer to the truth of Nature in design, while the faces are exactly like those of men as they were seen and known by the artists. Thus, they sought to reproduce what they saw in Nature and no more. . . .

In his preface to Part Three, Vasari stresses the fact that the artists of the second period had shown the way for the artists of the third period and made it possible for them to attain the summit of perfection and produce the most valuable and renowned modern works; works that, through their qualities and excellence, surpass even the achievements of the ancients. Still in a manner reminiscent of that of Pliny, he proceeds (*Lives* II, 153–155):

> [Leonardo da Vinci] began the third style, which I will call the modern, notable for boldness of design, the subtlest imitation of Nature in trifling details, good rule, better order, correct propor-

tion, perfect design and divine grace, prolific and diving to the depths of art, endowing his figures with motion and breath. . . .

[B]ut the most graceful of all was Raphael of Urbino, who, studying the labours of both the ancient and the modern masters, selected the best from each, and out of his garner enriched the art of painting with that absolute perfection which the figures of Apelles and Zeuxis anciently possessed, and even more, if I may say so. Nature herself was vanquished by his colours, and his invention was facile and appropriate. . . .

But the man who bears the palm of all ages, transcending and eclipsing all the rest, is the divine Michelagnolo Buonarroti, who is supreme not in one art only, but in all three at once. He surpasses not only all those who have, as it were, surpassed Nature, but the most famous ancients also, who undoubtedly surpassed her. . . . If by any chance there were any works of the most renowned Greeks and Romans which might be brought forward for comparison, his sculptures would only gain in value and renown as their manifest superiority to those of the ancients became more apparent.

Vasari thus presents the artists of the Renaissance as a series of inventors or innovators, chosen by God, each of whom contributed to the development of (Tuscan) art. With Michelangelo in sculpture and with Raphael in painting, art has now reached its high point, Raphael conquering Nature itself with his colors in a *certamen artis et naturae*, a competition between Art and Nature.[20] Their art equals and even surpasses that of Antiquity as well. It constitutes *la perfetta regola dell'arte* (the perfect rule of art), but, according to Vasari, the artists who attained the highest degree of perfection would not have reached their high position had not those who came before them been who they were.

Vasari's dependence on ancient Roman authors is unquestionable, although he barely acknowledges them. Pliny is referred to by name only three times in the Introduction and Prefaces in the *Lives*. Vasari's debt to Cicero, among others, has been stressed, but – as may be clear from the selections from Vasari's text quoted here (many more could be added as evidence) – Pliny's chapters on art have left their imprint on Vasari's *Lives*, not only as a model, but also on the level of style and rhetoric. The

opinion has been voiced that Vasari used Pliny only indirectly, but it must be rejected.[21]

Vasari quotes Pliny more or less verbatim in his introductory section on the history of art in antiquity.[22] His use of Pliny's model of evolution is clear in all his biographies of Italian artists, where one finds quotations, transitions, interpretations, and valuations with a choice of words close to that of Pliny.[23] Similarly close is his choice of anecdotes for illustrating artists' imitation of nature, their *veritas*. One example may suffice: Vasari mentions that the strawberries painted in a fresco by Bernazzano Milanese attracted turkeys, who pecked at the stucco to get the fruit. The anecdote reflects the story told by Pliny about grapes painted by Zeuxis (35.65–66).

As a feature of the only extant art history from antiquity, Pliny's model of evolution made its imprint on the conception of art and on art history in the Renaissance and in later times. In his article "The Renaissance Conception of Artistic Progress and its Consequences,"[24] E. H. Gombrich relates how already the authors of the early Renaissance drew on Pliny's text. The Florentine humanist Alamanno Rinuccini is clearly referring to criteria found in Pliny when in the preface to a translation of Philostratos he mentions Masaccio, who was able to paint whatever he found in Nature with a likeness so perfect that the viewer felt he was looking not at reproductions of objects, but at the objects themselves. Masaccio is placed close to the top of a scheme of evolution that began with Cimabue and Giotto. Lorenzo Ghiberti admired ancient art for its naturalism, and Book 1 of his *Commentarii* is almost a paraphrase of Pliny's chapters on art. He dedicates a long section to ancient bronze statuary, drawing heavily on Pliny, and especially in his own work as a sculptor he seems to have been influenced by Pliny's description of Lysippos.[25] Gombrich concludes that Ghiberti must have felt himself as a second Lysippos, by quoting his remark on his efforts to reach the high level of Lysippos: "*Ingegnai cercare imitare la natura quanto a me fu possibile*" ("I strove in all the measure to imitate nature as far as I could").

The model of evolution became a considerable stimulus for the artists of the Renaissance, but, as Gombrich emphasizes, at the same time it

dealt a collective trauma to those generations of artists who had to live with the realization that their activity was in a period that came after art had reached its high point, that is, in a period of decadence.

## Torkel Baden

When, in 1825, Torkel Baden, until 1823 secretary at the Danish Academy of Fine Arts, published for the benefit of Danish artists a short overview on the history of Greek painting, he enumerated fifty-three Greek painters in ninety pages, giving each a short presentation. A mere twenty-five pages were dedicated to the physical remnants of Greek art in the form of an appendix that was comprised of a very brief description, taken from Winckelmann, of paintings found in Herculaneum. In this connection he remarks that "There is enough left of Greek painting. We do not count them, we weigh them."[26]

Baden uses Pliny's chapters on Greek painting as a model and main source for his textbook. When he describes the artists, he even seems to write in the manner of Pliny, but the illusion of reading an ancient text was broken when he inserted his own comments, citing the opinions of contemporary German and French art historians, including Winckelmann and Goethe, the Comte de Caylus,[27] Lévesque,[28] Quatremère de Quincy,[29] and others, who had been working with Pliny or written treatises on his art chapters. He often supplemented his descriptions of artists with bibliographical information.

Apart from referring to contemporary critics, Baden turns to Renaissance and later artists who used the same techniques as the ancient Greek painters, as described by Pliny. When Pliny announces that great painting had to be exhibited to the public, Baden mentions the Dutch painter Bartholomeus van der Helst, who for the same reason preferred easel paintings to frescoes.[30] Baden presents the Greek painters in chronological succession, starting with the invention of painting and the delineation of a shadow, but, following Pliny, he soon leaps forward to Pheidias and his brother Panainos, and he quotes the different painters' contributions to the development of art. In his section on the painter Zeuxis, he even adds his personal comments. "Who finds the art of antiquity monotonous

is mistaken. The ancient artists were endowed with a spirit of imitation, a spirit which had encouraged the earliest artist to imitate Nature and brought their successors to imitate Nature and Art. Still with the original in mind they tried to make the proportions more perfect, making every detail more gracious and varying the relative proportions with only slight innovations. In that way the perfection of a given work of art, when shown to the public, was only to be seen as a step on the way to further perfection. The ancient artists saw no obstacle to their own originality in this process, as modern artists do, who to avoid imitation, are forced to move away from the simple and natural. . . ."[31] Baden concludes his remarks on the painter Zeuxis in this way: "He kept himself within the limits for painting, defined by Lessing, not pursuing new forms or boasting of his own originality."[32]

Baden's description of the paintings of Herculaneum is structured according to genre. He gives the reason for that choice in his conclusion: he prefers division by genres to a hierarchic, strictly academic order, which was not known to antiquity. "I do not accept difference in rank in the arts," he says.

> If there has to be such thing, there is nothing more natural than that proposed by Quatremère de Quincy, who divides the artists into three classes, which are related to the realms of nature. The first is the thinking and animated Nature, to which belong the arts which have Man as the object of imitation. The second is Nature seen as vegetative and in motion, to which one can refer landscapes, seascapes, etc. The third is Nature as dead and without life, to which one can relate depictions of meubles, utensils, objects for luxury as well as for the more basic necessities. When this division of the artists is accepted by all, there will be no other precedence among artists than that of one's talent in a given art. But as long as there are academies in this world, nothing changes. But these institutions are not everlasting. The academies built on the ruins of the arts, will fall into ruins themselves, when the arts once again have reached their former levels.[33]

Baden rather vehemently states that a hierarchic, strictly academic order was not known to antiquity. Surely, Pliny's lists of artists are presented chronologically or alphabetically or according to genre, but the relation

between some of his lists could easily be seen as hierarchical. Pliny begins with lists of the most famous sculptors in bronze and goes on to enumerate the less gifted artists in 30.85. But Pliny does not stress lack of talent or mention any academic ranking, as Baden puts it, when he mentions the less-known artists. Baden sneers at the academic order of his own day and seeks comfort in the texts of Pliny and Winckelmann, pointing them out as models.

Baden may have been a rather mediocre art historian without much originality, and he did not rank high in the Academy of Fine Arts in Copenhagen, which he in turn certainly did not rank high, as one may deduce from his remarks on academies. But on the verge of Romanticism, he was one of the last authors who, in the footsteps of Vasari and others (*mutatis mutandis*), used Pliny directly as a main model, systematic as well as moralistic, for a modern treatise on ancient art.

**NOTES**

1. Unless otherwise noted, all translations in this essay are my own.
2. R. Lenoble, *Esquisse d'une histoire de l'idée de nature* (Paris, 1969) 176–183.
3. A. Wallace-Hadrill, "Pliny the Elder and Man's Unnatural History," *Greece and Rome* 37 (1990) 85.
4. The wonders of the world: 36.64–100; the marvels of Rome: 36.101–125. Cf. J. Isager, *Pliny on Art and Society. The Elder Pliny's Chapters on the History of Art* (London and New York, 1991; Odense, 1991; repr. 1998) 83–84, 120.
5. E.g., 34.13, on bronze doors in a private house; 34.62, about the people demanding back a statue that Tiberius had transferred to his bedroom; 35.26, about a speech given by Agrippa on the question of making all statues and paintings public property.
6. For the discussion see C. C. Mattusch, "Corinthian Metalworking. An Inlaid Fulcrum Panel," *Hesperia* 60 (1991) 525–528; D. M. Jacobson and M. P. Weitzmann, "What was Corinthian Bronze?" *American Journal of Archaeology* 96 (1992) 237–247; A. R. Giumlia-Mair and P. T. Craddock, "Corinthium aes. Das schwarze Gold der Alchimisten," *Antike Welt* 24 (1993), Sondernummer.
7. Nero's Amazon: 34.48 and 82; Brutus' Boy: 34.82.
8. In Book 35 Pliny gives several examples of painting made with such mimetic perfection that animals reacted to objects in the painting: painted grapes attracted birds (35.65 and 66), and a horse made by Apelles made real horses neigh. Even the painter Zeuxis, who made the lifelike grapes, was fooled by a curtain painted so realistically by Parrhasios that Zeuxis asked him to draw back the curtain so he might see the picture concealed by it (35.65). Cf. Isager (supra n. 4) 136–140.

9.  See A. Corso, R. Mugellesi, and G. Rosati, eds., *Gaio Plinio Secondo. Storia Naturale* V (Turin, 1988) 161–169.

10. On the meaning of this term see J. J. Pollitt, *The Ancient View of Greek Art* (New Haven and London, 1974) 73–77; 106.

11. For a discussion of the term *numerosior* see Pollitt (supra n. 10) 409–415.

12. For a discussion of the relation between this term and *toreutice*, see Pollitt (supra n. 10) 107. For a different opinion see H. Le Bonniec, *Pline l'Ancien. Histoire Naturelle Livre XXXIV* (Paris, 1953) 217.

13. See B. Schweitzer, *Xenocrates von Athen. Beiträge zur Geschichte der antiken Kunstforschung und Kunstanschauung* (*Schriften der Königsberger Gelehrten Gesellschaft* 9; Halle, 1932) 1–52.

14. Cicero, *Brutus*, 18.70; and Quintilian 12.10.3–9. Cf. G. Oemichen, *Plinianische Studien zur geographischen und kunsthistorischen Literatur* (Erlangen, 1880; repr. Hildesheim, 1972) 162–169; S. Ferri, *Plinio il Vecchio. Storia delle Arti antiche* (Rome, 1946) 19–29; Isager (supra n. 4) 103–107.

15. Arist. *Poet.* 1449 a 9.

16. It may be evident from this conclusion that I cannot agree with G. Lahusen, "Antenore, Plinio e la statuaria romana" in E. Formigli, ed., *I Grandi Bronzi. Le fonderie e le techniche di lavorazione dall'età arcaica al Rinascimento* (Siena, 1999) 41, who states that art in bronze is considered *ars humanissima* by Pliny because it offers the best possibilities for making representations of the human body ("L'arte del bronzo era perciò considerata da Plinio 'ars humanissima', nel senso che poteva rappresentare nel migliore dei modi la figura umana").

17. Published in Florence in 1550 and enlarged in the second edition of 1568. The quotations from the second edition given in English in this essay are taken from the revision of the translation by A. B. Hinds (Temple Classics edition, 1900) published in the Everyman's Library in 1927 and reprinted as W. Gaunt, ed., *Giorgio Vasari. The Lives of the Painters, Sculptors, and Architects* (London and New York, 1963), hereafter abbreviated as *Lives*.

18. See Vasari's introduction to Part One (*Lives* [supra n. 17] I, 8): "Up to the present, I have discoursed upon the origin of sculpture and painting, perhaps more at length than was necessary at this stage. I have done so, not so much because I have been carried away by my love for the arts, as because I wish to be of service to the artists of our own day, by showing them how a small beginning leads to the highest elevation, and how from so noble a situation it is possible to fall to utterest ruin, and consequently, how these arts resemble nature as shown in our human bodies; and have their birth, growth, age and death, and I hope by this means they will be enabled more easily to recognise the perfection to which they have attained in our own times." Vasari concludes by remarking that should the arts once more "fall to a like ruin and disorder" – "which God forbid" – his work "may maintain the arts in life."

19. In the introduction to Part One (*Lives* [supra n. 17] I, 6) Vasari outlines the history of art from antiquity to his own time, that is, "the rise of the arts to perfection, their decline and their restoration or rather renaissance." He sees a continuing flourishing until the death of the last of the twelve Caesars, although

the former level of perfection and excellence was not maintained. He points to the sculpture and architecture of the time of Constantine as evidence for a decline, a gradual process in which art finally lost all perfection of design. Constantine's departure from Rome made a bad situation worse. Vasari further considers the new Christian religion as most harmful and destructive to the fine arts, and the rule of the Lombards, in which the arts "grew gradually worse and worse, until at length they reached the lowest depths of baseness" (*Lives* I, 12). Vasari sees a general improvement already by 1016, when the Pisans began to erect their cathedral.

20.  Cf. Pliny *NH* 21.4 on Pausias.

21.  As pointed out by G. Becatti, "Plinio e Vasari," in *Studi di Storia dell'Arte in Onore di Valerio Mariani* (Naples, 1971) 173–183.

22.  Cf. Preface to Part Two (Hinds [supra n. 17 ] I, 203): "The fate of painting and sculpture in the ancient times must have been so similar [to those of today] that with a change of names their cases would be exactly alike."

23.  Becatti, "Plinio e Vasari" (supra n. 21) 173, gives a list of Vasari's terms relating to art criticism that were taken from ancient authors, including Pliny: *ingegno* (*ingenium*), *studio* (*studium*), *diligenza* (*diligentia*), *invenzione* (*inventio*), *facilità* (*facilitas*), *sottiligliezza* (*subtilitas*), *bellezza* (*venustas*), *maestà* (*maiestas*). Becatti further presents a long list of examples from Vasari's *Lives* as evidence for Vasari's direct dependence on Pliny in composition, phrases, and concepts.

24.  In *Norm and Form: Studies in the Art of the Renaissance* (London and New York, 1966) 1–10; this paper was originally delivered in 1952.

25.  *NH* 34.61: "One ought to imitate Nature, not the works of other artists"; and *NH* 34.65: "Lysippos' predecessors made men as they really were, while Lysippos made them as they appeared to be."

26.  T. Baden, *Et kort Begreb af det græske Maleries Historie for Kunstnere* (A short concept of the history of Greek painting for artists) (Copenhagen, 1825) 93. This overview was originally prepared as a series of lectures to be given at the University of Copenhagen or at the Danish Academy of Fine Arts, but in 1794 Baden was appointed Professor at the University of Kiel, and the lectures were never held. In 1804 Baden returned to Copenhagen and became a secretary at the Academy of Fine Arts.

27.  In his "Réflexions" on Pliny's section on art in bronze, Caylus comments on Perillus, who discredited the *humanissima ars*, which had been created to "to control passion and instill virtue" ("pour corriger les passions et inspirer la vertu"): "I am sure that everybody in Antiquity has thought what Pliny says about Perillus, that he was even more cruel than Phalaris himself" ("je suis persuadé que toute l'antiquité a pensé ce que Pline nous dit de Peryllus, il fut plus cruel que Phalaris même"). Comte de Caylus, "Réflexions sur les chapitres du XXXIV.e Livre de Pline, dans lesquels il fait mention des ouvrages de bronze," *Mémoire de l'Académie Royale des Inscriptions et des Belles Lettres avec Les Mémoires de Littérature* XXV (1757) 347.

28.  Baden draws on an article by Pierre-Charles Lévesque (1795), in which, in connection with his exposition of Pliny's evolutionary model of highlights and

decadences in art, he tries to demonstrate how France alone has begun a new artistic era (P.-C. Lévesque, "Mémoire sur les progrès successifs de la peinture chez les Grecs," *Mémoire de l'Institut National des sciences et arts pour l'an IV de la République. Littérature et Beaux Arts* I (Paris, 1795) 462–463: "Dès que la peinture eut commencé chez les Grecs à dégénérer, tous les pas des artistes ne tendirent plus qu'à la decadence de l'art. C'est aussi ce qu'on vu dans l'Italie moderne. La France offre jusqu'ici le seul exemple de l'art se relevant d'un état de dépérissement avec l'éclat de la plus florissante jeunesse") ("As soon as the art of painting started to decline among the Greeks, every step taken by the artists led them nothing more than toward the decadence of the art. This is what we have seen in the Italy of today. Until now France offers the sole example of how art can reconstitute itself from a languishing state with a brilliance of the very flower of youth".) A Nestor in the art of painting made this new beginning; Lévesque points here to the artist Vien, who, at the instigation of Caylus, on the basis of Pliny's description, had tried to reconstruct the formula for wax-painting.

29. A short outline of Quatremère de Quincy's life and works can be found in J. Turner, ed., *The Dictionary of Art* 25 (1996) 798–799 s.v. (Y. Luke)
30. Baden (supra n. 26) 12.
31. Baden (supra n. 26) 28.
32. Baden (supra n. 26) 28. The allusion is to G. E. Lessing, *Laokoon oder über die Grenzen der Malerei und Poesie, mit beilaüfigen Erlaüterungen verschiedener Punkte der alten Kunstgeschichte* (Berlin, 1766) 229.
33. Baden (supra n. 26) 122–124.

# 4

# The Fate of Plate and Other Precious Materials: Toward a Historiography of Ancient Greek Minor (?) Arts

## KENNETH LAPATIN

The evolutionary paradigm of stylistic development that dominates the study of Greek art today may be grounded in ancient Greek and Latin texts,[1] but the preoccupation of modern scholarship with architecture in stone, marble and bronze sculpture, and painted pottery has no ancient pedigree. Classical authors established no such triad, for the Greeks (and Romans) were equally concerned with other objects, especially those fashioned from sumptuous materials, which, as in other periods and cultures, were often more consequential than those we privilege today. Along with the sculptors Polykleitos, Praxiteles, and Lysippos, and the painters Apelles, Parrhasios, and Zeuxis, workers in precious metals, gemstones, and fine weavings, such as Akragas, Boëthos, Mentor, Mys, Mnesarchos, Pyrgoteles, Theodoros, Akesas, and Helikon, were praised by classical writers.[2] Pheidias, the most celebrated of all ancient artists, was famous *not* for the Parthenon marbles, which are often attributed to his genius, but for monumental statues of gold and ivory. These were widely acclaimed (and frequently reproduced in other media) less for their stylistic innovations than because they so vividly conveyed the other-worldly power of their divine subjects. The splendor of their materials – semiprecious stones, fine woods, and amber, as well as gold and ivory – contributed to their mimetic success by presenting convincing simulacra of Olympian radiance.[3] In the *Iliad*, *Odyssey*, and other ancient texts, the gods are described as bright, shining, and luminous. Although they might disguise themselves and appear on earth in some other form, their resplendence, more often than not, revealed their true nature. Heroes

recognized the gods by their blazing eyes, glowing flesh, and glistening garments. In the first of the *Homeric Hymns* dedicated to Aphrodite, for example, the goddess appears before Anchises "clothed in a robe more brilliant than gleaming fire," "her cheeks radiant with divine beauty."[4] Gold, ivory, gemstones, and other exotic substances effectively communicated to mortal viewers the physical character of immortals.

Such materials also seemed to be endowed with spiritual qualities and thus bestowed merit upon their possessors.[5] Incorruptible gold was "the child of Zeus, . . . the most excellent of possessions" according to Pindar,[6] and numerous ancient texts indicate that precious metal objects played crucial roles in a variety of contexts. As temple inventories inscribed on stone make abundantly clear, the Parthenon and other buildings whose architectural sculptures are the focus of so much of our attention were built to house such sumptuous offerings along with dedications of luxurious textiles, gemstones, fine woods, and ivory.[7] Ivory was particularly appropriate for rendering beautiful flesh on account of its warmth and color (as in the myths of Pelops and Pygmalion and Galatea; cf. *Odyssey* 18.186, where Athena beautifies Penelope by making her "whiter than new-sawn ivory").[8] The expense and exotic origins of these materials added to their appeal, making them attractive and advantageous as superlative offerings that not only manifested the piety of their donors to the gods, who might "give something pleasing in return," but also demonstrated their donors' wealth and prestige to fellow mortals.[9] Pausanias considered Greeks of earlier times "to have been especially lavish in honoring the gods, and not at all miserly of resources, in that they imported ivory from India and Ethiopia to make statues,"[10] and the Elder Pliny observed that "tusks fetch a vast price and supply a very elegant material for images of the gods."[11] Indeed, the costliness of such images was such that in the fourth century B.C., the Athenian admiral Iphikrates intercepted the chryselephantine offerings of Dionysios I of Syracuse en route to Olympia and Delphi and converted them into cash in order to feed his troops.[12]

Precious stones, imported from abroad and worked with great skill, were also deemed to have mythical and magical as well as aesthetic and economic value. Superbly cut by skilled craftsmen, gems performed vital functions as personal insignia, tokens of political affiliation, and

dedications in sanctuaries. As magical charms, they could inspire love, guarantee faithfulness, cure the sick, and avert the evil eye. Amethyst, for example, was interpreted literally to mean "no drunkenness" and thus was appropriately employed for images of Dionysos and his circle. Other stones might make one lecherous, or more convincing in court; they might predict storms or prevent scorpion bites; and the list goes on.[13] Such objects and the beliefs that surrounded them, however, hardly accord well with the vision of the rational Greeks *we* have constructed. Could those inventors of democracy, philosophy, and so much more that we hold dear have been so irrational? Although a mainstay of classical studies through the eighteenth century,[14] gemstones now dwell largely in specialist publications where they tend to be demystified through "scientific" modes of analysis and categorization by shape, style, and date. Greek (and Roman) works in hard stones, as well as gold, ivory, silver, fine woods, amber, and textiles, however, ranked among the outstanding products of classical civilization and were arguably the most important to the ancients themselves (even if we do not understand fully ancient conceptions of quality).

To give but one example, in the middle of the sixth century B.C., the inhabitants of Phocaea decided to abandon their city rather than submit to the Medes. Herodotus reports, "They loaded onto their ships their children, women, and household property, and above all the images of the gods from sanctuaries and other dedications, everything, in fact, *except bronzes, stonework, and paintings*, and they sailed to Chios."[15] The Phocaeans abandoned the very objects that lie at the heart of our art histories. In specialized textbooks, just as in more general surveys of art history, virtually all illustrations devoted to Greek art depict objects made of either ceramic or stone.[16] The exceptions are inevitably bronze statue(tte)s or plaster models, and occasionally coins, with few if any objects in other, more precious materials. To be sure, items superbly fashioned of sumptuous substances are not as well preserved as marbles and pots, but they *do* survive in far greater quantities than standard treatments of ancient art would lead one to believe. The omission of sumptuous arts has skewed our notions of past artistic production and taste, as well as of religious practices and social, economic, and political relations.

Why, then, are exquisitely wrought and ideologically potent luxury arts habitually overlooked in accounts of Greek art? Their counterparts, after all, are regularly included in histories of ancient Near Eastern, Egyptian, Aegean Bronze Age, Etruscan, Late Antique, and Medieval art.[17] Survival, although certainly a factor, is not the answer. Ancient Greek gemstones of every period, for example, far outnumber preserved bronzes.[18] And yet Greek bronzes, whether they actually survive or are merely identified in Roman marble "copies," dominate ancient art history.[19] They are, of course, prominent in the first half of Book 34 of the Elder Pliny's *Natural History*, but Pliny also devoted his entire thirty-seventh book, the culmination of his encyclopedic work, to precious stones.[20]

The denigration of ancient Greek sumptuous arts into seemingly neutral *Kleinkunst* and thence into the pejoratively termed "minor arts" (now inadequately rehabilitated as "decorative arts") and their relegation to the margins of our discipline can be traced along a variety of trajectories. These trends overlap, interact, and mutually reinforce one another's effects. By concentrating on a few that seem to me to be significant, I do not mean to suggest that other factors have not also proved important. The threads of European intellectual history are interwoven, and to outline here the history of taste since classical antiquity is beyond my powers of concision. Instead, I hope to offer a starting point for a more integrated history of Greek visual culture.

Let us begin with the very notion of "Art" that has proved so detrimental to the study of objects created from sumptuous materials. It is, I hope, a classroom commonplace that the ancient Greeks had no concept of "Art" with a capital *A,* and that the temples, statues, and painted pots that fill our textbooks all served religious, social, political, and other practical purposes. The same holds true for precious objects, such as the famous ivory jumping figure from Samos that probably comprised the arm of a lyre,[21] or a less well-known gilded silver plaque representing Nike, one of a pair recovered from an aristocratic burial in Thrace.[22] These pieces operated in the same contexts as more modest artifacts, but, being fashioned from valuable, exotic, mythical, and magical substances, could better fulfill their functions as votives, funerary offerings, and status-enhancing commodities. The inherent properties of their

materials, moreover, permitted greater technical elaboration; entrusted to superior craftsmen, they were fashioned into products of distinction. Precious votives, such as the lyre, originally enhanced by amber inlays and dedicated to the goddess Hera, or the now fragmentary life-size gilded silver bull offered to Apollo at Delphi,[23] would potentially garner greater divine favor than bronzes or marbles, for in antiquity humility was not a virtue. Artists might revel in some pictorial breakthrough,[24] but patrons, as noted above, made offerings to the gods in the hope of "something pleasing in return."[25] At the beginning of the *Iliad*, the priest Chryses, spurned by Agamemnon, prays to Apollo: "Hear me Apollo, god of the silver bow. . . . [I]f ever I roofed a shrine to please your heart, ever turned the long rich bones of bulls and goats on your holy altar, now bring my prayer to pass."[26] As Pausanias recognized, the gods should be honored *lavishly*.

Funerals, too, provided occasions for ostentation, and the display and deposition of precious goods served the living as well as the dead. Such exhibitions, however, were often sources of contention, as evidenced by ancient sumptuary legislation, the precise reasons for which are hotly debated by scholars.[27] In private homes, meanwhile, gold and silver vessels (some inlaid with semiprecious stones) – produced in the same shapes as ceramics, decorated in the same styles and, it seems, with the same scenes[28] – would impress visitors far more than pots, however finely painted. According to Thucydides, the Athenians were duped into launching the disastrous Sicilian expedition of 415 B.C. by the inhabitants of Segesta, who entertained the Athenian ambassadors and ships' crews "in their private houses, collecting together all the cups of gold and silver in Segesta itself, borrowing others from the neighboring cities, Phoenician and Hellenic, and then letting each host produce them at banquets as though they were his own property. All used pretty much the same articles and everywhere there was a great abundance of them, so that the Athenians were astonished and when they got back to Athens told everyone of the vast quantities of valuable objects they had seen."[29]

Sumptuous objects were embedded in life, and the *strict* categorization of artifacts by media – essentially an academic enterprise – is not attested before the sixteenth century, when Academies of Art, concerned not only with practice, but also with theories of art, began to enshrine the Vasarian

triad of Architecture, Sculpture, and Painting. Giorgio Vasari lauded the creative and formative role of gold work and glyptic in the first edition of his *Vite* (1550), which he conceived amidst the splendor of Farnesine Rome. In the 1568 revision of this fundamental text, however, the Arretine painter and architect demoted the sumptuous arts and elevated Painting within what was to become the canonical triad by altering the order of terms in his title. Vasari's aim was to promote a concept of *disegno* and to advance his own status beyond that of his rivals, such as the goldsmith Benvenuto Cellini.[30] The impact of his efforts was not immediate, and gems continued to inform the practice of these arts long after Vasari. Connoisseurs still read ancient authors and coveted gems as well as marbles. In the seventeenth century, Franciscus Junius wrote of Akesas the weaver, as well as of Apelles; and in the eighteenth, J. J. Winckelmann, immersed in ancient texts and contemporary painting, produced a major catalogue of Philipp von Stosch's collection of intaglios (1760) and featured a gem, rather than a pot or a statue, on the title page of his monumental *History of Ancient Art* (1764). In fact, having seen little original Greek sculpture or painting, Winckelmann, like many others, believed that the history of Greek art could be written just as well from glyptographic as from any other evidence.[31] An engraving adorning the catalogue of the collection of the Duc d'Orléans, published in 1780, depicts the personifications of Architecture, Sculpture, and Painting looking to Glyptic for inspiration (Fig. 1).[32]

Nonetheless, over the years, art-historical (as well as political and racist) ideologies have contributed to the displacement and demotion of items fashioned from sumptuous materials from the lofty position they held in ancient art and culture (as well as in the Middle Ages and the Renaissance).[33] When Greek art is placed on the Procrustean bed of the triad of Architecture, Sculpture, and Painting, the sumptuous arts suffer: ruined temples, after all, are but empty shells, their interiors stripped of precious offerings; marbles stand in for the bronze and chryselephantine images admired by the ancients; and painted pots fill the gap created by the loss of celebrated panel paintings. Indeed, owing to the exaltation of Painting, ceramics have become a major sub-field of ancient art history, with the name of Euthymides on the lips of successful students in Art 101.[34]

Fig. 1. "Vignette" on page 1 of the first volume of G. de La Chau and G. M. le Blond, *Description des principales pierres gravées du cabinet de S. A. S. Monseigneur le Duc d'Orléans*... (Paris, 1780) designed by Charles Nicolas Cochin and engraved by Augustin de St. Aubin in 1779. (Typ 715 80.508F, Department of Printing and Graphic Arts, Houghton Library, Harvard College Library.)

That decorated pots have acquired an aesthetic significance inordinately greater than conceivable in antiquity leads us to the second of the trajectories I wish to discuss: anachronistic notions of "good taste," which is often considered, as Winckelmann declared at the beginning of his *Reflections on the Imitation of Greek Works in Painting and Sculpture* (1755), to have "had its origins under the skies of Greece."[35] Winckelmann's idea of "der gute Geschmack," which he optimistically thought was "becoming more prevalent throughout the world," was naturally no closer to the ancient Greeks' than is our own today. Nonetheless, the pervasive ideological construct of Greek taste as "pure" and "simple," which served Winckelmann in his campaign against the Rococo, went on to play a significant role not only in the elevation of ceramics,[36] but also in the debate over polychromy of the early and mid-nineteenth century.[37] Romantic notions of "Art for Art's Sake," Ruskin's crusade against ornament, and, more recently, the modernist aesthetic of "less is more" have all figured in the intellectual and moral shifts that

contributed to the devaluation of opulent artifacts prized by the ancients.[38]

Modern preferences for white stone sculpture and less costly and thus putatively more democratic ceramic pots – preferences that have been projected onto the Greeks, despite the explicit and copious testimony of ancient texts to the contrary – mask political, moral, and racist agendas. As proto-Anglo-Europeans, the Greeks are repeatedly praised for having created "perfect" forms from common materials. Paradoxically, painted pots are considered to have been within the reach of Everyman and simultaneously extolled as high art. Indeed, in the nineteenth century, perfection was sought no further than a red-figure vase or an Athenian marble.[39] How, in contrast, could finely crafted sumptuous objects, long the possessions of elites, serve as embodiments of the art of a free, democratic, and rational people? Ancient texts reveal that gold wreaths were awarded to potentates by a sycophantic *demos*.[40] Yet, because most surviving examples of ancient sumptuous arts have emerged from tombs outside modern Greece, such objects have all too often been perceived as the products of foreign – that is to say, non-Western European – aesthetics. The figures incised on the technically and materially splendid gold-figure silver *phiale mesomphalos* excavated in 1929 from a Thracian tomb near Duvanli in central Bulgaria (Fig. 2),[41] for example, compare favorably to those on Athenian red-figure pots. Yet it and similar objects were characterized by a prominent art historian as recently as 1996 as aesthetically "second-rate"[42] – despite the sophisticated poses of the warriors on the coursing chariots and the various positions of their shields, each emblazoned with a distinct device: one in profile, another frontal, the third seen in three-quarter view from the interior, the last from the exterior. Notwithstanding the stylistic similarity of this phiale to late fifth-century B.C. Athenian pots and marbles, it has been suggested that it and other such objects were commissioned from itinerant Greek craftsmen by rich, gaudy barbarians. The insinuation – contradicted by the incontrovertible record of temple inventories and ancient literature – is that no right-thinking Greek would be attracted by such an item, that such ornate and opulent objects are somehow not *truly* Greek. Yet the Duvanli phiale is certainly Athenian. Although found in Thrace, it

**Fig. 2.** Silver-gilt *phiale mesomphalos* from the Basova Tumulus, near Duvanli, Bulgaria. Late fifth century B.C. Plovdiv Archaeological Museum 1515. (The Art Archive/Archaeological Museum Sofia/Dagli Orti (A).)

was excavated with red-figure pottery, which no one has ever suggested is anything other than imported Athenian ware; it weighs 428 grams (1 Attic mina); and its iconography – *apobatai,* warriors who mount and dismount from chariots during a race – is manifestly Athenian: it even appears on the Parthenon frieze and Panathenaic prize amphoras.

Prevalent interpretations of Greek art, perhaps derived from Platonic notions of ideal forms, allow little tolerance for vibrant color or rich surface effects, although these are as evident in Late Archaic marbles and Late Classical ceramics as in other, less copiously preserved media. We have ascribed restrained and rational principles of organization to Greeks

across the board. Precious objects recovered abroad or comprised of imported – literally exotic – materials have been perceived and denigrated as the products of aberrant, foreign, even "Oriental" sensibilities, with all the essentialist baggage of such terms, despite the fact that the Greeks looked to other ancient civilizations not just for materials and markets, but also for cultural models.[43] The vast majority of pre-Hellenistic Greek gems, for example, are scarabs or scaraboid, but their backs, or rather tops, are seldom illustrated, and some of their beetles have actually been cut away.[44] Copious ancient evidence makes it clear that the Greeks produced and enjoyed such objects and admired complex polychromatic compositions, which are still discernible in the surviving painted decoration of the Acropolis korai[45] and on an elaborate painted and gilded marble throne from the Tomb of Eurydike at Vergina,[46] as well as in fanciful objects such as the Shield of Achilles (described at length in *Iliad* 18.478–607). That many surviving examples of Greek luxury arts not only were recovered abroad, but also date to the Hellenistic period – a period long considered "decadent" or "degenerate"[47] – may be another reason for their having been dismissed as evidence for *echt* Greek sensibilities.

So far in this brief survey we have seen how post-antique classifications of media and anachronistic notions of good taste, some of which carry political and racist undertones, have contributed to the marginalization of ancient Greek sumptuous arts. Ironically, the major monuments of our traditional art histories focus explicitly on them. The Parthenon frieze, whatever it represents, depicts men and women carrying musical instruments, metal vessels, ritual implements, and fine furniture, and it culminates in the folding of a (presumably elaborate) textile, all of which are mentioned in the inscribed inventories of the temple.[48] The famous grave stele of Hegeso[49] presents a scene repeated on numerous funeral monuments: the well-dressed daughter of Proxenos, seated on a finely wrought chair with a footstool, inspects an item of jewelry brought to her by an attendant. Two examples of the terracotta votive plaques from Locri, which have lost most of their polychromatic decoration, illustrate the importance of textiles and plate as well as the sophistication of lost work in wood and ivory (Figs. 3, 4).[50] While metal vessels dominate one composition, the other features a woman who stands before an ornate chair

Fig. 3. Terracotta votive plaque from Locri, 470–450 B.C. Museo Nazionale di Reggio Calabria (after Quagliati, *Ausonia* 3 [1908] 197, fig. 47).

and places a folded cloth in an elaborate chest adorned with inset figural panels depicting Athena striking down Pallas (or Enkelados) and a youth grasping the wrist of a maiden. Such scenes, which seem to have served as exempla for women, are actually preserved in furniture appliqués, for example, the so-called Morgan Ivory in New York.[51] Like the lost Chest of Kypselos, described at length by Pausanias (5.17.5–19.10), these objects, and those represented on literally thousands of other artifacts, populated the ancient "city of images" no less than black- and red-figure pots. And as we have seen, they served to convey social, religious, and political messages – through their materials as well as their decoration, for the iconography of the precious communicated wealth, power, prestige, and piety in the home and the city, in the cemetery and the sanctuary.[52]

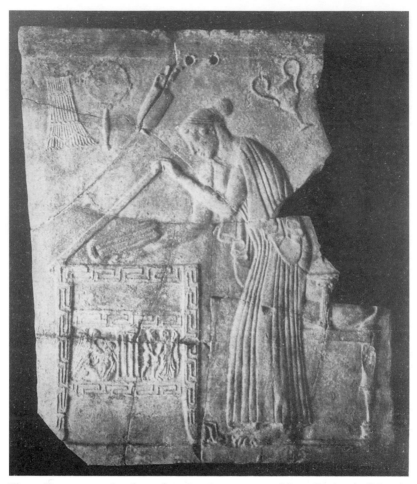

**Fig. 4.** Terracotta votive plaque from Locri, 470–450 B.C. Museo Nazionale di Reggio Calabria (after Quagliati, *Ausonia* 3 [1908] 215, fig. 63).

Perhaps the most significant reason for the absence of Greek sumptuous arts from our histories of art is their presumed inadequacy to the task of tracing the evolution of the naturalistic depiction of the human figure, the interpretative framework that continues to dominate the study of Greek art, although it is not employed in the analysis of the art of many other cultures. Stylistic development towards greater "realism," a topic of interest to ancient writers (as well as to early moderns, including Vasari and Winckelmann), is easily delineated through hundreds of

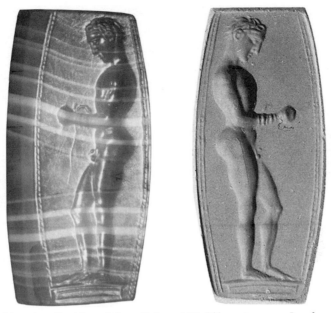

Fig. 5. (a) Agate sliced barrel from Epirus. Mid-fifth century B.C. London, British Museum 92.7–21.1. (Copyright The British Museum). (b) Impression from agate sliced barrel from Epirus (Fig. 5a). Mid-fifth century B.C. London, British Museum 92.7–21.1. (Copyright The British Museum.)

preserved marbles (Roman interleaved with Greek) and thousands of painted pots. The potential of pottery, hardly mentioned by ancient literary sources, to "indicat[e] the successful progress of Painting and design" was praised by the self-styled Baron d'Hancarville, who sought to increase the value of Sir William Hamilton's collection.[53] The canonical styles of Greek art, however, also evolved and can be traced across a variety of media. Repoussé diadems recovered from tombs in the Kerameikos cemetery are no less Geometric than "Dipylon" amphorae; Rhodian gold plaques depicting the *potnia theron*, the Mistress of the Animals, are as Orientalizing as the "Lady of Auxerre"; and a fifth-century B.C. agate intaglio depicting a youth in a contrapposto stance (Fig. 5) demonstrates the much vaunted "advances" in mimesis evident in Greek statues.[54] Although some scholars might be eager to determine which of the arts was the "leader" and which the "follower," most ancients, to judge from the available evidence, would have been more concerned with the effect

of the objects themselves and the connotations of their media in diverse contexts.

Fashion in antiquity, unlike today, was established at the top of society and trickled down, not up, through emulation and imitation. Though always a point of contention, and sometimes restricted through sumptuary legislation, luxury (*tryphe*) was celebrated and employed as a form of self-definition, as well as attacked, as the poems of Sappho, Alkaios, and Anakreon, not to mention the grave stele of a woman named Tryphe, carved in the second century B.C. (Fig. 6), demonstrate.[55]

The Greeks did not live in an exclusively red, black, or white world. Their architecture and sculpture were brightly painted, gilded, and even inlaid. Sanctuaries and the homes of elites who set the standards for other members of society contained vessels and jewelry of precious metals, polychromed ivories, opulent furniture, rich textiles, and other artifacts of distinction, objects not merely decorative, but politically, socially, and religiously potent. Excavations have recovered many such objects (and others never went under ground). The sumptuous arts, however, have paradoxically been accorded less, rather than more attention since the advent of scientific archaeology. The art histories of Junius and Winckelmann, although they followed the Vasarian tradition of privileging Painting, Sculpture, and Architecture, were still attuned to what we might call the visual culture of the Greeks, for neither treatment was conceived visually, and both relied heavily on the diversity of objects mentioned in ancient texts. For us, however, the Vasarian and Academic model has taken firm hold. Primed to believe that Painting, Sculpture, and Architecture are the only "true arts," and concerned with tracing the development of style and collecting evidence for "daily life" in a "democratic" society, we are willing to be misled by the disproportionately high rate of survival of ceramics and stone, try as we might to remind ourselves and our students otherwise. The products of ancient marble carvers and pot painters, fine as they are, are hardly representative of ancient art, and certainly not characteristic of what the Greeks themselves valued most in their material culture.

We might not be able to recover the most remarkable creations of Greek civilization, or even to define adequately the criteria by which such

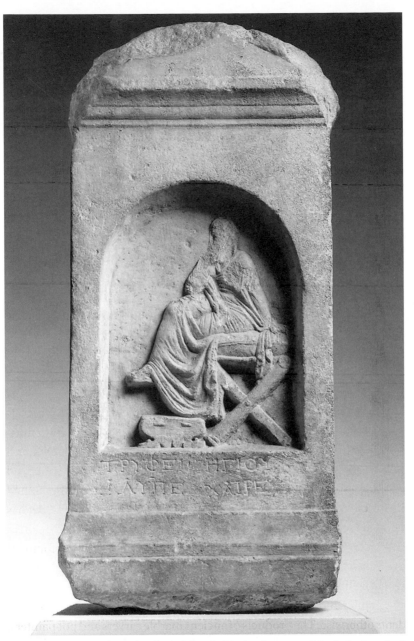

**Fig. 6.** Gravestone of Tryphe from Seleucia Pieria, the port of Antioch, inscribed ΤΡΥΦΕΙ ΗΓΙΟΥ / ΑΛΥΠΕ ΧΑΙΡΕ (Tryphe, [wife, or daughter] of Egias/Farewell, you [who are now] without pain). Second century B.C. The Art Museum, Princeton University, y1992-48. Gift of the Committee for the Excavation of Antioch to Princeton University. (Photo: Bruce M. White.)

Kenneth Lapatin

artifacts were judged by the ancients, but to ignore the physical and literary evidence for the appearance, technique, functions, and reception of the items made from precious materials, quite simply, is to impoverish the past. It is time that we move beyond anachronistic and reductive art histories and make room, as the Greeks themselves did, for the sumptuous arts.

NOTES

1. E.g., A. A. Donohue, "Winckelmann's History of Art and Polyclitus," in W. G. Moon, ed., *Polykleitos, the Doryphoros, and Tradition* (Madison, 1995) 327–353; J. J. Pollitt, *The Ancient View of Greek Art: Criticism, History, and Terminology* (New Haven, 1974). I am grateful to the editors of this volume and to Marina Belozerskaya for comments on earlier versions of this paper. Unless otherwise noted, all translations are my own.

2. E.g., F. Junius, *Catalogus Architectorum, Mechanicorum sed praecipue Pictorum, Statuariorum, Caelatorum, Tornatorum, aliorumque Artificum* (Rotterdam, 1694, ed. and trans. K. Aldrich, P. Fehl, and R. Fehl as *Franciscus Junius, The Literature of Classical Art* II. *A Lexicon of Artists and Their Works*; Berkeley, Los Angeles, and London, 1991); and J. Overbeck, *Die antiken Schriftquellen zur Geschichte der bildenden Künste bei den Griechen* (Leipzig, 1866; repr. Hildesheim, 1959).

3. See, e.g., K. D. S. Lapatin, *Chryselephantine Statuary in the Ancient Mediterranean World* (Oxford, 2001) passim, esp. 15–16, 61–95; and for Pheidias's career and fortune Overbeck, *Schriftquellen* (supra n. 2) nos. 618–807; E.B Harrison, "Pheidias" in O. Palagia and J. J. Pollitt, eds., *Personal Styles in Greek Sculpture* (*Yale Classical Studies* 30; Cambridge, 1996) 16–65; and C. Höcker and L. Schneider, *Phidias* (Hamburg, 1993).

4. 5.86: πέπλον μὲν γὰρ ἕεστο φαεινότερον πυρὸς αὐγῆς; 5.174-175: κάλλος δὲ παρειάων ἀπέλαμπεν / ἄμβροτον. Trans. adapted from A. N. Athanassakis, *The Homeric Hymns* (Baltimore, 1976).

5. See, e.g., H. L. Lorimer, "Gold and Ivory in Greek Mythology," in *Greek Poetry and Life (Essays Presented to Gilbert Murray on his 70th Birthday)* (Oxford, 1936) 14–33; L. Kurke, *Coins, Bodies, Games, and Gold: The Politics of Meaning in Ancient Greece* (Princeton, 1999) passim, esp. 10–14, 41–64.

6. Frag. 209 (Bowra): Διὸς παῖς ὁ χρυσός· / κεῖνον οὐ σὴς οὐδὲ κίς, / δάπτει <δὲ> βροτέαν φρένα κάρτι- / στον κτεάνων; cf. *Ol.* 1.1–2.

7. For precious objects in temple inventories see S. A. Aleshire, *The Athenian Asklepieion: The People, Their Dedications, and the Inventories* (Amsterdam, 1989); D. Harris, *Treasures of the Parthenon and Erechtheion* (Oxford, 1995); R. Hamilton, *Treasure Map: A Guide to the Delian Inventories* (Ann Arbor, 2000). For additional contexts see M. Vickers and D. Gill, *Artful Crafts: Ancient Greek Silverware and Pottery* (Oxford, 1994), esp. 33–76; A. Despini, *Greek Art: Ancient Gold Jewelry* (Athens, 1996) 25–45; M. Vickers, *Images on Textiles: The Weave of*

84

*Fifth-Century Athenian Art and Society* (*Xenia. Konstanzer althistorische Vorträge und Forschungen* 42; Konstanz, 1999); and D. Plantzos, *Hellenistic Engraved Gems* (Oxford, 1999), esp. 109–112.

8.  Ovid, *Met.* 10.243–297; Pliny, *NH* 28.34; *Od.* 18.186: λευκοτέην δ' ἄρα μιν θῆκε πριστοῦ ἐλέφαντος.

9.  The phrase is from the dedication of Mantiklos to Apollo: Museum of Fine Arts, Boston, inv. no. 03.997: Μαντικλος μ'ανεϑ̄εκε ϝεκαβολο͂ι αργυροτοχσο͂ι| τας {δ} δεκατας · τυ δε Φοίβε διδοι χαριϝετταν αμοιϝ[αν]. Transcription from: J. Boardman, *Greek Sculpture: The Archaic Period* (London, 1978) fig. 10.

10. 5.12.3: φιλότιμοι δὲ ἐς τὰ μάλιστά μοι καὶ ἐς θεῶν τιμὴν οὐ φειδωλοὶ χρημάτων γενέσθαι δοκοῦσιν οἱ Ἕλληνες, οἷς γε παρὰ Ἰνδῶν ἤγετο καὶ ἐξ Αἰθιοπίας ἐλέφας ἐς ποίησιν ἀγαλμάτων.

11. *NH* 8.31: *dentibus ingens pretium et deorum simulacris lautissima ex his materia.* Trans. H. Rackham (Cambridge, Mass., 1953).

12. Diodorus Siculus 16.57.2.

13. Pliny, *NH* 37 passim; G. F. Kunz, *The Curious Lore of Precious Stones* (New York, 1913; repr. 1971); S. Eitrem, "Die magischen Gemmen und ihre Weihe," *Symbolae Osloenses* 19 (1939) 57–85; A. Delatte and P. Derchain, *Les intailles magiques gréco-égyptiennes* (Paris, 1964); M. Smith, "Relations between Magical Papyri and Magical Gems," *Papyrologica Bruxellensia* 18 (1979) 129–136; Plantzos, *Hellenistic Engraved Gems* (supra n. 7) 109–112; C. A. Faraone, *Ancient Greek Love Magic* (Cambridge, Mass., 1999) passim.

14. P. Zazoff and H. Zazoff, *Gemmensammler und Gemmenforscher: Von einer noblen Passion zur Wissenschaft* (Munich, 1983); see also infra n. 39.

15. Herodotus 1.164: κατασπάσαντες τὰς πεντηκοντέρους, ἐσθέμενοι τέκνα καὶ γυναῖκας καὶ ἔπιπλα πάντα, πρὸς δὲ καὶ τὰ ἀγάλματα τά ἐκ τῶν ἱρῶν καὶ τὰ ἄλλα ἀναθήματα, χωρὶς ὅ τι χαλκὸς ἢ λίθος ἢ γραφὴ ἦν, τὰ δὲ ἄλλα πάντα ἐσθέντες καὶ αὐτοὶ ἐσβάντες ἔπλεον ἐπὶ Χίου.

16. See, e.g., R. G. Tansey and and F. S. Kleiner, *Gardner's Art through the Ages* (10th ed.; Fort Worth, 1996); H. Honour and J. Fleming, *The Visual Arts: A History* (4th ed.; Upper Saddle River, N.J., 1995); M. Stokstad, *Art History* (New York, 1995); E. H. Gombrich, *The Story of Art* (14th ed.; Oxford, 1984); H. W. Janson, *A History of Art* (3rd ed.; London, 1982).

17. Cf. the corresponding chapters in the texts cited in the previous note.

18. Cf., e.g., J. Boardman, *Greek Gems and Finger Rings* (London, 1970) and Plantzos, *Hellenistic Engraved Gems* (supra n. 7) with C. C. Mattusch, *Greek Bronze Statuary* (Ithaca, 1988); C. Rolley, *Greek Bronzes*, trans. R. Howell (London and New York, 1986); and A. Stewart, *Greek Sculpture: An Exploration* (New Haven, 1990) I, 315–316: Appendix 1, "Extant Greek Bronze Statues."

19. For the reevaluation of Roman "copies" see, e.g., M. Marvin, "Copying in Roman Sculpture: The Replica Series," in *Retaining the Original: Multiple Originals, Copies, and Reproductions* (*Studies in the History of Art* 20; Washington, D.C., 1989) 29–45; eadem, "Roman Sculptural Reproductions or Polykleitos: The Sequel," in A. Hughes and E. Ranfft, eds., *Sculpture and Its Reproductions* (London, 1997) 7–28, 168–173; C. C. Mattusch, *Classical Bronzes: The Art and*

*Craft of Greek and Roman Statuary* (Ithaca, 1996); B. S. Ridgway, *Roman Copies of Greek Sculpture: The Problem of the Originals* (*Jerome Lectures* 15; Ann Arbor, 1984).

20. Book 37, apart from a single chapter (8), is omitted by K. Jex-Blake and E. Sellers, *The Elder Pliny's Chapters on the History of Art* (London, 1896; repr. Chicago, 1967) as are most of Books 34 and 36 – yet for the coherence of Pliny's design and ideology, see J. Isager, *Pliny on Art and Society* (Odense, 1991; repr. 1998); and S. Carey, "The Problem of Totality: Collecting Greek Art, Wonders and Luxury in Pliny the Elder's Natural History," *Journal of the History of Collections* 12 (2000) 1–13. More recently than Jex-Blake and Sellers, J. J. Pollitt has devoted six chapters (totalling more than 100 pages) of his sourcebook, *The Art of Ancient Greece* (2nd ed.; Cambridge, 1990) to sculpture, three to painting (more than 50 pages), and one to architecture (25 pages); "The decorative arts," in contrast, are treated in a single chapter of 15 pages, one-third of which are given over to the Chest of Kypselos.

21. Samos Museum E88: D. Ohly, "Zur Rekonstruktion des samischen Geräts mit dem Elfenbeinjüngling," *Mitteilungen des Deutschen Archäologischen Instituts, Athenische Abteilung* 74 (1959) 48–56; Boardman, *Archaic* (supra n. 9) fig. 54.

22. Sofia Archaeological Museum inv. no. 4013: L. Casson et al., *Thracian Treasures from Bulgaria* (New York, 1977) 28.

23. Delphi Museum: P. Amandry, "Statue de taureau en argent," *Études delphiques* (*Bulletin de correspondance hellénique* Suppl. 4; 1977) 274–293.

24. See, e.g., Athens, National Museum inv. no. 39, a stele from Orchomenos inscribed "Alxenor of Naxos made this: just look" (Ἀλχσηνο̄ρ εποιησεν ho Ναχσιος · αλλ' εσιδε[σϑε]): Boardman, *Archaic* (supra n. 9) fig. 244; cf. infra n. 34.

25. See supra n. 9.

26. *Il.* 1.37–41: κλῦθί μευ, ἀργυρότοξ' … | … εἴ ποτέ τοι χαρίεντ' ἐπὶ νηὸν ἔρεψα, | ἢ εἰ δή ποτέ τοι κατὰ πίονα μηρί' ἔκηα | ταύρων ἠδ' αἰγῶν, τόδε μοι κρήηνον ἐέλδωρ. Trans. R. Fagles (New York, 1990).

27. See, e.g., C. Ampolo, "Il lusso funerario e la città arcaica," *AION* 6 (1984) 71–102; R. Garland, "The Well-Ordered Corpse: An Investigation into the Motives behind Greek Funerary Legislation," *Bulletin of the Institute of Classical Studies* 36 (1989) 1–15; I. Morris, "Law, Culture and Funerary Art in Athens, 600–300 B.C.," *Hephaistos* 11/12 (1992/93) 35–50; M. Toher, "Greek Funerary Legislation and the Two Spartan Funerals," in M. A. Flower and M. Toher, eds., *Georgica: Studies in Honour of George Cawkwell* (*Bulletin of the Institute of Classical Studies* Suppl. 58; 1991) 159–175; R. Seaford, *Reciprocity and Ritual* (Oxford, 1994) 74–87; A. Hunt, *The Governance of Consuming Passions: A History of Sumptuary Law* (New York, 1996) esp. 18–19.

28. D. Strong, *Greek and Roman Gold and Silver Plate* (Ithaca, 1966); A. Oliver, *Silver for the Gods: 800 Years of Greek and Roman Silver* (Toledo, 1977); Vickers and Gill, *Artful Crafts* (supra n. 7). The artistic priority or influence of one medium over or on another remains controversial, but references to plate in ancient texts leave no doubt of its social predominance.

29. Thucydides 6.46: καὶ ἰδίᾳ ξενίσεις ποιούμενοι τῶν τριηριτῶν τά τε ἐξ αὐτῆς Ἐγέστης ἐκπώματα καὶ χρυσᾶ καὶ ἀργυρᾶ ξυλλέξαντες καὶ τά ἐκ τῶν ἐγγὺς πόλεων καὶ Φοινικικῶν καὶ Ἑλληνίδων αἰτησάμενοι ἐσέφερον ἐς τὰς ἑστιάσεις ὡς οἰκεῖα ἕκαστοι. καὶ πάντων ὡς ἐπὶ τὸ πολὺ τοῖς αὐτοῖς χρω-μένων καὶ πανταχοῦ πολλῶν φαινομένων μεγάλην τὴν ἔκπληξιν τοῖς ἐκ τῶν τριήρων Ἀθηναίοις παρεῖχε, καὶ ἀφικόμενοι ἐς τὰς Ἀθήνας διεθρόησαν ὡς χρήματα πολλὰ ἴδοιεν. Trans. adapted from R. Warner, *History of the Peloponnesian War* (Harmondsworth, 1954).

30. M. Collareta, "L'historien et la technique. Sur le rôle de l'orfèvrerie dans les *Vite de Vasari*," in E. Pommier, ed., *Histoire de l'historie de l'art. Cycle de conférences organisé au musée du Louvre par le Service culturel* I (Paris, 1995) 165–176; see also P. Rubin, *Giorgio Vasari: Art and History* (New Haven, 1995). Vasari significantly altered his title from *Le Vite de più eccellenti Architetti, Pittori, et Scultori* in 1550 to . . . *Pittori, Scultori, e Architettori* in 1568.

31. Junius, *Catalogus* (supra n. 2); J. J. Winckelmann, *Description des pierres gravées du feu Baron de Stosch dediée à son Eminence Monseigneur le Cardinal Aléxandre Albani par M. l'Abbé Winckelmann Bibliothecaire de son Eminence* (Florence, 1760), esp. ix–x: "car on trouve dans une bien plus grand étendue les dégrés de l'art dans une Collection de Pierres gravées, comme celle-ci, qu'on ne peut les remarquer dans les Monuments plus grands qui nous sont restés. . . . L'Art chez les Grecs se trouve également ici dès son origine, & on le suit pas à pas dans son accroissement jusqu'au sublime où il s'éleva, & semblables époques de l'Art ne sauroient se fixer sur les Marbres, aussi bien qu'on les trouve ici sur les pierres gravées & pâtes de verre" (because the stages of art are found to a much greater extent in a collection of engraved gems like this one than can be discerned in the larger monuments that are left to us. . . . Among the Greeks, art is present here in like measure from its very beginnings and can be followed bit by bit in its growth up to the sublime level to which it rose; and comparable periods of art cannot be determined as well on the basis of the marbles as they can be through the engraved stones and glass pastes); see also idem, *Geschichte der Kunst des Alterthums* (Dresden, 1764). See also W. Leppmann, *Winckelmann* (New York, 1970) 193.

32. G. de La Chau and G. M. le Blond, *Description des principales pierres gravées du cabinet de S. A. S. Monseigneur le Duc d'Orléans* . . . (Paris, 1780) 1; cf. the "Explication" of this "Vignette" on page d1[recto]; see also Zazoff and Zazoff, *Gemmensammler und Gemmenforscher* (supra n. 14) esp. 145–146.

33. Academic theory, however, often fails to have a direct impact on the practice of collectors, dealers, and the interests of curators and the museum-going public. Ancient gold work, for example, has long attracted popular audiences through dramatic, blockbuster exhibitions and lavishly illustrated catalogues, the most recent sponsored by great jewelry merchants such as Cartier and the old Boston firm Shreve, Crump, and Low: see D. Williams and J. Ogden, *Greek Gold: Jewelry of the Classical World* (London and New York, 1994); I. Marazov, ed., *Ancient Gold: Wealth of the Thracians* (New York, 1998); and E. Reeder, ed., *Scythian Gold: Treasures from the Ancient Ukraine* (New York, 1999).

34. Although known to collectors much earlier, ancient pots became symbols of status only in the mid-eighteenth century, when Greek wares were recognized in Italy (by Winckelmann, among others); see, e.g., R. M. Cook, *Greek Painted Pottery* (3rd ed.; London, 1997) esp. 276–280. This shift is evident in Pompeo Battoni's 1767 portrait of the Grand Tourist Prince Karl Wilhelm Ferdinand, later Duke of Brauschweig and Lüneburg, who, apparently under the direction of Winckelmann, posed with pots as props, rather than with the more customary Roman architecture or sculpture: see A. Wilton and I. Bignamini, eds., *Grand Tour: The Lure of Italy in the Eighteenth Century* (London, 1996) 81–82, no. 39; see also I. Jenkins and K. Sloan, eds., *Vases and Volcanoes: Sir William Hamilton and His Collections* (London, 1996), esp. 40–64 and 139–159; and, for the history of scholarship of Greek pottery in general, Cook, 275–311; D. von Bothmer, "Greek Vase-painting: Two Hundred Years of Connoisseurship," in M. True, ed., *Papers on the Amasis Painter and His World* (Malibu, 1987) 184–204; Vickers and Gill, *Artful Crafts* (supra n. 7), esp. ch. 1; and B. A. Sparkes, *The Red and Black: Studies in Greek Pottery* (London, 1996), esp. ch. 2. For the widespread misunderstanding resulting from the tendentious conflation of and inattention to the inscriptions on the two sides of Euthymides' famous amphora from Vulci, now in Munich (Antikensammlungen 2307 [J.378], acquired in 1841), see Vickers and Gill, 97–98 with bibliography, esp. n. 153.

35. J. J. Winckelmann, *Gedanken ueber die Nachahmung der griechischen Werke in der Malerei und Bildhauerkunst* (Dresden, 1755; bilingual ed., trans. E. Heyer and R. C. Norton as *Reflections on the Imitation of Greek Works in Painting and Sculpture,* La Salle, 1987) 2–3: "Der gute Geschmack, welcher sich mehr und mehr durch die Welt ausbreitet, hat sich angefangen zuerst unter dem griechischen Himmel zu bilden." ("Good taste, which is becoming more prevalent throughout the world, had its origins under the skies of Greece.")

36. Vickers and Gill, *Artful Crafts* (supra n. 7) 1–32; see also supra n. 34.

37. A. Bluhm et al., *The Colour of Sculpture, 1840–1910* (Zwolle, 1996); D. Van Zanten, *The Architectural Polychromy of the 1830's* (New York, 1977).

38. The expression "*L'art pour l'art*" was apparently coined by early nineteenth-century French philosophers (e.g., Benjamin Constant, *Journal intime,* 11 February 1804; Victor Cousin, *Du vrai, du beau, et du bien* [lecture delivered at the Sorbonne, 1818]) and seems to have become so popular that by 1872 George Sand considered it "an empty phrase" (letter to Alexandre Saint-Jean); half a century later the Latin motto *Ars gratia artis* was concocted for Metro-Goldwyn-Mayer film studios by the American songwriter Howard Dietz, who apparently intended to communicate the idea that "art is beholden to the artists"; see E. Knowles, ed., *The Oxford Dictionary of Quotations* (5th ed.; Oxford, 1999) 235, 238, 267, and 643. For John Ruskin's ideas, see *Seven Lamps of Architecture* II [*Lamp of Truth*] (London, 1949). Adolf Loos, *Ornament und Verbrechen* (trans. M. Mitchell in *Ornament and Crime: Selected Essays* [Riverside, 1997] 167–176) is certainly relevant here, as, perhaps, is Shakespeare's dictum (*Merchant of Venice,* Act III, Sc. 2): "The world is still deceived with ornament." Often attributed to

Ludwig Mies van der Rohe, "less is more" is a proverb attested as early as the mid-nineteenth century; see Knowles, 605.

39.  See, e.g., P. Tournikiotis, ed., *The Parthenon and Its Impact in Modern Times* (Athens, 1994); R. Jenkyns, *The Victorians and Ancient Greece* (Cambridge, Mass., 1980) passim, esp. 145–154 for whiteness and 298–330 for the reception of fifth-century B.C. Athenian monuments. The success of Wedgwood's imitations of ancient ceramics and the production of forgeries are also reliable indices of taste: for a fake fragment of (or after) the Parthenon frieze acquired by the British Museum in 1889, see B. Ashmole, *Forgeries of Ancient Sculpture in Marble: Creation and Detection* (Oxford, 1961). The widespread forgery of gems in the eighteenth century, incidentally, not only indicates a thriving market for ancient intaglios (see J. Rudoe, "The Faking of Gems in the Eighteenth Century," in M. Jones, ed., *Why Fakes Matter: Essays on the Problems of Authenticity* [London, 1992] 23–31), but, once recognized, may have offered additional motivation for their eventual removal from the art-historical canon.

40.  C. A. Lawton, *Attic Document Reliefs* (Oxford, 1995) 30–34; see also Harris, *Treasures of the Parthenon and Erechtheion* (supra n. 7) 104–105, 230–232; and 238 for dedications of wreaths sent to Athena from members of the second Athenian confederacy (378–338 B.C.) For the ancient origins of modern biases against luxury see, e.g., L. Kurke, "The Politics of ἁβροσύνη in Archaic Greece," *Classical Antiquity* 11 (1992) 90–121.

41.  Plovdiv, Archaeological Museum, inv. no. 1515: B. D. Filow, *Die Grabhügelnekropole bei Duvanlij in Südbulgarien* (Sofia, 1934) 63–65, no. 2, pl. IV; Strong, *Greek and Roman Gold and Silver Plate* (supra n. 28) 74–75, 80, pl. 15 B; I. Venedikov and T. Gerassimov, *Thracian Art Treasures* (London, 1975) 362, pls. 170–172; D. Musti et al., *L'Oro dei Greci* (Novara, 1992) 170, 266, no. 136; Vickers and Gill, *Artful Crafts* (supra n. 7) 40–41, 131–135, figs. 2.2, 5.22–23; I. Marazov, ed., *Ancient Gold* (supra n. 33) 138–139 no. 64.

42.  D. Williams, "Refiguring Attic Red-figure," *Revue archéologique* 1996.2: 227–252, quote 236.

43.  See, e.g., M. C. Miller, *Athens and Persia in the Fifth Century BC: A Study in Cultural Receptivity* (Cambridge, 1997) for the Classical period; see also E. W. Said, *Orientalism* (New York, 1978; repr. 1994). In a particularly telling nationalist twist of racist interpretations of ancient art, Greek works in gold and silver found within the borders of countries recently freed from the Soviet bloc are now shipped abroad and presented to the world as ancient Bulgarian or Ukrainian artifacts; see supra n. 33.

44.  See, e.g., Boardman, *Greek Gems and Finger Rings* (supra n. 18); idem, *Archaic Greek Gems* (Evanston, 1968) passim, esp. 55 and pl. XL.

45.  See, e.g., V. Manzelli, *La Policromia nella Statuaria Greca Arcaica* (*Studia Archaeologica* 69; Rome, 1994); G. M. A. Richter, *Korai: Archaic Greek Maidens* (London, 1970) esp. 14–15; P. Reuterswärd, *Studien zur Polychromie der Plastik, Griechenland und Rom* (Stockholm, 1960).

46.  R. Ginouvès, ed., *Macedonia from Philip II to the Roman Conquest* (Princeton, 1994) 154–161, figs. 135–137. This splendid object, discovered in 1987, was

vandalized sometime between August 13 and September 9, 2001, when looters hacked away six marble figurines. A report on the theft appeared in *E Kathimerini*, September 12, 2001.

47. See, e.g., Winckelmann, *Geschichte* (supra n. 31) with the commentary of Donohue (supra n. 1), esp. 331–332, 335; and the apologia of R. B. Richardson, *A History of Greek Sculpture* (New York, 1911) 247.

48. Harris, *Treasures of the Parthenon and Erechtheion* (supra n. 7) passim. For the frieze itself see, e.g., I. Jenkins, *The Parthenon Frieze* (London and Austin, 1994); and, most recently, J. Neils, *The Parthenon Frieze* (Cambridge, 2001).

49. Athens, National Archaeological Museum inv. no. 3624: S. Karouzou, *National Archaeological Museum: Collection of Sculpture. A Catalogue* (Athens, 1968) 77–78, pl. 32; Stewart, *Greek Sculpture* (supra n. 18) pl. 477.

50. Reggio Calabria, National Museum: Q. Quagliati, "Rilievi votivi arcaici in terracotta di Lokri Epizephyrioi," *Ausonia: Rivista della Società Italiana di Archeologia e Storia dell'Arte* 3 (1908 [1909]) 136–234, 196–200, esp. fig. 47, 215–216, fig. 63; G. M. A. Richter, *The Furniture of the Greeks, Etruscans and Romans* (London, 1966) figs. 604, 386.

51. Metropolitan Museum of Art 17.190.73: G. M. A. Richter, *The Metropolitan Museum of Art: Handbook of the Greek Collection* (Cambridge, Mass., 1953) 31–32; J. Mertens, *The Metropolitan Museum of Art: Greece and Rome* (New York, 1987) 26.

52. C. Bérard et al., *A City of Images: Iconography and Society in Ancient Greece*, trans. D. Lyons (Princeton, 1989) is one of many recent iconological studies that profitably explores how and what ancient imagery communicated to its viewers; its authors, however, focus exclusively on pottery. For other decorated objects that might also be investigated along similar lines see, e.g., Richter, *Furniture* (supra n. 50); R. Meiggs, *Trees and Timber in the Ancient Mediterranean World* (Oxford, 1982), ch. 10, 279–299; Vickers, *Images on Textiles* (supra n. 7). For the social meanings of sumptuous artifacts see, e.g., the discussions of sumptuary legislation, supra n. 27; Kurke (supra n. 40); Miller (supra n. 43); cf. A. Cutler, "Uses of Luxury: On the Functions of Consumption and Symbolic Capital in Byzantine Culture," in A. Guillou and J. Durand, eds., *Byzance et les images. Cycle de conférences organisé au musée du Louvre par le Service culturel du 5 octobre à 7 décembre 1992* (Paris, 1994) 287–327.

53. P. F. Hugues d' Hancarville, *Antiquités étrusques, grecques et romaines, Tirées du Cabinet de M. William Hamilton, Envoyé extraordinaire et plénipoteniare de S. M. Britannique en Cour de Naples* (4 vols.; Naples, 1766–1767 [1767–1776]) I, 168: "We shall shew hereafter other paintings which will fill up the spaces between these three times [the infancy, perfection, and the sublime], not only among the Greeks, but also among the Etruscans and the Romans, for such is the value of the singular Collection which we present to the Public, that of all the Collections that can possibly be made either of Marbles, Bronzes, Medals or engraved Stones, this alone is capable of indicating the successive progress of Painting and design; and as in a Gallery of Pictures one endeavors to unite those of the Masters from Ghiotto [sic] and Cimabue down to our time, so in this Collection

one may see the stiles [*sic*] of the different of the Arts of the Ancients; it is not then without reason that we have said that this Collection is equally proper for the compleating [*sic*] of well understood Collections of Prints and designs, or to furnish in a manner not only agreeable but usefull [*sic*] and instructiwe [*sic*], the Cabinet of a Man of Taste and letters, since by it's [*sic*] assistance he may see as a kind of Geographical Chart the whole progress, and as one may say, count every step of human industry in the most agreeable art it has invented." See also I. Jenkins, " 'Contemporary Minds': Sir William Hamilton's Affair with Antiquity," and "D'Hancarville's 'Exhibition' of Hamilton's Vases," in Jenkins and Sloan, eds., *Vases and Volcanoes* (supra n. 34) 40–64, 149–155; F. Haskell, "The Baron d'Hancarville, an adventurer and art historian in eighteenth-century Europe," in E. Chaney and N. Ritchie, eds., *Oxford, China and Italy: Writings in Honour of Sir Harold Acton* (London, 1984) 177–191; repr. in F. Haskell, *Past and Present in Art and Taste. Selected Essays* (New Haven, 1987) 30–45; P. Griener, *Le antichità etrusche greche e romane 1766–1776 di Pierre Hugues d'Hancarville. La pubblicazione delle ceramiche antiche della prima collezione Hamilton* (Rome, 1992); and Vickers and Gill, *Artful Crafts* (supra n. 7), esp. 6–16. Of course, it was not until the twentieth century that the enormous corpus of Athenian ceramics was heroically classified by Sir John Beazley, who also provided numerous anonymous craftsmen with names and thus, significantly, expanded the potential for biography in the Vasarian mode. Although best known for his work on pots, he also wrote a catalogue of gems: J. D. Beazley, *The Lewes House Gems* (Oxford, 1920). See also the essays in D. C. Kurtz, ed., *Beazley in Oxford* (Oxford, 1985); M. Robertson, "Adopting an Approach I," in T. Rasmussen and N. Spivey, eds., *Looking at Greek Vases* (Cambridge, 1991) 1–12; J. Whitley, "Beazley as Theorist," *Antiquity* 71.271 (1997) 40–47; and Mary Beard's essay in this volume.

54.    Diadems: Paris, Louvre, inv. nos. 1291, 475: Musti et al., *L'Oro dei Greci* (supra n. 41) figs. 49, 51; plaques: London, British Museum inv. nos. 1128–30: L. Burn, *The British Museum Book of Greek and Roman Art* (London, 1991) 38–39, fig. 27; gem: London, British Museum inv. no. 92.7–21.1: H. B. Walters, *Catalogue of Engraved Gems and Cameos, Greek, Etruscan and Roman in the British Museum* (London, 1926) no. 562, pl. 10; Boardman, *Greek Gems and Finger Rings* (supra n. 18) 196, 199, 203 (nos. 2 and 5), pl. 516; see also J. Boardman, "Three Greek Gem Masters," *The Burlington Magazine* 111 (no. 799; Oct. 1969) 587–596, esp. 591, figs. 23–24.

55.    See Kurke (supra n. 40) and Miller (supra n. 43) for positive views of luxury. Gravestone: The Art Museum, Princeton University y1992–48: B. S. Ridgway, *Greek Sculpture in the Art Museum, Princeton University* (Princeton, 1994) 34–37 (no. 10); C. Kondoleon, *Antioch: The Lost Ancient City* (Princeton, 2000) 139 (no. 27). Cf. the mosaics that depict the personification of the concept dating from the Roman Imperial period: Kondoleon 76, fig. 9; J. Ch. Balty, "Tryphe," in *Lexicon Iconographicum Mythologiae Classicae* VIII.1 (Zurich, 1997) 96–97.

# "*Der Stil der Nachahmer*": A Brief Historiography of Stylistic Retrospection

## MARK D. FULLERTON

### The Problem of "Retrospection"

Our entire understanding of ancient Greek art is rooted in the concept of stylistic development. Periodization lends structure to historical disciplines, and in the case of Greek painting and sculpture the figural forms found in works of successive periods display a progression that seems to justify a system of stylistic eras. The earliest historical period of the Greek city-states takes its very name – "Geometric" – from the style of its painted ceramics. The story hence is familiar; the styles of the succeeding epochs trace a path from generally abstract approximations of organic form to increasingly realistic renderings, reaching a perfect balance between the real and ideal in the Classical period of the fifth and fourth centuries B.C. Although the situation for Hellenistic and Roman times is far less clear-cut, histories of art seek (and find) within this post-Classical "decline" systems of stylistic succession down to the beginning of Medieval formalism in the later Roman Empire.

This stylistic progression follows a basically organic model of bloom and decay, the significance of which for the modern (and ancient) apperception of Greek art should not be underestimated. It provides for the organization into discrete and comprehensible sub-units of more than a millennium of artistic production. More important, since almost none of the extant works from those eras can be assigned dates on the basis of documentary sources, the system itself is used to place each of its members within a chronological sequence. Perhaps most significant of

all, the location of each stylistic era within this structure plays no small role in our attitudes toward that period. For example, from its privileged place as the stage of "bloom," the Classical era has long been held to be a zenith in the development of Western civilization – a culture worthy of emulation in its entirety, not only in its art. Similarly, the Archaic has often been described as a period of youthful vigor and noble purity, while Hellenistic and Roman times, as we shall see, were thought to have been decadent and imitative.

In recent years the validity of the organic scheme has come into question, despite its general usefulness for arranging Greek art on a broad scale. If applied too rigidly, it fails to admit such clearly present phenomena as generational lag in the development of style, the use of differing styles for different subjects or themes, and regional variation among centers – issues that have been dealt with elsewhere.[1] I am concerned here with a class of monument that threatens to fall outside the organic scheme altogether. I refer to works displaying stylistic features that are clearly characteristic of eras earlier than their time of creation. In the broader study of cultural production all such features are called "archaisms," while scholarship on ancient sculpture has developed a more specific terminology. Works from after 480 B.C. that bear stylistic features of the Archaic period are called "archaistic" or "archaizing." Works from after the time of Alexander that show characteristics of the Classical period are termed "classicizing." In practice, of course, archaizing and classicizing features are most often mixed, not only with one another but also, in Hellenistic and Roman works, with features typical of those later eras. Indeed, it is on the basis of such a mixture of features that scholars traditionally distinguish archaistic works from Archaic or classicizing from Classical.

A second problem comes with the recognition that from time to time, and frequently from the first century B.C. onward, sculptural workshops produced copies of existing statues, including not only those that follow Archaic, Classical, and Hellenistic prototypes but also others that copy archaizing and classicizing works created in the same epoch as the copies themselves. Therefore, a statue assigned a Roman date on the basis of material or carving technique that has, for example, Classical stylistic features could be a copy of a Classical work, could be a creation in

Classical style, or could be a copy of such a creation. Several categories thus emerge: archaizing, classicizing, mixed archaizing-classicizing, and copies of Archaic and Classical, as well as copies of archaizing and classicizing works. Terminology is, obviously, an especially significant issue in the study of these works. To avoid the difficulties of making such distinctions, some scholars refer to all such works as "emulative" or, as I have here, "retrospective," but these terms too can be problematically prescriptive – an issue I shall explore further.

As an illustration of these phenomena, one can look at a statue of Athena found in the Villa of the Papyri at Herculaneum in the eighteenth century (Fig. 1).[2] It is immediately apparent that this statue displays some stylistic inconsistencies. The diagonal accent of the short mantle as well as its simple linear patterns of pleats recalls works from before 480 B.C. (the Archaic period). The positioning of the statue in a flat, striding, striking pose with trailing foot most closely resembles slightly later work from the generation before 450 B.C., such as the famous bronze god from Cape Artemision. Finally, the facial features of the Athena, like the form and drapery patterns of its undergarment (a sleeved chiton with overfold), are characteristic of the era of the Parthenon itself (erected 447–432 B.C.), or even slightly later. Although this piece is invariably called the *archaistic* Athena, as it obviously is, it has Classical features as well. Moreover, while it is surely Roman in date, fragments of a statue of the same type were found on the Acropolis of Athens, and the date of these is a point of disagreement.[3] So while the Herculaneum statue is likely to be a copy, it is not certain whether it is a copy of a Classical archaistic work or of a work of approximately the same date (late first century B.C.) as the copy itself. In the latter case, the type is not only archaistic but to an equal or even greater extent, classicizing.

The Herculaneum Athena is more than a poster child for tortuous terminology; it illustrates as well how such works fail to fit within an organic stylistic development. It lacks the internal stylistic coherence of a kind that such a scheme demands. It displays features patently similar to those found on earlier works and, thus, features that should have been abandoned by sculptors working within a system of sequential, exclusionary styles. Despite efforts to do so, it has proved impossible to arrange works

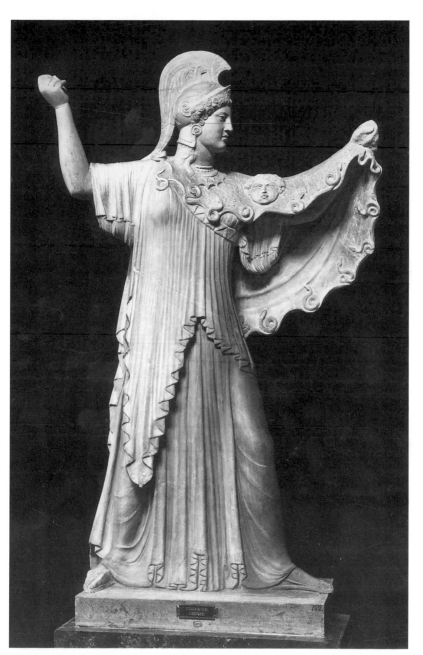

**Fig. 1.** Archaistic Athena from the Villa dei Papiri, Herculaneum. First century B.C. Naples, Museo Nazionale no. 6007. (Copyright Alinari/Art Resource, N.Y.)

such as this into their own stylistic developmental scheme. One might simply say that the statue dates from a late, derivative, "eclectic" stage in the development and thus is entirely outside the system (as in some sense it probably is). However, the Herculaneum Athena still might copy a statue from the fifth century B.C., and in any case it can easily be shown that the use in Greek art of clearly "obsolete" stylistic features occurred at least as early as the Archaic period itself.[4] Whatever the date of this Athena, the phenomenon that we have provisionally termed "stylistic retrospection" threatens by its anomalous existence to subvert the organic system of development that is the very foundation for the study of Greek art. Scholars have dealt with this threat in a variety of ways over the years, either dismissing these "archaizing" works as different and irrelevant or, more interestingly, co-opting them into a supporting role within the scheme. Just how this has been done tells us much about the times and attitudes of the scholars in question.

## Winckelmann and Imitation

More than anyone else, Johann Joachim Winckelmann is responsible for canonizing the sequence of styles in Greek art to which we still adhere today.[5] The system begins from the assumption of a floruit in the Classical period, lasting roughly from the Periklean era to the age of Alexander. This artistic acme, lasting a bit over a century, was further subdivided by Winckelmann into two sequential stylistic phases: the "grand" (ca. 480–400 B.C., what is now called "Early and High Classical") and the "beautiful" (roughly the fourth century B.C., or "Late Classical"). As the organic model demands, the Classical is preceded by an anticipatory stage; his "older" style corresponds to what is now called the Archaic era (650– 480 B.C.). Just as inevitably, following the zenith there must be decline, and the period after Alexander (d. 323 B.C.) fulfills this role. What is illustrative of Winckelmann, indeed of early modern attitudes generally, is that this last phase is characterized as the age of the "Nachahmer" – "imitators."

That we might better understand this characterization, a few general observations on Winckelmann's history are in order. First, what

large-scale material evidence he had for his treatment of Greek sculpture and painting consisted, virtually in its entirety, of Roman works. He drew heavily on the evidence of gems (still difficult to date today) and coins, which provided his basic chronology of forms. However, Greek vases in Winckelmann's day were not recognized as such (they were thought to be Etruscan), and what few works of Greek sculpture there may have been in Rome (or Germany) at the time were not recognized as different from the many Roman pieces. Consequently, his ability to distinguish archaistic works from Archaic or classicizing from Classical was limited at best.[6] His treatment of sculpture from the "older" style, for example, features works like an archaistic Athena in the Albani collection or the archaistic four-gods relief, signed by Kallimachos, in the Capitoline.[7] His sense of style was strong enough that he could recognize that the author of the latter work could not have been the High Classical Athenian sculptor of that name (he considered the signature a later addition), but the difference between a Greek work and a later "imitation" was less clearly defined. On the other hand, he did recognize that later iterations of Archaic style occurred. As an example of a work that appears to be of the older style but is not, he cites the famous archaistic relief of Artemis, Leto, Apollo, and Nike of the so-called Citharoedus type. Yet he recognizes its later date not from its stylistic deviation from Archaic forms but from the Corinthian temple that forms a backdrop for the scene.[8] Given his near total reliance on Roman works to construct his Greek chronology, it is no surprise to find him asserting that there was no Roman art apart from Greek.[9]

As others have clearly demonstrated, in fact, Winckelmann's scheme has little to do with his empirical study of works of art (although that study was intensive and his knowledge of images encyclopedic), but rather it was received by him as a pre-existing construct and used a priori as an organizational system.[10] The roots of his scheme are mutiple. He clearly drew from the analogy of more recent artistic developments, from a formalized Medieval to Renaissance and Baroque art, employing an organic scheme already used by Vasari.[11] He was also intimately familiar with the sequencing of Greek artists found in Pliny's *Natural History* as well as the related schemes to be found in such ancient writers on rhetoric as Cicero, Quintilian, and Dionysius of Halicarnassus. Within these writings, two

not entirely incompatible traditions exalt the era of Perikles (Pheidias) and that of Alexander (Lysippos), and Winckelmann's scheme seems also to recognize two acmes at precisely these same periods.[12]

These schemes must have held further appeal for Winckelmann because of a second major theme in his work: the deterministic relationship between art and history. For Winckelmann, the great accomplishments of the Greeks were a direct result of their liberty, collectively and individually – a sentiment consistent with the growing humanism of the Enlightenment.[13] Another enabling historical condition (not always consonant with the first) is the concentration of resources in the hands of able leadership and the resulting respite from war that makes great artistic commissions possible. The shift from the first condition to the second occurs in the time of Alexander – a shift necessitated by Winckelmann's location of two great eras of artistic accomplishment in very different historical circumstances.[14]

As important as these sources were, the organic scheme of stylistic development was for Winckelmann far more than simply an accepted truth. He treats it as an inevitability deriving as if from a natural law. There are in all things, he states, five stages: beginning, progress, state of rest, decline, and end; his system has four stages because art did not end, at least within the historical boundaries of Winckelmann's project.[15] Thus, his scheme can be seen to derive both from the intellectual study of pre-existing thought and from an acceptance of the necessity of universal rules, in keeping with the burgeoning contemporary interest in discerning laws of physical and natural science. The impact of this way of thinking is especially clear in his treatment of the post-Classical era of artistic development. He explicitly states that Classical art had achieved such perfection that there was no longer the opportunity for improvement; since art could not advance, it could only go backward – to imitation, and imitations are always inferior to that which has been imitated.[16] Art after Alexander – what we call Hellenistic art – was inevitably, according to this system, decadent and imitative.

What is curious in Winckelmann's treatment of Hellenistic art, however, is that he seldom, if ever, characterizes the actual works of art from

this period, insofar as he recognized them, as debased or derivative. In fact, his attitude toward the phenomenon of imitation itself is nothing if not ambivalent. On more than one occasion he refers to the continued consciousness of the grandeur of Classical art as a thing to be commended, a fact that is not surprising when we consider that a primary objective of his work is the recognition of Classical Greece as a model for emulation in his own time.[17] Indeed, Winckelmann's major publication, *Reflections on the Imitation of Greek Works in Painting and Sculpture*, is entirely devoted to this theme.[18] An especially illustrative bit of logical acrobatics can be found in his treatment of the historical circumstances of art in the second century B.C. He accepts at face value Pliny's assertion that art ceased after the 121st Olympiad (296–293 B.C.); indeed, the statement is supportive of both his developmental system, which demands decline after Alexander, and his historicism, which connects artistic stagnation with loss of liberty.[19] Pliny's equally famous (and enigmatic) attribution of artistic revival to the 156th Olympiad (156–153) is more troublesome for Winckelmann, since this was a period of direct Roman domination in Greece. Pliny intended, he suggests, to write 145th Olympiad (200–197),[20] corresponding more closely with the specious declaration of Greek freedom by Flamininus in 197/6. More important than the revisionism here, however, is Winckelmann's clear indication that he considers a revival of Classical form such as Pliny's words imply to be a positive development; the example he uses is none other than the Belvedere torso, identified by Winckelmann as post-Classical from the letter-forms of its signature.[21]

If the continued respect for Classical style seen in some Hellenistic sculpture is taken by Winckelmann to be positive, what then constitutes "decline"? Interestingly, there is little if anything in his treatment that coincides with more recent criticisms of the art of this period, commonly derided not only as "imitative" or "eclectic" but also as excessively realistic or exaggeratedly dramatic ("baroque"). We must keep in mind that he knew none of the major works on which we rely – especially the sculptures excavated at Pergamon and other Asiatic sites. He did, however, know the Laocoon, and, again like Pliny, he held it in the highest esteem.[22] The perfection of this work, in Winckelmann's view, led him to attribute it to

the era of Alexander – a judgement that accommodates both the highly emotional style of the piece and Winckelmann's practice of attributing the "best" work to certain historical eras. What appears to us as the most "Hellenistic"-looking of works is in his eyes completely consistent with a late Classical date. It thus appears that Winckelmann, despite his characterization of the era after Alexander as one of artistic decline, had no clear conception of a stylistic distinction between the Classical and what later came to be called the Hellenistic. Indeed, this is almost surely why he recognized no Roman art as existing apart from Greek.

What, then, was Winckelmann's legacy on the issue of "retrospection"? To him we owe the canonization of a developmental system that derives from natural law and as such is accepted without empirical demonstration. This scheme produces as its corollary a decadent and imitative Hellenistic/Roman era. Winckelmann himself neither displays any clear notion of how this decadence manifested itself nor indicates that a recurrence of Classical formal devices constitutes in any way a mark of decline. Yet he constructed, through his chronological sequence, a basis for the construal of copying, classicism, and archaism by later generations of scholars. As original works of Greek art became better known in the nineteenth century, their juxtaposition with such works as those known to Winckelmann resulted in a much greater awareness of the distinction between a Classical work, for example, and a Hellenistic or Roman work in classical style.[23] Winckelmann's own view of what the relationship might have been is of course impossible to know, but his history – accepted as gospel by succeeding generations – provided for an easy assessment of the later work as inferior, derivative, and, more important, deliberately referential to past works and the epochs that created them. In this respect, the impact of Winckelmann's work looms large even to the present day.

A heightened recognition of Hellenistic production in Classical (or earlier) style as distinct from the works of the Greek era itself comes about, as is so often the case, when the phenomenon is named. The term "Neo-Attic," still much used in contemporary scholarship, owes its coinage to Heinrich Brunn and its popularization to Friedrich Hauser,

both working in the mid- to late nineteenth century.[24] Brunn's work depended heavily on epigraphic evidence. Like Winckelmann, he recognized the signature of the Classical-looking Belvedere torso as necessarily later than the Classical era. He added to this piece several other signed works with signatures that similarly indicated a later date, including the Medici Venus, the Farnese Herakles, and the bronze bust from the Villa of the Papyri, recognized only a decade later as copying the Doryphoros.[25] The names with which these artists signed their works shared an Athenian ethnic, and thus Brunn termed them "neu-attisch" to distinguish them from the "alt-attisch" masters from the era of Pheidias and Praxiteles. Also like Winckelmann, Brunn seemed to regard these works more as a later manifestation of Classical idealism and grandeur than as something either derivative or decadent. His label, however, was not in the long run particularly well chosen, since both its "neo" and its "Attic" aspects have led to no small amount of misunderstanding of the use of Classical styles in post-Classical times.[26]

Among the works collected by Brunn were two signed marble vases that, together with a third example not mentioned by him, formed the core of Hauser's work on Neo-Attic reliefs. Hauser recognized that the statuary collected in Brunn's Neo-Attic group seemed to follow or copy Classical types, and he sought to apply the same principle to the reliefs. In addition to these works he identified more than 150 (unsigned) examples, and by careful scrutiny was able to determine that most of the figures found on these reliefs were patterned after a relatively small number of figural types. While the basic types themselves had Classical parallels, and thus a Classical pedigree, it was equally clear to Hauser that the late Hellenistic and Roman workshops that produced these objects felt free to mix, match, and modify such inherited forms and features to produce a decoration that fit, both physically and thematically, the monument so adorned. Imitation is, for the Neo-Attic reliefs, a fundamental principle of production; it is less easy to ascertain to what degree these figures were meant to be deliberately referential to particular prominent prototypes, and a focus on this concern seems to have arisen only somewhat after Hauser's time.

Mark D. Fullerton

## Copies, Types, and Prototypes

It was Hauser's contemporary Adolf Furtwängler who was most respon-
sible for the transformation of the way we think about the "retrospec-
tive" classes of Hellenistic and Roman sculpture. Like his teacher Brunn,
Furtwängler was intensely interested in the role of individual masters (es-
pecially sculptors) in the development of Greek art, and he likewise drew
on the literary tradition for the bulk of his information.[27] Moreover, the
degree of familiarity with actual Greek works had increased substantially
since the late eighteenth century, and Furtwängler was well aware of the
difference between Classical (or Archaic) work and later works in earlier
styles.[28] He is also largely responsible for codifying a process – still com-
mon today – that uses the latter to substitute for the former to construct
an art history for Classical Greece.

Furtwängler's project had two components – *Meisterforschung* and
*Kopienkritik* – that needed to be employed together. The former refers
to the combing of literary sources to collect available information on
particular artists: name, patronymic, polis of origin, dates of activity,
training, commissions, and attributions. In some rare cases, such as
those of Lysippos, Pheidias, or Polykleitos, there were even comments
that explicitly or implicitly provided information about the artist's style.
From these data, and by using also the stylistic sequence handed down
from Winckelmann, it was possible to infer much about the kinds of
works a particular artist created and even about what they might have
looked like. This much had already been substantially completed be-
fore Furtwängler's time. His contribution lay largely in the second step.
Furtwängler, like Hauser, recognized the reiterative nature of much
Hellenistic and Roman sculpture. Sifting through the massive quantity
of Roman statues in Classical style, he recognized that there were many
instances of duplication; in fact, there were in some cases as many as fifty
statues or fragments thereof that appeared to adhere to a common type.
That type, he assumed, corresponded to a masterwork of the Classical era,
in most cases a lost bronze. Careful study of the copy series (*Kopienkritik*)
would allow for a reconstruction of this lost Classical original; the corpus
of vanished "Masterpieces of Greek Sculpture" thus constructed has,

in turn, provided the basis for the writing of Greek art history ever since.[29]

The serious problems with Furtwängler's method were (and remain) evident even to its practitioners. It is clear from Furtwängler's own discussion of, or rather silence concerning, his methodology that his is a practice entirely rooted in subjectivity.[30] He explicitly eschews a statement of method (he has never been able to see any use in talk about method, as he puts it) and believes that his method is better inferred from its application in his treatments of individual masters. He recognizes that the practice of *Kopienkritik* is complicated by the fact that the individual examples within copy series differ considerably from one another, but he is confident that the scholar (meaning himself) can, through long familiarity with the monuments and, wherever possible, autopsy, discern which were the features of the original and what were changes made by the copyist. Some may doubt his conclusions, he admits, but when they themselves come to know the evidence as completely as does Furtwängler himself, the doubts will vanish. A purer statement of nineteenth-century positivism is difficult to imagine.

I am not so concerned here with the validity of Furtwängler's work as a highly constructed history of Greek art, a topic that would require an essay in and of itself. What is more pertinent is the impact of his work on twentieth-century attitudes toward the phenomena under consideration here: classicism, archaism, and copying. Although "reiterative" styles were not themselves Furtwängler's primary subject, nonetheless his art history determined almost entirely the way in which such classes of sculpture have been construed in the past century. In this regard two issues are primary: the definition of copy (as opposed to a work of classicism or archaism) and the relationship between alleged copies and purported originals.

The first of these issues was an indirect and, to Furtwängler, peripheral result of the practice of *Kopienkritik*. As the scholar scrutinizes the copy series and decides which features belong to the original and which do not, inevitably some of the "copies" are determined not to belong to the series. Rather than reclassify these works as adaptations or creations, however, Furtwängler preferred wherever possible to see them as copies after different originals. While Furtwängler was fully aware of unique

classicizing sculptures like the Melian Aphrodite, his work exemplifies a conviction (persisting still today) that copy series necessarily follow "masterpiece" prototypes from the Classical epoch and that deviations from what are thought to be Classical features are copyist's "mistakes."[31] This attitude derives from the second issue mentioned – the assumption that every Roman statue that looks like a copy not only is a copy, but is a deliberate reproduction of a particular Classical "masterpiece." The Roman copyists, according to Furtwängler, picked from the best and most famous works that antiquity possessed.

It should be obvious enough that this view was an a priori precondition to Furtwängler's work and not a conclusion deduced empirically from his lifelong scrutiny of Roman statues. It was necessitated by his objective of writing a history of Greek art through Roman examples, a project necessitated by a sad fact of preservation, pointed out by Furtwängler himself: works extant from Classical Greece were, except in extremely rare instances, not the masterpieces of bronze casting, but products of secondary production such as architectural sculpture and votive or funerary reliefs. To support his project, Furtwängler necessarily adopted and promulgated a method that was far less empirical, and far less cognizant of the creative aspects of Hellenistic and Roman classicism, than that seen in the works of Hauser, Brunn, or even Winckelmann. Like the giants who preceded him, Furtwängler was well steeped in the literary tradition. Yet, ironically, he did not seem to be aware that there is virtually no literary or epigraphical evidence suggesting that Roman statues functioned as copies in the modern sense, that is, as intentional and understood substitutes for particular well-known originals. There is, moreover, a great deal of evidence that such works were purchased and commissioned not for the fame of a particular prototype or Classical master, but for their subject matter and style (generally interrelated) and their appropriateness to a particular context of display.[32]

It was clearly Furtwängler's objective to force the corpus of Roman "ideal" statuary (referred to today as *Idealplastik* in order to differentiate it from portraiture) to function in a way that suited his purpose. If these works did not copy Classical masterpieces, then his work would be without validity. Moreover, as he himself states, his work was

made possible through the technologies of exact reproduction. While Furtwängler stresses the importance of photography, without which the close comparisons on which the practice of *Kopienkritik* depends would be impossible,[33] it should be remembered that until his time, it had been the practice, especially in the universities of northern Europe, to amass large collections of casts of ancient statues for the study and teaching of antique art.[34] In a sense, what Furtwängler did was to assume that the vast statuary collections and displays in Roman villas, baths, theaters, and fora functioned for the Roman viewer as might a cast collection for the German university student – as clearly intended and didactically motivated substitutes for those remote originals that were the true object of interest.

The impact of Furtwängler's work on the study of "retrospective" styles was enormous. Furtwängler effectively eradicated the phenomenon of classicism by recasting its examples as variously imperfect copies after famous Classical originals. On the other hand, in the years following World War I, attention turned much more intensively toward the parallel phenomena of copies and archaistic works. Georg Lippold, in what remains to this day the fundamental work on copying, sought to make sense of the complex corpus of statuary that had been relatively simplistically treated by Furtwängler.[35] Lippold was acutely aware of the variation among copies after a particular original and the differing relationships that could exist between a copy and its original. He subdivides these relationships into a myriad of different categories (*Kopie, Replik, Wiederholung, Nachbildung, Umstilisierung, Umbildung, Umschöpfung, Weiterbildung*) defined ultimately by degree of fidelity to the original or the degree to which the sculptor intended the piece to be a copy. Since originals almost never exist (with one or two exceptions) and thus are entirely inferred from the copy series, and since the stonecarver's intentions are equally irretrievable, it would seem that Lippold's subcategories are as subjectively conceived as are Furtwängler's *Meisterwerke*. However, Lippold's work is not without importance. He was the first to attempt systematically to trace a history of copying from Classical times onward, and while he may not have problematized copying on a conceptual basis as explicitly as do some contemporary scholars, neither did he simply accept copying at

face value, as did Furtwängler, as a straightforward means to an end.[36] Lippold's work was enormously significant in its foregrounding of copies as a class of monument and of copying itself as an issue. Indeed, in this respect his treatment was far more circumspect than much of today's scholarship.

Slightly earlier than Lippold's *Kopien und Umbildungen* were two monographs on archaistic sculpture that were similarly conceived in the tradition of Furtwängler's *Meisterwerke*.[37] Heinrich Bulle's monograph of 1918 on archaistic statuary represents a straightforward application of Furtwängler's principles of *Kopienkritik*.[38] He recognized a large number of works as archaistic (rather than Archaic), but in many, or even most, cases he identified them as Roman copies of archaistic works from the Classical period, even though there is little if any evidence that such works were created at that time. By doing so, he was able to construct a history of archaistic sculpture that begins immediately after the end of the Archaic period and continues up to and through Roman times. In some few cases Bulle worked, as did Furtwängler, from a copy series, but in the vast majority of instances the pieces were unique, and even scholars who rely heavily on evidence from copies are reluctant to work from single pieces. Moreover, it is now clear that most of the types that are known from replica series are quite clearly late Hellenistic or Roman in origin – a fact contradicting Furtwängler's claim that only great and famous Classical masterpieces were copied.[39]

In his monograph of 1922, Eduard Schmidt sought to write a succinct general account of the archaistic style.[40] Like Bulle, he was interested in tracing a history of the phenomenon from the Archaic period onward. He focussed especially on the development of the archaistic form of striding Athena painted on the Panathenaic prize amphoras of the fourth century B.C. On this basis, he located the origin of a comprehensive archaistic style (as opposed to a simple lingering archaism) in the fourth century. The many archaistic figural types of Neo-Attic reliefs, collected and analyzed by Hauser a generation earlier, were, in Schmidt's scheme, copied from fourth-century prototypes. Schmidt's chronology has been followed, especially in German scholarship, to the present day. A similar approach,

still rooted in the tenets of Furtwängler, was extended a generation later by Werner Fuchs, who sought to identify the Classical masterpieces he believed lay behind virtually all Neo-Attic figural types.[41] Now, more than forty years later, his treatment remains influential, and the assumption of Classical prototypes behind archaistic works in both statuary and relief continues to dominate.[42]

In the meantime, an alternative chronology for archaism was proposed by Giovanni Becatti and endorsed in a series of articles by Christine Havelock. A true archaistic style was not, according to these scholars, developed until the Hellenistic period and was popularized by the Neo-Attic works themselves. These later artists, it is argued, did not copy Classical prototypes but rather created the figural types for the monuments in question. This revisionist scheme depends on the redating of key monuments[43] and, not unlike Schmidt's system, on the reclassification of several more works as "traditional" or "hieratic" rather than "archaistic." It has not, therefore, gained many adherents in toto, although its shifting of creative developments to the Hellenistic period is a valuable contribution.

Behind all these controversies stands a number of related issues. First, when dealing with the phenomena of archaism, classicism, and copying, the definitions one chooses and uses will lead inevitably to conclusions about origin, development, and even signification (or, it seems sometimes, vice versa). A second issue of fundamental importance is continuity. How one identifies a point of origin for archaistic (or later classicizing) is contingent on one's view of whether a continuous tradition in the use of certain stylistic features differs entirely from the use of similar features at a substantially later period after a break or suspension. That is, can a work be archaistic only if it dates at least, say, a generation after 480 B.C., or classicizing only if it comes from the third century or later?[44] Finally – and here the imprint of Furtwängler is most evident – there is the reliance on concepts of copying, or rather on the two unquestioned assumptions that were the underpinning of his *Meisterwerke*: 1) later works that resemble earlier works were deliberate reproductions after particular models, and 2) copies are an unproblematic path to knowing Greek art.

Mark D. Fullerton

## Modern (Re)visions

During the 1970s there began to emerge a body of scholarship that of-
fered a reevaluation of classicism, archaism, and copying. Emphasis now
shifted from the role of these images as a basis for reconstructing (or
constructing) Greek originals to their role as expressions of Roman taste
and bearers of Roman messages. The roots of this development are trace-
able to two highly significant trends in the 1960s – one in Greek, the
other in Roman art. Rhys Carpenter, in what appears to be a brief hand-
book of Greek sculpture, offered in fact a revolutionary approach. By
relying primarily on Greek originals (thereby de-emphasizing the use of
copies) and by rejecting the role of Greek masters and substituting a for-
mal stylistic development entirely independent of historical context, he
rejects both key principles of the Furtwänglerian project.[45] If Carpenter
is to be followed, the corpus of *Idealplastik* must be largely eliminated as
works of Greek art. His contemporaries, especially but not exclusively in
Italy, were constructing compelling arguments for ancient Roman art as
an indigenous development.[46] While many features of Roman art obvi-
ously derive from a language of visual style in the Greek tradition, others
can be traced to origins that are Etruscan or even pre-Etruscan. It was a
natural development that the "retrospective" styles be reevaluated in this
context.

Paul Zanker, whose early scholarly work was in the field of Greek art
but who has become famous as a Roman art historian, was the first to
devote a volume to classicism in statuary.[47] While his treatment demon-
strates well the ways in which Roman statuary can reflect "Polykleitan" or
"Praxitelean" stylistic traditions, his objective lay primarily in restoring
"romanitas" to this body of material. Zanker was especially interested in
the semiotics of what he saw as revivalist styles, that is to say, in the ways in
which Romans used the styles of Greek art to create various atmospheres
and visual environments for specifically Roman functions, be they public
or private.[48] Since the 1970s, Brunilde S. Ridgway has contributed enor-
mously to this topic, largely from the point of view of Greek art. Each
book in her series on the styles of Archaic and Classical Greek sculpture
devotes considerable attention to the later manifestations of the styles in

question.[49] She addresses each stylistic phenomenon as an entity in itself, not shrinking from problems of definition but rather seeking clarification and refinement, and keeping an eye at all times on the questions of chronology, motivation, and meaning.

Inevitably in these works Ridgway encountered the question of distinguishing copies of Classical or Archaic works from later creations in these styles. Some very obvious examples of copy series after classicizing creations – such as the Stephanos youth, for example – had long been recognized. Ridgway, however, has led us to accept that some classicizing statuary types might differ only slightly from Classical types. Examples occur throughout her work, but most illustrative is her seminal reevaluation of the famous Ephesian Amazon group.[50] Traditionally connected with Pliny's anecdote concerning a contest among four (or five) famous masters of ca. 430 B.C., a group of Roman statues representing Amazons in Classical style had been organized into four or five types, and a long line of scholars had spilled much ink arguing the attribution of one or another type to one or another master. Ridgway argued, on the basis of stylistic analysis, that only two of the types were actually of the fifth century, one was no earlier than the fourth century, and the others were Roman creations based on these types themselves. The group, if one had ever existed, would have had to have emerged over time, and Pliny's contest is shown to be a fiction constructed in retrospect. In what has become a summary statement for such revisionist approaches, Ridgway urged in conclusion that we "render unto Caesar what is Caesar's."

It would be inaccurate to say that Ridgway's article converted a generation, but it most certainly helped throw into question long-held assumptions about distinctions between copies and creations. More unsettling still were recent developments in the study of Greek bronzes. The discovery of the Riace warriors in 1972 and their exhaustive study during the 1980s resulted in a heightened uncertainty about our ability to distinguish, by connoisseurship alone, between Greek bronze originals of the fifth and fourth centuries and later works in Classical style.[51] If we cannot make this judgment concerning Greek bronzes, how can we hope to make them in the case of Roman "copies," most of which were mediocre workshop products? Moreover, during the past decade, much progress

has been made in the study of Greek bronze-casting.[52] Among the surprising results are the acknowledgement that indirect casting was the rule rather than the exception, and that these works, long held to be the unique products of individual genius like some Hellenic Michelangelo, were in actuality mass produced after basic models with variations introduced by the piecing together of stock parts. The equivalence between quality and originality – an axiom of western European art history from Vasari to Winckelmann and Furtwängler – seems not to apply in ancient art. Moreover, Carol C. Mattusch's recent discoveries function as a warning against a traditional attitude, derived ultimately from Winckelmann's style system, that designing sculptures, or other images, after a model was a late and inferior development resulting from artistic impoverishment. She reminds us again that Greek art, like all ancient art, was reiterative from its outset.

After a century or so, it seems that the evidence is at hand that would allow scholars to throw off the shackles of Furtwängler's method. Yet both *Kopienkritik* and *Meisterforschung* are alive and thriving. Monographs and articles on individual artists, histories of sculpture based largely on the personalities of artists, and positivistic typologies of complex replica series continue to proliferate. What this means for the study of Classical art is somewhat peripheral to the objectives of this essay and has in any case been recently treated by others.[53] For our purposes, the implications are clear. It is still widely assumed that Roman copy series follow Classical originals, unless there is some clear reason why they cannot. It is further taken for granted that formal resemblance constitutes conceptual equivalence, that is, that what may have been produced through a process of copying was both intended and understood as a copy after a particular original.[54] Finally, it seems to be accepted that our concept of stylistic periods was as much the basis for ancient readings of sculpture as it is today. In other words, we read High Classical forms in, for example, Augustan art as unequivocal references to Periklean Athens, or archaistic forms as a reference to the ancient age of tyrants.

In point of fact, the situation is both far more complex and far more interesting. Stylistic features, once developed, never go completely out of use. Fifth-century stylistic features are found in fourth-century and

Hellenistic as well as Roman works. Copies, as we have already seen, are just as likely to reflect types created in the second or first centuries as those belonging to the fifth or fourth. Thus, a classicizing work of the Early Empire could as easily refer to a classicizing work of the Hellenistic period as to a particular Classical work. Or, alternatively, there may be no particular referent at all. Some styles were simply appropriate – *decor* in Latin terms – for certain subjects and certain themes. While some Roman statues no doubt do copy Greek originals, and some examples of classicism probably were meant to be read as references to the Classical past, we cannot assume that such was the case in all or even most cases. Each example needs to be examined on its own merits, in its own context, insofar as we can determine it, and in view of its apparent function. Indeed, because of the intricacy of the situation, I have found myself unable even to name the phenomenon that is under discussion, taking refuge in the quotation marks around "retrospection."

These issues are not simple, and simplistic terminology and methods do not apply. I would like to conclude, however, by pointing out an existing model that may offer some directions for future development. Allusion was as important in the verbal as in the visual arts during Hellenistic and Roman times, and literary scholars have adopted from poststructuralist criticism the concept of intertextuality.[55] Although uses and definitions for intertextuality are far from uniform, its application as described by the late Donald Fowler might be useful for the study of sculpture.[56] For him, intertextuality differs from allusion in that it shifts the construction of meaning from the author to the reader and from a specific referent to the textual system within which the reader is operating. Thus, the intentions of the author become less significant or even insignificant, a fact that paves the way for a more effective criticism, since the author's intentions may have been conscious or unconscious and are, in any case, irretrievable. In short, the emphasis is shifted from questions that cannot be answered to ones that are both more capable of being addressed and more apt to produce a useful understanding of the ways in which meaning is constructed. Transferring the concept to the study of sculpture, we might concern ourselves less with Roman *Idealplastik* as a means to imagining Greek originals that might never have existed,

# Mark D. Fullerton

or with the reuse of Classical and Archaic formal devices as a deliberate, specific, and even nostalgic reference to some lost golden past. These notions are, as we can now see, rooted in the romance of Winckelmann and nurtured in Furtwängler's attempts to practice positivistic science. Instead, we can consider these stylistic manifestations as operating within a world of styles and images that constitute the Greek *and* Roman figural tradition, where types and figures, once invented, are retained, reused, and adapted to new purposes and where each image has not a single source but a whole universe of referents that varies with the particular experiences of each audience.[57]

I do not imagine that such a development will be universally welcomed. Fowler quotes a diatribe as recent as 1995:

> I am still convinced that a fair amount of modern work with a theoretical basis has not helped us in any way to understand the texts. . . . Take intertextuality. In the study of Latin literature this has not produced new knowledge, but new terms to describe old practices, and with these terms nothing except obscurity and banality, pretentious writing and penitential reading. My advice to the young would be to cast out theory, and get down to real work on the texts, the monuments, the surviving objects, the evidence.[58]

Many in the field of ancient sculpture are similarly invested in the status quo, unaware, perhaps, of the degree to which their methods are derived from a tradition of scholarship conditioned, like ancient art itself, by its own historical context. As products of our own time as well, we are obligated to recognize the ultimate purpose of a postmodern historiography. By heightening our awareness of how we have come to work and reason as we do, it frees us, in the end, to consider other options.

### NOTES

1. M. D. Fullerton, "Description vs. Prescription: A Semantics of Sculptural Style," in K. J. Hartswick and M. Sturgeon, eds., ΣΤΕΦΑΝΟΣ: *Studies in Honor of Brunilde Sismondo Ridgway* (Philadelphia, 1998) 69–77.
2. Naples, Museo Nazionale 6007: M. Fullerton, *The Archaistic Style in Roman Statuary; Mnemosyne Suppl.* 110 (Leiden, 1990) 46–53. C. C. Barslow, *Rediscovering Antiquity. Karl Weber and the Excavation of Herculaneum, Pompeii, and Stabiae* (Cambridge, 1995) 203–204.

112

3. M. Brouskari, "Η Αθηνά του τύπου Herculaneum στήν Ακρόπόλη," in H. Kyrieleis, ed., *Archaische und klassische griechische Plastik. Akten des internationalen Kolloquiums vom 22.-25. April 1985 in Athen* II (Mainz, 1986) 77–83. M. D. Fullerton, "The Date of the Herculaneum Pallas Type," *Archäologischer Anzeiger* 1989, 57–67.

4. Fullerton (supra n. 2) 4 n. 19.

5. J. J. Winckelmann, *Geschichte der Kunst des Altertums* (Dresden, first published 1764). Page references are given to the two-volume reprint of the translation by G. H. Lodge, *History of Ancient Art* (New York, 1968).

6. A. A. Donohue, "Winckelmann's History of Art and Polyclitus," in W. G. Moon, ed., *Polykleitos, the Doryphoros, and Tradition* (Madison, 1995) 327–353; 349 n. 54 for C. Justi's discussion of Winckelmann's dependence on his contemporary – the Comte de Caylus – for his sense of the archaistic as opposed to Archaic.

7. Winckelmann (supra n. 5) II, 147. The Albani Athena: Fullerton (supra n. 2) 63–64. The Capitoline relief: M.-A. Zagdoun, *La sculpture archaïsante dans l'art hellénistique et dans l'art romain du haut-empire* (*Bibliothèque des Écoles françaises d'Athènes et de Rome* 269; Athens and Paris, 1989) 121–122, fig. 143.

8. Winckelmann (supra n. 5) II, 125–126. He cites also the archaistic striding Athenas on coins of Alexander, datable again on external evidence. For the Citharoedus type: Zagdoun (supra n. 7) 105–110.

9. Winckelmann (supra n. 5) II, 156.

10. Donohue (supra n. 6).

11. Among his explicit statements of this analogy are Winckelmann (supra n. 5) II, 116–117, 143.

12. Donohue (supra n. 6) 337–338, 341–334. Donohue most clearly unravels the relationships among these authors and between the ancient traditions and Winckelmann.

13. And equally drawn from ancient sources: Donohue (supra n. 6) 342–343.

14. Winckelmann (supra n. 5) II, 225–226.

15. Winckelmann (supra n. 5) II, 116–117. For Winckelmann's sources on this statement see Donohue (supra n. 6) n. 13.

16. Winckelmann (supra n. 5) II, 143. This thought, too, echoes earlier opinion, both antique and Renaissance. Donohue (supra n. 6) 334–336.

17. On imitation as positive see Winckelmann (supra n. 5) II, 144–145, 151–152.

18. *Gedancken über die Nachahmung der Griechischen Wercke in der Mahlerey und Bildhauer-Kunst.* First published in 1755. See the text of the second edition of 1756 with parallel English translation by E. Heyer and R. C. Norton, *Reflections on the Imitation of Greek Works in Painting and Sculpture* (La Salle, 1987). Cf. S. L. Marchand, *Down from Olympus: Archaeology and Philhellenism in Germany 1750–1970* (Princeton, 1996) esp. 3–35 for the emergence of Classical Greece as an artistic and intellectual model from the time of Winckelmann up to the beginning of the nineteenth century.

19. Winckelmann (supra n. 5) II, 240.

20. Rather than 155th, although Pliny's text (*NH* 34.19.52) actually reads "156th," Winckelmann misread or misremembered. Winckelmann (supra n. 5) II, 262–263.

21. Winckelmann (supra n. 5) II, 263–265.

22. Winckelmann (supra n. 5) II, 228–232.

23. Although the possibility that many "Greek" works were Roman copies had already been suggested by certain of Winckelmann's contemporaries. A. Potts, "Greek Sculpture and Roman Copies I: Anton Raphael Mengs and the Eighteenth Century," *Journal of the Warburg and Courtauld Institutes* 43 (1980) 150–173.

24. H. Brunn, *Geschichte der griechischen Künstler* (Braunschweig, 1853) 559–570, esp. 560. F. Hauser, *Die neu-attischen Reliefs* (Stuttgart, 1889).

25. K. Friedrichs, *Der Doryphoros des Polyklet* (Berlin, 1863).

26. M. Fullerton, "Atticism, Classicism, and the Origins of Neo-Attic Sculpture," in O. Palagia and W. Coulson, eds., *Regional Schools in Hellenistic Sculpture* (London, 1998) 95–99.

27. The greater portion of the extant literary evidence had already been collected and organized by Overbeck. J. Overbeck, *Die antiken Schriftquellen zur Geschichte der bildenden Künste bei den Griechen* (Leipzig and Berlin, 1868).

28. It was he, in fact, who first recognized the Aphrodite from Melos as Hellenistic rather than of the fourth century. A. Furtwängler, *Meisterwerke der griechischen Plastik: Kunstgeschichtliche Untersuchungen* (Leipzig, 1893) 599–655.

29. On Furtwängler's method and impact, see J. J. Pollitt, "Introduction: Masters and Masterworks in the Study of Classical Sculpture," in O. Palagia and J. J. Pollitt, eds., *Personal Styles in Greek Sculpture* (Cambridge, 1996) 1–15; and for the application of what still remains a fundamentally nineteenth-century practice today, see the papers on individual artists in that volume.

30. Furtwängler (supra n. 28) "Vorwort," esp. p. x.

31. On copyists' "mistakes" see especially M. Bieber, *Ancient Copies. Contributions to the History of Greek and Roman Art* (New York 1977) 6.

32. E. K. Gazda, "Roman Copies: The Unmaking of a Modern Myth," *Journal of Roman Archaeology* 8 (1995) 530–534; M. Marvin, "Copying in Roman Sculpture: The Replica Series," in *Retaining the Original: Multiple Originals, Copies, and Reproductions* (*Studies in the History of Art* 20; Washington, D.C., 1989) 29–45.

33. Furtwängler (supra n. 28) x; Pollitt, "Masters and Masterworks" (supra n. 29) 11–14.

34. F. Haskell and N. Penny, *Taste and the Antique: The Lure of Classical Sculpture 1500–1900* (New Haven, 1982) 16–17, 31–36, 79–91, 117–124; Pollitt, "Masters and Masterworks" (supra n. 29) 12.

35. G. Lippold, *Kopien und Umbildungen griechischen Statuen* (Munich, 1923). The tradition lives on; see A. Filges, *Standbilder jugendlicher Göttinnen. Klassische und frühhellenistische Gewandstatuen mit Brustwulst und ihre kaiserzeitliche Rezeption* (Cologne, 1997), and my review, "Some Statuary Types and the Perils of Positivism," *Journal of Roman Archaeology* 13 (2000) 509–514.

36. Although Lippold did go on, in later years, to write his own history of Greek sculpture, based largely on copies, which was as influential in its own time as Furtwängler's had been: *Die griechische Plastik* (*Handbuch der Archäologie im Rahmen des Handbuchs der Altertumswissenschaft* III.1; Munich, 1950). Cf. A. Stewart, *Greek Sculpture, An Exploration* (New Haven, 1990) I, 30, who describes Lippold's work as still "the basic reference book in the field."

37. For a fuller treatment of scholarship on the archaistic style see Fullerton (supra n. 2) 1–12.

38. H. Bulle, "Archaisierende griechische Rundplastik," *Abhandlungen der Bayerischen Akademie der Wissenschaften. Philosophische-philologische Klasse* 30.2 (Munich, 1918) 3–36.

39. On this point see especially Fullerton (supra n. 3); idem, "Archaistic Statuary of the Hellenistic Period," *Mitteilungen des Deutschen Archäologischen Instituts, Athenische Abteilung* 102 (1987) 259–278. The Herculaneum Athena was already postulated to be Hellenistic by E. B. Harrison, *The Athenian Agora* XI: *Archaic and Archaistic Sculpture* (Princeton, 1965) 74. Other criticism of Bulle's identification of such pieces as copies of Classical works can be found: Bieber (supra n. 31) 2.

40. E. Schmidt, *Archaistische Kunst in Griechenland und Rom* (Munich, 1922).

41. W. Fuchs, *Die Vorbilder der neuattischen Reliefs* (*Jahrbuch des Deutschen Archäologischen Instituts. Ergänzungsheft* 20; Berlin, 1959).

42. M. Fuchs, *Glyptothek München. Katalog der Skulpturen* VI. *Römische Idealplastik* (Munich, 1992) and Zagdoun (supra n. 7).

43. Most notably the frieze of archaistic dancers from Samothrace which is, according to all evidence, of the fourth century. On Becatti, Havelock, and the controversy, see M. Fullerton, "Archaistic Statuary" (supra n. 39) 259–261. Fullerton (supra n. 2) 3.

44. It should be immediately apparent that these questions derive, to a substantial degree, from the arbitrary system of style classification that is inherited from Winckelmann.

45. R. Carpenter, *Greek Sculpture: A Critical Review* (Chicago, 1960). One of his most explicit criticisms of traditional approaches can be found in a review of M. Bieber's *The Sculpture of the Hellenistic Age* (New York, 1955) in *Art Bulletin* 39 (1957) 67–73. See, esp., 69, concerning the method of Furtwängler et al.: "It has unquestioningly been an impressive achievement; but it could hardly fail to be somewhat faulty insofar as a knowledge of Greek and Latin and a knack for sorting photographs is not an entirely adequate substitute for an understanding of sculpture." Cf. his earlier "Observations on Familiar Statuary in Rome," *Memoirs of the American Academy in Rome* 18 (1941) 1–2.

46. Most conspicuous is Ranuccio Bianchi-Bandinelli's (d. 1975) series on Italic and Roman art, clearly influenced by Marxist thought: *Etruschi e Italici prima del dominio di Roma* (2nd ed.; Milan, 1981); *Rome – The Centre of Power* (New York, 1970); *Rome – The Late Empire* (New York, 1971) Cf. also the contributions of Otto J. Brendel (d. 1973), *Etruscan Art* (2nd ed.; New Haven, 1995) and *Prolegomena to the Study of Roman Art: Expanded from Prolegomena*



## Mark D. Fullerton

to a Book on Roman Art (New Haven, 1979), an expanded version of Brendel's 1953 essay with a foreword by J. J. Pollitt. Brendel makes one of the most articulate cases ever argued for the complexity of Roman art and its Italic traditions.

47. *Klassizistische Statuen. Studien zur Veränderung des Kunstgeschmacks in der römischen Kaiserzeit* (Mainz, 1974). Zanker's dissertation, for example, deals with Attic vase-painting: *Wandel der Hermesgestalt in der attischen Vasenmalerei* (Bonn, 1965).

48. This interest is especially clear in his treatment of Augustan art: P. Zanker, trans. A. Shapiro, *The Power of Images in the Age of Augustus* (Jerome Lectures 16; Ann Arbor, 1988), esp. 239–263. Similar attitudes are reflected in T. Hölscher, *Römische Bildsprache als semantisches System* (Heidelberg, 1987).

49. E.g., B. S. Ridgway, *The Severe Style in Greek Sculpture* (Princeton, 1970) 93–148; eadem, *The Archaic Style in Greek Sculpture* (Princeton, 1977; 2nd ed., Chicago, 1993) 445–473; eadem, *Fifth Century Styles in Greek Sculpture* (Princeton, 1981) 222–248.

50. B. S. Ridgway, "A Story of Five Amazons," *American Journal of Archaeology* 78 (1974) 1–17. Studies following her method include, e.g., K. J. Hartswick, "The Athena Lemnia Reconsidered," *AJA* 87 (1983) 335–346 and idem, "The Ares Borghese Reconsidered," *Revue archéologique* 1990.2, 227–283. For an especially ingenious, even brilliant, application of *Kopienkritik* and *Meisterforschung*, approximately contemporary with Ridgway's article on the Amazons, see E. B. Harrison's three articles on Alkamenes' sculptures for the Hephaisteion, *AJA* 81 (1977) 137–178, 265–287, 411–426.

51. B. S. Ridgway, "The Riace Bronzes: A Minority Viewpoint," *Bollettino d'Arte*. Serie Speciale 3.2.2-3 (1984) 313–326. Even if her assessment of these spectacularly high-quality pieces as Roman is rejected, she has successfully demonstrated that they bear features generally held to be typical of classicizing works.

52. C. C. Mattusch, *Classical Bronzes: The Art and Craft of Greek and Roman Statuary* (Ithaca and London, 1996). D. Haynes, *The Technique of Greek Bronze Statuary* (Mainz, 1992).

53. B. S. Ridgway, "The Study of Classical Sculpture at the End of the Twentieth Century," *American Journal of Archaeology* 98 (1994) 759–772.

54. I anticipate some revisions of these views in the forthcoming: E. Gazda, ed., *The Ancient Art of Emulation: Studies in Artistic Originality and Tradition from the Present to Classical Antiquity* (Ann Arbor, 2002) (non vidi). For now, see E. Gazda, "Roman Sculpture and the Ethos of Emulation: Reconsidering Repetition," *Harvard Studies in Classical Philology* 97 (1995) 121–156.

55. For example, the papers collected from two conferences on "Memory, Allusion, and Intertextuality in Classical Studies" at Seattle and Oxford and published in *Materiali e discussioni per l'analisi dei testi classici* 39 (Pisa and Rome, 1997); S. Hinds, *Allusion and Intertext: Dynamics of Appropriation in Roman Poetry* (Cambridge and New York, 1998); G. B. Conte, *The Rhetoric of Imitation: Genre and Poetic Memory in Virgil and Other Latin Poets* (*Cornell Studies in*

*Classical Philology* 44; Ithaca, 1986); D. Fowler, *Roman Constructions: Readings in Postmodern Latin* (Oxford and New York, 2000), especially the papers in Part II: Intertextualities.

56. L. Edmunds, "Intertextuality Today," *Lexis* 13 (1995) 3–22. D. Fowler, "On the Shoulders of Giants: Intertextuality and Classical Studies," in *Materiali*, and reprinted in *Roman Constructions* (supra n. 55) 115–137. This article includes a very useful select bibliography on intertextuality.

57. I have earlier addressed some of these issues: "Imitation and Intertextuality in Roman Art," *Journal of Roman Archaeology* 10 (1997) 427–440, much remains to be done.

58. D. West, "Cast Out Theory," Classical Association Presidential Address 1995, 16–17. Quoted by Fowler (supra n. 55) 13.

# 6

## The *Peplos* and the "Dorian Question"

### MIREILLE M. LEE

Of all Greek garments, the *peplos* (plural: *peploi*) is perhaps the one we believe we know best.[1] It is conventionally understood as an untailored rectangle of wool that was wrapped around the wearer and fastened at the shoulders with pins (see Fig. 1). A fold at the top of the garment created what is known as the *apoptygma* or overfold. The *peplos* was sometimes girded under this overfold, creating a pouch-like *kolpos*;[2] an over-girded *peplos* is known as the "*peplos* of Athena" from its frequent appearance in her images.[3] This garment is considered a hallmark of the Severe style of Greek art, appearing in both sculpture and painting in the decades after the Persian Wars, roughly 480 to 450 B.C.[4] The pinned woolen *peplos* is generally identified as Dorian dress, in contrast to the sewn linen Ionian *chiton*; its appearance in Greek art in the third quarter of the fifth century is thought to reflect a rejection of the eastern Ionian dress in favor of the traditional Dorian garment.

While our inherited understanding of the *peplos* has been fundamental to the analysis of stylistic change in sculpture from the Archaic to the Early Classical periods, the present study demonstrates that our notion of the *peplos* is constructed from incompatible literary and visual evidence. Our terminology for dress cannot be matched with certainty to descriptions in literary sources or with images in sculpture or vase-painting. Conversely, many garments represented in Greek art cannot be associated with specific terms or descriptions. Ostensibly historical information proves unreliable. We cannot be sure that the garments represented in art reflect those worn in life. In an effort to make sense of a vast and diverse

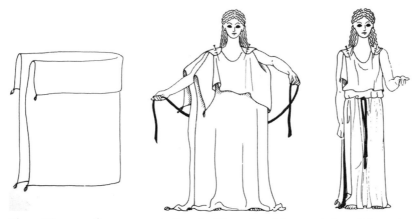

**Fig. 1.** Diagram of arrangement of *peplos* (Reproduced by permission of the artist from J. Neils, ed., *Goddess and Polis: The Panathenaic Festival in Ancient Athens* [Princeton, 1992] Fig. 70).

corpus of evidence, scholars have made tenuous connections between unrelated data. This study deconstructs the traditional interpretation of the *peplos*, identifies the disparate evidence on which that interpretation rests, and exposes the biases of the nineteenth-century German scholars who determined our understanding of this significant garment.

## Evidence for the *Peplos*

The *locus classicus* in literature for the garment we call *peplos* is a passage from Herodotus's *Histories*, written in the middle of the fifth century B.C.[5] At one point in the Athenian rise to power, the men of Athens undertook a disastrous attack on Aegina in which all the Athenians died but one:

> Even the one man, say the Athenians, did not survive finally but ended in the following way. He came back to Athens and told what had happened, and the womenfolk of the Athenian men who had fought against Aegina, furious that he alone of all should have escaped, encircled the man and stabbed him with the brooch-pins (περόναι) with which they fastened their robes (ἱμάτια), each one asking him, "Where is my man?"
>
> So he too died; and to the Athenians this deed of the women seemed even worse than the defeat itself. They could think of no way to punish the women but to change their dress (ἐσθῆτα)

to the Ionian mode; for before this the Athenian women wore clothes (ἐσθῆτα) of the Dorian fashion, which is very like that of Corinth. The Athenians now changed this into a linen tunic (λίνεον κιθῶνα), that the women might use no pins. In truth, this women's clothing (ἐσθής) was not originally Ionian but Carian, for in Greece all the older sort of women's dress (ἐσθής) was what we now call Dorian. (5.87–88)[6]

Herodotus's testimony regarding the changes in women's dress styles seems to account for a similar development in Greek art from a simple, pinned dress to the sewn linen *chiton*: the earliest Archaic korai on the Athenian Acropolis appear to wear the pinned Dorian garment (Fig. 2), while their successors wear the Ionian *chiton* (Fig. 3).[7] The reappearance of the Dorian garment in art of the early fifth century is often explained as a symbol of renewed panhellenic sentiment following Persian Wars.[8] The change from the Ionian style of dress *back* to the Dorian seems to be corroborated by Thucydides' discussion of the customs of the Greeks from earliest times:

> The Athenians were the first to lay aside their weapons, and to adopt an easier and more luxurious mode of life; indeed, it is only lately that their rich old men left off the luxury of wearing linen *chitones* and fastening a knot of their hair with a tie of golden grasshoppers, a fashion which spread to their Ionian kindred, and long prevailed among the old men there. On the contrary a modest style of dressing, more in conformity with modern ideas, was first adopted by the Lacedaemonians, the rich doing their best to assimilate their way of life to that of the common people. (1.6.3–5)[9]

Although it is unclear to what extent Thucydides' testimony also applies to women's dress,[10] it does support the notion of a change in Athenian dress sometime in the fifth century, a change from a luxurious Ionian garment to a more modest style of dress such as that worn in the Dorian region of Laconia.[11]

The literary testimony for women's dress is problematic on several levels. First, we cannot be sure that the events described in literature, even the historical accounts of Herodotus and Thucydides, accurately reflect real events. The historicity of the Athenian expedition to Aegina is

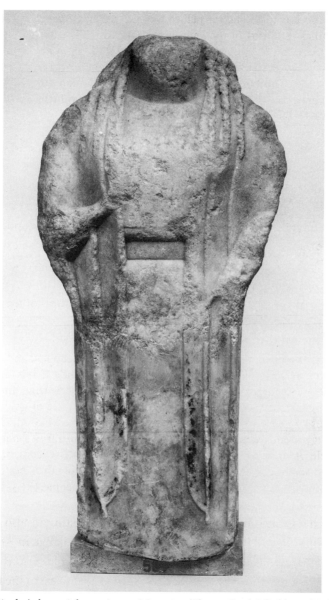

**Fig. 2.** Archaic kore, Athens, Acrop. Mus. 589. (Photo: Greek Ministry of Culture.)

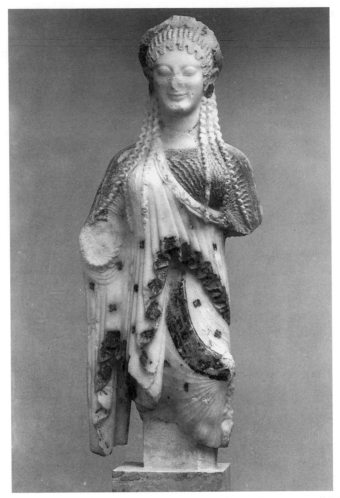

**Fig. 3.** Archaic kore, Athens, Acrop. Mus. 675. (Photo: Greek Ministry of Culture.)

itself doubtful,[12] and it seems likely that the story was a popular tale that explained a real change at Athens in the sixth century or earlier.[13] An additional problem is that the testimony of both Herodotus and Thucydides refers specifically to the city of Athens, while the iconographic changes in feminine dress are broadly panhellenic. Both large- and small-scale sculptures of *peplophoroi* (female figures wearing the *peplos*) have been found from Magna Graecia in the West to Lycia in the East (even farther east than Caria, the supposed source of the Ionian *chiton*). More perplexing

is the fact that although Herodotus was writing in the middle of the fifth century, when the *peplos* is ubiquitous in sculpture, he does not indicate that the pinned garment had been readopted by Athenian women.

The most serious problem for scholars of ancient dress is that Herodotus nowhere identifies the pinned garment called Dorian as *peplos*; he refers to it only as *himation* and *esthes*. How did the pinned Dorian garment described by Herodotus become equated with the *peplos*, a feminine garment known from Greek literature as early as Homer? To complicate the issue further, modern scholars have at times used the terms *peplos* and *Doric chiton* interchangeably.[14] How did the *chiton*, which, according to the literary sources, was an Ionian garment, become a Dorian garment as well? Historiographic analysis of the scholarship on Greek dress shows that our identification of the *peplos* derives from a German preoccupation, beginning in the early nineteenth century, with the Dorian and Ionian Greek *Stämme*, or tribes. The German identification with the Greeks, especially the Dorians, as their Indo-European ancestors has led to a serious misunderstanding of the literary, artistic, and archaeological evidence for the *peplos*. In tracing the misidentification of the *peplos*, it is useful to examine briefly the problems associated with the study of Greek dress in general and the early scholarship on the *peplos* in particular.

## Problems in the Study of Greek Dress

The study of ancient Greek dress is fraught with difficulties.[15] Although a few precious fragments of textiles have been recovered, no complete garments have been preserved from the Classical period in Greece.[16] To reconstruct a history of Greek dress, scholars have depended primarily on representations of garments in art and references to garments in texts. The textual evidence is notoriously difficult to decipher. Although many names for garments exist in literature, specific articles of dress are rarely described in enough detail to be identified in the visual evidence. Of course, the audiences for whom these works were intended did not require such explanations; they knew the garments from their own lives or were shown them as costumes on the stage.[17] The names of garments mentioned in the texts also change over time and according to genre. The

*peplos*, for example, is the primary garment of women and goddesses in Homer, whereas in Classical comedy the *peplos* is absent and the *chiton* and *himation* are the usual garments.[18] We therefore cannot assume that the terminology of Greek dress remained consistent over time and in all contexts, or indeed whether different nomenclature reflects distinct garments.[19] Finally, although later Greek, Roman, and Byzantine commentators and lexicographers have frequently been cited by modern scholars of dress, these sources must be consulted with extreme caution. As in the case of Roman copies of Greek statues, the Romans possessed their own interpretations of Greek garments that do not necessarily reflect the notions of the Greeks themselves.[20] Although both Roman and Byzantine writers were less removed in time and place from Classical dress than are modern scholars, they still lacked direct access to Classical garments, which were no longer worn, and their observations are colored by their knowledge of the dress of their own time.

Within the history of scholarship on Greek dress, the *peplos* has been particularly elusive. The garment has been identified variously as an overgarment, an undergarment, a shawl or mantle, and a veil. Some have considered it sacred to Athena, while others believed it was an everyday garment worn by mortal women. Although today we consider the *peplos* specifically a Dorian garment, its ethnic derivation is not addressed by early scholars of ancient dress. No other Greek garment seems to have generated as much controversy as the *peplos*, and although modern scholars are generally confident in their recognition of the garment, a review of the scholarship demonstrates the problems surrounding its identification.

## Early Scholarship on the *Peplos*

Modern scholarship on ancient dress dates to the Renaissance, before many monuments and written sources had been rediscovered. One of the earliest treatises on the subject is *De re vestiaria libellus*, a compendium of Greek and Latin terms relating to dress written in 1535 by Lazare de Baïf (1496?–1547), intended as a brief introduction to ancient dress.[21] Citing mostly Latin authors and lexicographers, Baïf provides definitions for

words used to describe dress, often associating ancient garments with Renaissance correlates.[22] Baïf does not name the *peplos*, only the λινοῦς χιτών (linen *chiton*), which he identifies with the Roman tunic, and the "Pallium Græcorum," which he associates with the Roman toga.[23]

The *peplos* was first identified by Claudius Salmasius (Claude Saumaise) (1588–1653) in his commentary on Tertullian's *De pallio* as the garment sacred to Minerva and other deities.[24] He contends that the ancient critics were unsure as to whether it was an undergarment like a tunic, or an overgarment like the *pallium*. Citing Pollux, *Onomasticon* 6.50 (on the *peplos*), he concludes that it was sometimes worn as a tunic and sometimes as a *pallium*.[25]

The first explicit description of a garment resembling that known to modern scholars as the *peplos* is found in "De re vestiaria" by Octavius Ferrarius (1518–1586) included in the *Thesaurus antiquitatus romanum* of 1697.[26] Ferrarius describes several different types of *pallium*: the usual Greek type was comprised of two pieces of square cloth that were pinned at the shoulders with fibulae; philosophers, however, wore a different garment that was semicircular in shape and was not fastened with pins but was thrown over the shoulder.[27] Ferrarius suggests that the square *pallium* was in fact borrowed by the Greeks from Asian or Oriental peoples.[28] In his "Analecta de re vestiaria," Ferrarius further defines the women's *pallium* as an upper garment, worn over the tunic, that was called by the Romans *palla* and by the Greeks *peplos*.[29]

By the eighteenth century, burgeoning numbers of excavated monuments permitted study of ancient dress on the basis of visual representations. The difficulty of reconciling observed garments with the names of garments given by the ancient authors is lamented by the highly esteemed Benedictine scholar, "the Learned Father" Bernard de Montfaucon (1655–1741):

> There is no Part of Antiquities more curious and useful than that which treats of the Habits; and none also more obscure. We are equally at a Loss to find out the Shape of a great many Habits mentioned by *Greek* and *Latin* Authors, and to discover by what names they called other Habits which Monuments shew us the Form of, without their Name.[30]

**Fig. 4.** Drawing of relief from the "*Parthenion* or Temple of *Minerva*." B. de Montfaucon, *Antiquity Explained, and Represented in, Sculptures* III, opposite p. 7, no. 3. (Photo: Bryn Mawr College, Visual Resources Department.)

To his credit, Montfaucon displays a certain caution in his discussion of ancient dress. An illustration of south metope 19 from the "*Parthenion* or Temple of *Minerva*" (Fig. 4), in which the female figure wears the garment modern scholars understand as a *peplos*, is described as: "a Man and a Woman; the Man habited in a Tunick that reaches to the Ground, and a *Pallium* or Cloak. . . . As to the Habit of the Woman, it will be better observ'd with the Eye than describ'd."[31] Montfaucon knew several names

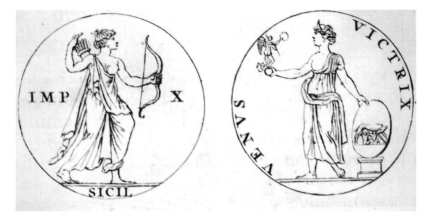

**Fig. 5.** (a) Engraving of Roman coin depicting Diana. E. Spanheim, *Les Césars de l'Empereur Julien*, 123. (Photo: Cornell University Library, Division of Rare and Manuscript Collections.) (b) Engraving of Roman coin depicting Venus-Victrix. E. Spanheim, *Les Césars de l'Empereur Julien*, 123. (Photo: Cornell University Library, Division of Rare and Manuscript Collections.)

for overgarments worn by Greek and Roman women, among them *peplos*, but he hesitated to identify them among the monuments, "the marbles affording us no Light into the Matter: Nor do the Authors that mention these Habits give us any Marks of Distinction; but on the contrary rather for the most part seem to intend nothing less than to instruct us therein."[32]

Given the difficulty of identifying the garments depicted in sculpture, it should not be surprising that the first explicit exegesis of the *peplos* is found not in a treatise on art, but in a literary commentary. Ezechiel Spanheim (1629–1710), in his French translation of Julian's *Caesars* (published posthumously in 1728),[33] explains the *peplos* given to Constantine by Pleasure (336)[34] as a sleeveless mantle worn by women and goddesses that was attached at one or both shoulders with *fibulae*.[35] Although the primary evidence for this identification is derived from literature,[36] he also cites engravings of Roman coins and statues as illustrations of the garment (Figs. 5, 6). The pictorial evidence seems to have informed his conception of the *peplos* as an ankle-length garment rather than simply an overgarment worn on top of a tunic, for example. Although Spanheim's conclusions were dismissed (or ignored) by later scholars, it is

**Fig. 6.** (a) Engraving of statue of "Eternity." E. Spanheim, *Les Césars de l'Empereur Julien*, 123. (Photo: Cornell University Library, Division of Rare and Manuscript Collections). (b) Engraving of statue of "Venus-Victrix." E. Spanheim, *Les Césars de l'Empereur Julien*, 123. (Photo: Cornell University Library, Division of Rare Manuscript Collections.)

interesting to note that his identification of the *peplos* as a long garment pinned at the shoulders (rather than a shawl or cape, for example, as some of his successors suggest) is akin to the modern definition of the *peplos*.

## Winckelmann and the Advent of the Dorians

Whereas much of the early scholarship on Greek dress focused on the identification of particular types of garments (the *peplos* or the *pallium*, for example), Johann Joachim Winckelmann (1717–1768) proposes a new conception of Greek dress based on tribal origin that has persisted to the present. His interpretation of the *peplos* seems to have evolved over time. In his early pamphlet *Gedanken über die Nachahmung der griechischen*

*Werke in der Malerei und Bildhauerkunst,* first published in 1755, he notes only that "the entire outer garment of Greek women was of very thin material and therefore was called peplon, a 'veil' [*Schleier*]."[37] A decade later, in his monumental *Geschichte der Kunst des Altertums* of 1764, Winckelmann modifies his identification of the *peplos,* which he now describes as a cloak (*Mantel*):

> It was termed by the Greeks *peplos,* a word which, though at first applied exclusively to the mantle of Pallas, was afterwards used in speaking of the mantle of other divinities and of men. It was not square, as Salmasius has supposed, but perfectly circular, just as the cloak of modern days is cut. This must also have been the shape of the cloak of men.[38]

Winckelmann believed that this cloak was usually worn under the right arm and cast over the left shoulder, but that sometimes it was attached at the shoulders with buttons, so that it hung down the back.[39] He describes in addition another, smaller, cloak that extended to the hips and consisted of two parts sewn together and fastened on the shoulders by buttons. This "cloak" is surely what modern scholars understand to be the overfold.

Elsewhere in the section on drapery, in remarks unrelated to his comments on the *peplos,* Winckelmann notes: "In the earliest ages, the style of female dress was the same with all Greeks, namely, the Doric. At a later period, the Ionians departed from the general mode."[40] Although he does not cite an ancient source for this information, it is certainly based in some measure on Herodotus 5.87–89, quoted previously. His attention to the Doric and Ionic styles is surely related to the same humanistic currents that gave rise to the scheme of Friedrich von Schlegel (1772–1829) of the Greek *Stämme* (branches or schools) of poetry, which would influence German scholarship generally in the nineteenth century.[41] Winckelmann does not identify the *peplos* as Doric; nor is he able to differentiate between the Doric and Ionic styles, conflating them in his discussion of types of garments. He asserts nonetheless that artists continued to represent divine figures and heroes in garments "of the most ancient style," even after the adoption of Ionic dress by Greek women.[42]

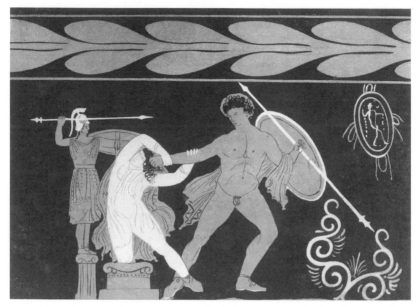

**Fig. 7.** Drawing of "The rape of Cassandra," from a vase-painting. C. A. Böttiger, *Über den Raub der Cassandra.* (Photo: Metropolitan Museum of Art.)

The distinction between the Doric and Ionic styles of dress was clarified by Carl August Böttiger (1760–1835), who also suggested a new identification for the *peplos*. In his book-length essay of 1794 on a vase-painting of the rape of Cassandra, Böttiger acknowledges the considerable confusion surrounding the *peplos* and suggests that the solution lies in the etymology of the term. He proposes that πέπλος is derived from περίπελος, a compound of περί (around) and πέλομαι (to be in motion), and that the *peplos* should therefore refer to a more or less close-fitting garment that surrounded the body, rather than to a garment that is thrown over the shoulders like a cloak.[43] This garment, which the author describes as a "frock-coat" (*Leibrock*) is represented on the Palladion in a vase-painting depicting the rape of Cassandra (Fig. 7).

Certainly Böttiger's most lasting contribution to the study of Greek dress is his differentiation between the Doric and Ionic styles of dress. Expanding on Winckelmann's identification of the two types, Böttiger suggests that the oldest feminine garment of the Greeks was a sleeveless *tunica* comprised of two pieces of fabric attached at the shoulders

with clasps (*Schnallen*) and girded at the waist so that it hung more or less to the knees.[44] This was the dress of the women of the Doric tribes, who were characterized as wearing a single garment (μονοχίτων), and it was preserved among the Spartan maidens even when other tribes adopted a second garment, the Ionic *tunica*, which was sleeved and worn without clasps.[45] To "dress Dorian" was δωριάζειν; to "dress Ionian," ἰωνίζειν.[46] Böttiger suggests that even after the appropriation of Ionic dress in the Greek homeland, artists remembered the old, traditional dress, and resurrected it as an "artistic costume" for goddesses and heroines.[47]

Although Böttiger provides clear definitions of both the *peplos* and Doric dress, he does not explicitly associate one with the other. His description of the single Doric garment could easily be ascribed to the *peplos* of the Palladion, and yet he considers the *peplos* only as the garment sacred to Athena.[48] Although the *peplos* would not be identified as Doric for another hundred years, Böttiger's identification of the Doric and Ionic styles formed the basis for scholarship on Greek dress for the next century.

## German Scholarship of the Nineteenth Century: *Doriertum*

Following Schlegel's identification of the Greek *Stämme* in the late eighteenth century, interest in the various subgroups of the Greeks was acute among German scholars, and the problem of the Doric and Ionic styles of dress became central to German scholarship during the course of the nineteenth century. The particular German affinity for the Dorians was influenced by the works Karl Otfried Müller (1797–1840),[49] whose two volumes on the Dorians, published in 1824, were only part of a projected comprehensive study of all the Greek *Stämme* that he never completed.[50]

Although Müller had made reference to certain aspects of Doric and Ionic dress in his earliest works,[51] a full description of the Doric type does not appear until *Die Dorier*. Müller notes that the Doric garment is sometimes called *himation* and sometimes *chiton* by the ancient writers, "the former more correctly, as appears from works of art; and the latter

word was used metaphorically, from the resemblance of the himation to the linen chiton of the Ionians."[52] Müller defines the Doric *chiton* as a sleeveless woolen garment that was fastened on the shoulders by clasps. Only one side of the garment was closed; the other was either left open or perhaps fastened with more pins.[53] Müller notes that the Doric *chiton* is the dress worn by Athena and also by Nikai.[54] According to Müller the *peplos* was not an article of Doric dress.[55] Some years later, in his *Handbuch der Archäologie der Kunst*, Müller further suggests that the *peplos* was an early form of the *himation* that had been abandoned by the Classical Greeks, surviving only in statues of Athena.[56] Regarding the appearance of the term *peplos* in Classical tragedy, he suggests that the tragedians were uncertain as to its meaning, noting that Sophocles (*Trachiniae* 921) refers to it as a Doric *chiton*.[57]

A new conception of the *peplos* was proposed in the first (1884) edition of *Das homerische Epos aus den Denkmälern erläutert* by Wolfgang Helbig (1839–1915), in which the author attempts to reconcile the descriptions of garments in the epic poems with representations of garments in early Greek art.[58] Helbig suggests that the Homeric *peplos*, worn exclusively by women and goddesses in the poems, was essentially the same as the masculine *chiton*, that is, a sewn linen chemise with sleeves that was fastened down the front (κατὰ στῆθος).[59] In particular he cites Archaic renderings of garments with decorative strips down the front, which he suggests are reminiscent of this frontal opening (Fig. 8).[60] He argues that the *chiton* (and therefore the *peplos*) was adopted by the Greeks from the Phoenicians and cites Egyptian representations of Asian peoples who seem to wear garments with such frontal openings.[61]

Helbig's hypotheses were vigorously denounced by Franz Studniczka (1860–1929) in his *Beiträge zur Geschichte der altgriechischen Tracht* of 1886. Studniczka seems to have been strongly influenced by the discovery in the early nineteenth century of the connections among the various Indo-European languages, including Sanskrit, Greek, Latin, and German. Following the current German interest in etymology as a means of inter-preting culture,[62] Studniczka cites linguistic evidence in favor of a Semitic origin for the word *chiton*, but an Indo-European source for the word

Fig. 8. Drawing of Homeric women's dress. W. Helbig, *Das homerische Epos aus den Denkmälern erläutert* (2nd ed.) 139, fig. 27. (Photo: Bryn Mawr College, Visual Resources Department.)

*peplos*, which he suggests shares the same root *plo-* (in reduplicated form) with the Latin words *palla* and *pallium*.[63] Since Indo-European garments were pinned, not sewn, he argues that the early Greek dress must have been pinned as well.[64] As illustrations of the early Greek *peplos*, Studniczka cites various figures on the François Vase (Figs. 9, 10) who wear garments pinned *katà stêthos*, meaning not, as Helbig had assumed, *on the chest*, but rather *toward* or *alongside the chest*, that is, on the shoulders.[65] These pinned garments are not, in principle, different from the Doric garment represented in Classical art, and Studniczka asserts that the Homeric *peplos* is in fact Doric.[66] Working within the tradition of scholarship that claimed racial unity among the Indo-European-speaking peoples,[67] he suggests that the early Greeks originally wore a Doric (that is, a pure Hellenic, Indo-European, Aryan) garment, the *peplos*, but that at some later time they suffered a sort of Semitic infiltration in the form of the Ionic *chiton*.[68] As a result of the Persian Wars, however, the Greeks resumed their national costume as a means of asserting their Hellenic identity, as evidenced by Aeschylus *Persians*, 181–183, in which a woman wearing a Doric *peplos* appears in a dream as the personification of Greece.[69]

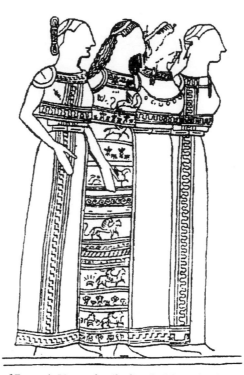

**Fig. 9.** Drawing of François Vase – detail of Moirai (Fates). Kleitias and Ergotimos, ca. 570 B.C. F. Studniczka, *Beiträge zur Geschichte der altgriechischen Tracht* 98, fig. 28. (Photo: Bryn Mawr College, Visual Resources Department.)

## Problems of Interpretation: What Is a *Peplos*?

Following the publication of Studniczka's thesis, the essential equivalence of the Doric garment and the Homeric *peplos* found ready acceptance among scholars, and his diagrams of the arrangement of the *peplos* were broadly reproduced (Figs. 11–14).[70] His interpretation has been dominant for more than a century.[71] Some of the inconsistencies in his arguments, most notably the absence of the *peplos* from Herodotus's discussion of Doric and Ionic styles of dress, are explained by Studniczka's adherence to the intellectual currents in Germany at that time, which emphasized Indo-European linguistic theory and the German cultural and ethnic identification with the Greeks. But while Studniczka's argument is logical from a linguistic standpoint, it is unclear whether the term *peplos* indeed

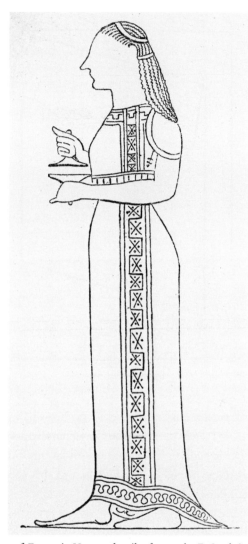

**Fig. 10.** Drawing of François Vase – detail of nymph. F. Studniczka, *Beiträge zur Geschichte der altgriechischen Tracht* 98, fig. 29. (Photo: Bryn Mawr College, Visual Resources Department.)

refers to the pinned garment depicted in later Greek art or, conversely, whether the pinned garment represented in art was in fact called *peplos*.

Studniczka assumes that as a result of the anti-Ionian sentiment following Persian Wars, women rejected the Ionic *chiton* in favor of the

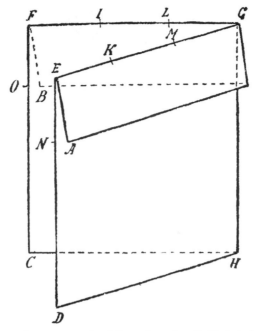

**Fig. 11.** Diagram of arrangement of "open" *peplos*. F. Studniczka, *Beiträge zur Geschichte der altgriechischen Tracht* 6, fig. 1. (Photo: Bryn Mawr College, Visual Resources Department.)

traditional Doric *peplos*. His primary evidence for this interpretation is literary, the scene in Aeschylus's *Persians* in which the personification of Greece wears a Doric *peplos*.[72] On closer examination of this passage, his interpretation is undermined by the fact that in this scene the parallel personification of Persia also wears a *peplos*:

> Two beautifully dressed women seemed to appear to me, one decked out in Persian *peploi*, the other in Doric.
>
> (*Pers.* 181–183)[73]

It seems that in this case the *peplos* cannot be interpreted as specifically a Doric or even a Hellenic garment. In addition, since Herodotus, writing in the middle of the fifth century, does not mention Greek women taking up the pinned Dorian garment after the Persian Wars, this historical assumption must be questioned.

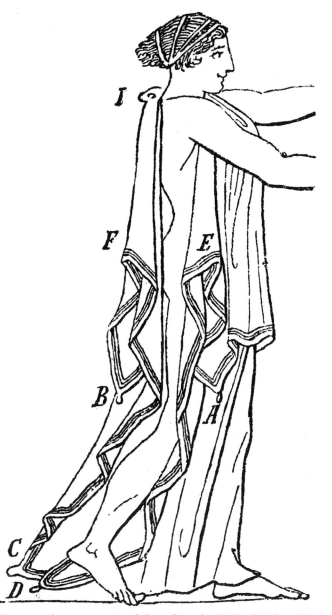

**Fig. 12.** Diagram of arrangement of "open" *peplos*. F. Studniczka, *Beiträge zur Geschichte der altgriechischen Tracht* 7, fig. 2. (Photo: Bryn Mawr College, Visual Resources Department.)

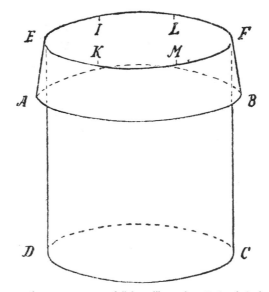

**Fig. 13.** Diagram of arrangement of "closed" *peplos*. F. Studniczka, *Beiträge zur Geschichte der altgriechischen Tracht* 10, fig. 6. (Photo: Bryn Mawr College, Visual Resources Department.)

The artistic evidence for the *peplos* is likewise problematic. Studniczka cites the François Vase (Figs. 9, 10) as evidence for the pinned Doric garment. Of course, this vase dates to ca. 570 B.C. and therefore is not evidence for the existence of the pinned garment after 480/79, the end of the Persian Wars. But in fact the representation of dress pins is extremely rare in either painting or sculpture of the Archaic or Classical periods.[74] While the absence of fasteners can be explained away by artistic license, the fact that pins are so central to the story of Herodotus, which is the basis of Studniczka's conception of the Doric garment, suggests that dress fasteners should be prominent in artistic representations.[75]

The most likely solution to the problem of the missing dress pins is that women did not in fact readopt the old pinned garment in the fifth century B.C. This interpretation is supported by the fact that few functional dress pins have been discovered in Greece in contexts later than the seventh century B.C.[76] Studniczka (and others) assumed that the garments represented in art replicated those worn in contemporary life.[77] In fact, there is no reason a priori why this should be the case,

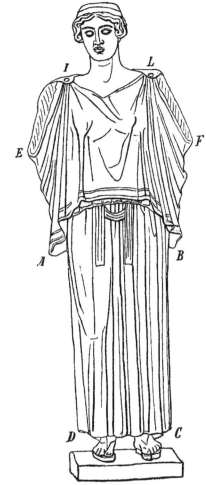

**Fig. 14.** Diagram of arrangement of "closed" *peplos*. F. Studniczka, *Beiträge zur Geschichte der altgriechischen Tracht* 10, fig. 5. (Photo: Bryn Mawr College, Visual Resources Department.)

especially since most artistic representations during the Early Classical period depict mythological and heroic stories and events. A more likely interpretation is that the simple, pinned garment was remembered from earlier times (perhaps through its continued use in ritual contexts?) and applied to heroic and mythological figures in art of the fifth century as a means of marking them as historical. As we have seen, this theory had in fact been put forth in the eighteenth and nineteenth centuries by Winckelmann, Böttiger, Becker, and Müller, but had been forgotten by Studniczka and later scholars who assumed the historicity of the garment

as a means of asserting the vitality of the Dorians, their ethnic and cultural ancestors.

Modern emphasis on the Dorian and Ionian styles of dress, as canonized by Studniczka, not only clouds scholarly vision of the evidence for Greek dress, but also detracts from the reasoning behind the dichotomy in the first place. The concepts of Dorian and Ionian are so firmly entrenched in our scholarly discourse that we do not question their identification or even their appropriateness as categories for analysis. In fact, our conceptions "go back so far in [the] intellectual tradition that the fragility of their basis is hard to recognize."[78] Having exposed the unsubstantial basis for our identification of the *peplos*, we are in the enviable position of looking at the evidence afresh, to understand it on its own terms. By diverging from the traditional binary opposition of Doric/Ionic::*peplos*/*chiton*, we can begin to ask new questions of the evidence, especially the social and semiotic functions of Greek garments, which have been largely neglected.

## NOTES

1.  I wish to thank the editors for their useful comments. Special thanks are due also to Joseph L. Rife, who aided in translating Renaissance and early modern scholarship in Latin and discussed with me many other aspects of this study. L. Battezzato kindly forwarded me the proofs of his recent work on Dorian dress in Greek tragedy in advance of their appearance in print. This article was completed while I was a visiting scholar in the Department of Classics at Cornell University. I thank Hayden Pelliccia for making the excellent resources at Cornell available to me.

    This article is derived from a chapter of my dissertation, "The Myth of the Classical *Peplos*" (Bryn Mawr College, 1999). Aspects of this work have been presented at the Joint Annual Meetings of the Archaeological Institute of America and the American Philological Association: "The Tragedic *Peplos*: A Heroic Garment Transformed," APA *Abstract Book* (2001) 203; "The Gendered Meaning of the Early Classical Peplos," *American Journal of Archaeology* 104 (2000) 355–356; "Problems of the Classical Peplophoros," *AJA* 103 (1999) 269.

    The following abbreviations are employed:

    Böttiger, *Raub der Cassandra*: C. A. Böttiger, *Über den Raub der Cassandra auf einem alten Gefässe von gebrannter Erde* (Weimar, 1794)

    Helbig, *Das homerische Epos*: W. Helbig, *Das homerische Epos aus den Denkmälern erläutert* (2nd ed.; Leipzig, 1884)

    Ferrarius, "De re vestiaria": O. Ferrarius, "De re vestiaria" in J. G. Graevius, ed., *Thesaurus Antiquitatus Romanum* VI (Leiden, 1697) 605–912

Lee, "Myth": M. M. Lee, "The Myth of the Classical *Peplos*" (diss. Bryn Mawr College, 1999)

Müller, *History and Antiquities*: K. O. Müller, *The History and Antiquities of the Doric Race*, trans. H. Tufnell and G. C. Lewis (2nd ed.; London, 1839)

Studniczka, *Beiträge*: F. Studniczka, *Beiträge zur Geschichte der altgriechischen Tracht* (Vienna, 1886)

2. The terms *apoptygma* and *kolpos* are problematic. See M. M. Lee, "Problems of Dress Terminology: *kolpos* and *apoptygma*," in preparation.

3. Although Athena is frequently represented wearing the over-girded *peplos*, it is worn by other goddesses as well, and may serve to distinguish active figures (B. S. Ridgway, *Severe Style* [Princeton, 1970] 29) or perhaps maiden divinities (E. B. Harrison, *The Athenian Agora* XI: *Archaic and Archaistic Sculpture* [Princeton, 1965] 52).

4. Ridgway, *Severe Style* (supra n. 3) 8.

5. For discussion of the literary testimonia for the *peplos*, see Lee, "Myth" 58–217, Ch. 3: "Literary Evidence for the Classical *Peplos*." See also the older but still useful discussions by M. M. Evans, *Chapters on Greek Dress* (London, 1893) 27–29; and E. B. Abrahams, *Greek Dress: A Study of the Costumes Worn in Ancient Greece, from Pre-Hellenic Times to the Hellenistic Age* (London, 1908) 39–42 (both repr. in M. Johnson, ed., *Ancient Greek Dress* [Chicago, 1964]).

   Renate Tölle-Kastenbein promised a review of ancient uses of the term *peplos* in the third volume of her three-part study of the *peplophoros* sculptural type (*Frühklassische Peplosfiguren. Originale* [Mainz, 1980] 239), but the volume was unpublished at her death in 1995 (Monika Kastenbein, *per ep.*).

6. Translation adapted from D. Grene, trans., *Herodotus: The History* (Chicago, 1987).

7. Athens, Acropolis Museum 589 and 675. Most earlier scholars failed to note that this early *peplos* is worn with a sleeved undergarment.

8. Studniczka, *Beiträge* vii; H. Weber, "Griechische Frauentrachten im vierten Jahrhundert vor der Zeitwende," in *Beiträge zur Trachtsgeschichte Griechenlands* (Würzburg, 1938) 120.

9. Translation adapted from R. Crawley, trans., *Thucydides. The Peloponnesian War* (London and New York, 1910; repr. New York, 1982).

10. G. Crane notes, "Thucydides excluded women from his work to a degree unmatched by virtually any classical Greek author." *Thucydides and the Ancient Simplicity: The Limits of Political Realism* (Berkeley, Los Angeles, and London, 1998) 57.

   On men's dress in fifth-century Athens, see A. G. Geddes, "Rags and Riches: The Costume of Athenian Men in the Fifth Century," *Classical Quarterly* 37 (1987) 307–331.

11. A. W. Gomme, *A Historical Commentary on Thucydides* I (Oxford, 1945) 101–106.

12. T. Figueira, "Herodotus on the Early History of Aegina," *American Journal of Philology* 106 (1985) 49–74; repr. with revisions in idem, *Excursions in Epichoric History: Aiginetan Essays* (Lanham, 1993) 35–60.

13. C. Dewald suggests that the Herodotean tale is derived from a series of misogynistic folk stories in which a group of maddened women attacks a defenseless male: "Women and Culture in Herodotus' *Histories*," in H. P. Foley, ed., *Reflections of Women in Antiquity* (New York, London, and Paris, 1981) 98. Compare, for example, Euripides' *Bacchae*, in which a group of female followers of Dionysos, possessed by the god, dismembers Pentheus, king of Thebes. L. Battezzato notes that the story of Herodotus is "a very impressive metaphor of the disturbing qualities of the Dorian dress when worn by the 'wrong sex'": "Dorian Dress in Greek Tragedy," in M. Cropp, K. Lee, and D. Sansone, eds., *Euripides and Tragic Theatre in the Late Fifth Century* (*Illinois Classical Studies* 24–25; Champaign, 1999–2000) 353.

14. Ridgway notes that the *peplos* is "sometimes misleadingly called" a Doric *chiton*: *Severe Style* (supra n. 3) 9.

15. An excellent overview of the problems surrounding the study of ancient dress, with special reference to the *peplos*, is B. S. Ridgway, "The Fashion of the Elgin Kore," *The J. Paul Getty Museum Journal* 12 (1984) 29–58.

16. Fragments of textiles, such the fourth-century B.C. examples from Kertch with figural decoration in various techniques (including painting or resist-dying, embroidery, and tapestry), are rare and certainly do not give an adequate indication of the construction of actual garments. For the Kertch fragments and the archaeological evidence for Greek textiles in general, including ancient cloth-making technology, see E. J. W. Barber, *Prehistoric Textiles: The Development of Cloth in the Neolithic and Bronze Ages, with Special Reference to the Aegean* (Princeton, 1990), esp. 206–209 on the Kertch textiles. Although complete garments of all periods are preserved in Egypt, they represent a different tradition and cannot be cited as evidence for Greek dress.

17. On the appearance of theatrical costume, see I. Brooke, *Costume in Greek Classic Drama* (London, 1962) and L. M. Stone, *Costume in Aristophanic Comedy* (New York, 1981; repr. Salem, N.H., 1984). The recent article by L. Battezzato on Dorian dress in Greek tragedy accepts the traditional identification of the *peplos* that is questioned in the present study: Battezzato, "Dorian Dress in Greek Tragedy," supra n. 13.

18. See M. Lee, "Evil Wealth of Raiment: The *Peplos* in Greek Tragedy" (in preparation), and Lee, "Myth" 58–63 and 72–77, esp. 76–77.

19. The problem of dress terminology persists in our own culture. The meaning of "robe" for example, is quite different now than it was in Elizabethan England, and women's hosiery is variously called pantyhose, stockings, nylons, or tights (the latter having a different meaning in the United Kingdom than in the United States). Likewise, we use "dress" to refer to garments that look very different over time, as in fact may have been the case in antiquity.

20. On Roman misunderstanding of Greek garments, see M. Bieber, *Ancient Copies: Contributions to the History of Greek and Roman Art* (New York, 1977) 27–39 and passim.

21. L. de Baïf, *De re vestiaria libellus, ex Bayfio excerptus: addita vulgaris linguae interpretatione, in adulesc[n]tuloru[m] gratiam atq[ue]; utilitatem* (2nd ed.; Paris, 1535).

22. A particularly curious example given by Baïf concerns a garment that peasants of his time called *hoqueton*, a term he suggests retained the ancient meaning of ὁ χιτών: (supra n. 21) *De re vestiaria libellus* 21.

23. Baïf, *De re vestiaria libellus* (supra n. 21) 21–22, 36.

24. C. Salmasius, *Tertulliani Liber de Pallio* (Leiden, 1656). On Tertullian's *De pallio*, see C. Vout, "The Myth of the Toga: Understanding the History of Roman Dress," *Greece and Rome* 43 (1996) 204–220, esp. 216–218.

25. Salmasius was also an editor of Pollux's *Onomasticon*.

26. Ferrarius, "De re vestiaria" 605–912.

27. Ferrarius, "De re vestiaria" 870.

28. Ferrarius, "De re vestiaria" 870. Compare the arguments of Studniczka for an Indo-European origin of the *peplos*: infra, pp. 132–133.

29. O. Ferrarius, "Analecta de re vestiaria," in J. G. Graevius, ed., *Thesaurus Antiquitatus Romanum* VI (Leiden, 1697) 1103.

30. B. de Montfaucon, *Antiquity Explained, and Represented in, Sculptures*, trans. D. Humphreys (London, 1721–1722) suppl. III, 259. The series consists of five volumes and five supplements. The original French edition, *L'antiquité expliquée et représentée en figures*, appeared in Paris in 1719. A facsimile of the English translation was published in New York in 1976.

31. Montfaucon, *Antiquity Explained, and Represented in, Sculptures* (supra n. 30) III 7.

32. Montfaucon, *Antiquity Explained, and Represented in, Sculptures* (supra n. 30) III 24.

33. J. E. Sandys cites 1696 as the original date of this work: *A History of Classical Scholarship* II (3rd ed.; Cambridge, 1921; repr. New York and London, 1967) 327.

34. E. Spanheim, *Les Césars de l'Empereur Julien, traduits du Grec. Par Feu Mr. le Baron de Spanheim, avec des Remarques et des Preuves, enrichie de plus de 300 Médailles, et autres Anciens Monumens Gravés par Bernard Picart le Roman* (Amsterdam, 1728) 276–277.

35. Spanheim, *Les Césars de l'Empereur Julien* 123–124. Spanheim notes that the garment also appears in some cases to be secured over the arm below the level of the breast (see Fig. 6b).

36. Spanheim, *Les Césars de l'Empereur Julien* 123–126. Spanheim quotes extensively from Homer and the Greek tragedians, as well as Xenophon, Theocritus, Clement of Alexandria, Tertullian, and Pollux.

37. J. J. Winckelmann, *Reflections on the Imitation of Greek Works in Painting and Sculpture*, trans. E. Heyer and R. C. Norton (La Salle, 1987) 31–32.

38. J. J. Winckelmann, *The History of Ancient Art*, trans. G. H. Lodge (Boston, 1880) II, 15 (p. 200 in the facsimile of the first German edition, *Geschichte der Kunst des Alterthums* [Dresden, 1764; repr. Baden-Baden and Strasbourg, 1966]).

39. Winckelmann, *The History of Ancient Art* II, 18 (p. 203 in the facsimile of the first German edition [supra n. 38]). Although his text is not accompanied by plates, it seems that Winckelmann understood the *peplos*-cloak as a round piece of cloth that could be worn in two different ways: either as a kind of shawl wrapped around the upper body, or as the "shoulder-pinned back-mantle"

identified by L. J. Roccos, "The Shoulder-pinned Back Mantle in Greek and Roman Sculpture" (diss. New York University, 1986) and "Back-Mantle and Peplos: The Special Costume of Greek Maidens in Fourth-Century and Votive Reliefs," *Hesperia* 69 (2000) 235–265.

40. Winckelmann, *The History of Ancient Art* II, 9 (p. 194 in the facsimile of the first German edition [supra n. 38]).

41. See infra pp. 131–133. On Schlegel's conception of the Greek *Stämme* and its influence on German Hellenism, see E. Rawson, *The Spartan Tradition in European Thought* (Oxford, 1969) 306–343.

42. Winckelmann, *The History of Ancient Art* II, 9 (p. 194 in the facsimile of the first German edition [supra n. 38]).

43. Böttiger, *Raub der Cassandra* 69.

Böttiger was an extremely prolific scholar whose short articles and notes on various aspects of ancient dress appeared in a wide range of publications, including the *Journal des Luxus und der Moden*. See his *Kleine Schriften archäologischen und antiquarischen Inhalts*, ed. J. Sillig (Dresden and Leipzig, 1837–1838). Note, however, the complaint of Wilhelm Adolf Becker (1796–1846) regarding Böttiger's work: "Some of his inquiries are . . . absurdly frivolous; for instance, his investigations as to the use of pocket-handkerchiefs by Grecian ladies": *Charicles or Illustrations of the Private Life of the Ancient Greeks* (3rd ed; London and New York, 1866) xiii.

44. Böttiger, *Raub der Cassandra* 60. Böttiger credits Pollux and the works of Salmasius and Albert Rubens as sources for this information, without citing specific passages.

Rubens, son of the painter Peter Paul Rubens, published an essay in 1665 entitled *De re vestiaria veterum* in which he identifies the *peplos* as the Greek equivalent of the Roman *palla*. This treatise on ancient dress appeared together with his better-known essays on the Gemma Tiberiana and the Gemma Augustea. Although the latter was republished in 1968, his discussion of ancient dress remains relatively inaccessible to modern scholars. See N. T. de Grummond, "The Study of Classical Costume by Philip, Albert, and Peter Paul Rubens," *Journal of the Ringling Museum of Art* (1983) 78–93.

45. Böttiger, *Raub der Cassandra* 60, 61, n. 60. That Dorian women were μονοχίτων is mentioned in Athenaeus, *Deipnosophistae* 13.589.

46. Böttiger, *Raub der Cassandra* 61, n. 60. The distinction between δωριάζειν and ἰωνίζειν is derived from a scholiast on Clement of Alexandria, *Paedagogus* 2.10 cited in the commentary by Friedrich Sylburg.

47. Böttiger, *Raub der Cassandra* 62. Compare Winckelmann, supra p. 129.

48. Böttiger, *Raub der Cassandra* 69.

49. Scholarship on Karl Otfried Müller has undergone a renaissance in recent years, following a long period in which he was avoided on account of the Nazi interest in his work. See W. M. Calder III and R. Schlesier, eds., *Zwischen Rationalismus und Romantik: Karl Otfried Müller und die antike Kultur* (Hildesheim, 1998); J. H. Blok, "Quests for a Scientific Mythology: F. Creuzer and K. O. Müller on History and Myth," in A. Grafton and S. L. Marchand, eds., *Proof and*

Persuasion in History (History and Theory Theme Issue 33; 1994) 26–52. Charges of Müller's racism brought by M. Bernal, in Black Athena: The Afroasiatic Roots of Classical Civilization I (New Brunswick, N.J., 1987) 308–316 have been contested by J. Blok, "Proof and Persuasion in Black Athena I: The case of K. O. Müller," in W. M. J. van Binsbergen, ed., Black Athena: Ten Years After (Talanta 28/29; 1997) 173–208 (with response by Bernal, 209–218). On the Nazi appropriation of Müller's work, see V. Losemann, "Die Dorier im Deutschland der dreißiger und vierziger Jahre," in Zwischen Rationalismus und Romantik 313–348.

50. K. O. Müller, *Geschichten hellenischer Stämme und Städte* II–III. *Die Dorier* (Breslau, 1824). An English translation (with changes authorized by Müller) was published at Oxford in 1830 as *The History and Antiquities of the Doric Race*; a second, revised edition was issued in London in 1839; see supra n. 1. It has been said that this work represents "more an impressive hymn on the excellence of everything Doric than a narration of history": R. Pfeiffer, *History of Classical Scholarship from 1300 to 1850* (Oxford, 1976) 187. *Der Dorier* was poorly received in its own time (J. Blok, " 'Romantische Poesie, Naturphilosophie, Construktion der Geschichte': K. O. Müller's Understanding of History and Myth," in *Zwischen Rationalismus und Romantik* [supra n. 49] 88), and Müller intended to revise it as a result of his personal examination of the evidence during his travels in Greece (Blok, "Proof and Persuasion," [supra n. 49] 195–196). Müller's untimely death in Athens of a fever contracted while copying inscriptions in Delphi precluded further work.

51. In his *Aegineticorum liber* (Berlin, 1817) 64, n. "b", Müller concurs with Herodotus's statement (5.88) that the Dorian dress was similar to the Corinthian. Müller discusses the adoption of Ionic dress in Athens in his treatment of the Erechtheion caryatids: *Minervae Poliadis Sacra et Aedem in Arce Athenarum* (Göttingen, 1820) 40–42.

52. Müller, *History and Antiquities* 274–275. It is uncertain from this passage how Müller conceives of the *himation* in relation to the *chiton*.

53. Müller, *History and Antiquities* 275.

54. Müller, *History and Antiquities* 276.

55. "Euripides (*Androm.* 599. and *Hec.* ubi sup.) calls the Doric dress inaccurately πέπλος" (Müller, *History and Antiquities* 275, n. "m").

56. K. O. Müller, *Handbuch der Archäologie der Kunst* (2nd ed.; Breslau, 1835) 473. An English translation appeared as *Ancient Art and its Remains; or A Manual of the Archaeology of Art*, trans. J. Leitch (London, 1852).

Following Müller, W. A. Becker did not identify the *peplos* as any particular garment; *Charicles* (supra, n. 43) 428: "The word πέπλος, with the exception of the Panathenaic, denotes any article of apparel ordinarily used. . . . If there was originally a particular garment called by this name, it must have become obsolete."

57. Müller, *Handbuch der Archäologie der Kunst* 474.

58. The section on Homeric dress is completely rewritten in the 1887 edition in response to Studniczka, *Beiträge* (see infra, pp. 132–133).

59. Helbig, *Das homerische Epos* 137. Helbig cites as evidence for this frontal closure the description of the toilette of Hera in the *Iliad* (14.180), in which she secures her *heanos kata stêthos* with golden fasteners. Helbig conflates the different names assigned to feminine garments in the Homeric poems, reflecting his reliance on the commentary of Aristarchus, a Hellenistic scholiast of Homer, who had likewise identified the *heanos* with the *peplos*: K. Lehrs, *De Aristarchi studiis homericis* (2nd ed.; Leipzig, 1865) 193.

60. Helbig, *Das homerische Epos* 137–140.

61. Helbig, *Das homerische Epos* 131, 147. Ferrarius had likewise assumed an Eastern origin for the *peplos*: "De re vestiaria" 870.

62. Blok, "Quests for a Scientific Mythology: F. Creuzer and K. O. Müller on History and Myth" (supra n. 49) 27.

63. Studniczka, *Beiträge* 15–16, 93. The etymology for the root *plo-* is taken from G. Curtius, *Grundzüge der griechischen Etymologie* (5th ed; Leipzig, 1879) 271, no. 352. Curtius does not include the word πέπλος in the entry. Compare the etymology suggested by Böttiger; p. 130.

64. Studniczka, *Beiträge* 76–77, 82–83.

65. Studniczka, *Beiträge* 97.
    Although Studniczka cites the figures on the François Vase as evidence for an early Greek pinned garment, pins are rarely depicted in either sculpture or vase-painting (see infra, p. 138).

66. Studniczka, *Beiträge zur Geschichte der altgriechischen Tracht* (supra n. 7) 117.

67. Rawson, *The Spartan Tradition in European Thought* (supra n. 41) 333.

68. Studniczka, *Beiträge* VI. Studniczka's linguistic theories regarding the Indo-European origin of the *peplos* and the Semitic origin of the *chiton* have been corroborated by later studies. See in particular E. J. W. Barber, "The PIE Notion of Cloth and Clothing," *Journal of Indo-European Studies* 3 (1975) 294–320; and O. Szemerényi, "The Origins of the Greek Lexicon: *ex oriente lux,*" *Journal of Hellenic Studies* 94 (1974) 148. It is worth noting that with the decipherment of Linear B, we now know that both linen (*ri-no*) and the *chiton* (*ki-to*) were known in Greece as early as the Bronze Age. See S. Marinatos, *Kleidung, Haar- und Barttracht* (*Archaeologia Homerica* 1 A, B; Göttingen, 1967) A19 and Barber, *Prehistoric Textiles* (supra n. 16) 313.

69. Studniczka, *Beiträge* 12.

70. A thesis by Walter Müller, *Quaestiones vestiariae* (Göttingen, 1890), reviews the arguments of both Helbig and Studniczka, favoring those of Studniczka.

71. The few dissenting opinions are not usually acknowledged. Studniczka's identification of the *peplos* was questioned by Tölle-Kastenbein (*Frühklassische Peplosfiguren* [supra n. 5] 239) and also by H. L. Lorimer, who noted that "the current use of it (the term *peplos*) to denote Dorian costume has no ancient authority" and "the fact that the word is not employed by Herodotus in the passage which constitutes our principal authority on the subject is conclusive against its bearing this meaning in ordinary Greek": *Homer and the Monuments* (London, 1950) 389. S. Marinatos concurred with Lorimer, suggesting that the

Homeric *peplos* was probably a veil (*Kleidung, Haar- und Barttracht* [supra n. 68] A43). *Peplos* in modern Greek means "veil."

72. This passage is discussed in "'Evil Wealth of Raiment': The *Peplos* in Greek Tragedy" (supra n. 18).

73. Translation adapted from E. Hall, ed., trans., *Aeschylus: Persians* (Warminster, 1996).

74. Lee, "Myth" 270–350, Ch. 5: "The *Peplophoros* in Early Classical Sculpture."

75. The few representations of fasteners in Greek sculpture are in the form of round buttons or brooches, not the shaft-style pins suggested by Herodotus's story.

76. Lorimer, *Homer and the Monuments* (supra n. 71) 351, 396, 401.

77. For explicit statements regarding the supposed historicity of the garments represented in art, see J. P. Small, "The Tarquins and Servius Tullius at Banquet," *Mélanges de l'École française de Rome, Antiquité* 103 (1991) 247; J. Boardman, "Symbol and Story in Geometric Art," in W. Moon, ed., *Ancient Greek Art and Iconography* (Madison, 1983) 31.

78. Rawson, *The Spartan Tradition in European Thought* (supra n. 41) 343.

# 7

## Mrs. Arthur Strong, Morelli, and the Troopers of Cortés*

MARY BEARD

On July 14, 1925, a gala dinner was held at the Hotel Cecil in London to mark the "retirement" of Mrs. Arthur Strong from her post as Assistant Director of the British School at Rome.[1] There were almost 200 guests, ranging from Mrs. Strong's family and her friends from college days to political grandees, notable intellectuals and – to add some bona fide royal allure – one of Queen Victoria's innumerable grandchildren, Princess Helena Victoria. The Earl of Oxford and Asquith (otherwise known as H. H. Asquith the [ex-]Prime Minister) rubbed distinguished shoulders with the stars of the Academy and of the chattering classes: the historian G. M. Trevelyan, the (J. G.) Frazers, Gisela Richter, Mrs. Holman Hunt (Mrs. Strong had modelled for her husband years before), Mary Costelloe (aka Mrs. Bernard Berenson), and well over a hundred more. The speeches, celebrating Mrs. Strong's career, came with the coffee. Asquith was no more extravagant in his praises than any of the others who rose to their feet when he puffed, "[T]here is no more distinguished woman scholar to be found anywhere today."

Mrs. Strong's fame has not lasted. It is true that Roman art historians, particularly in the United States, still recognize her influence; her history of Roman sculpture was after all the first *history* of Roman sculpture ever produced in English. It is also true that many of us still use the translation and commentary on *The Elder Pliny's Chapters on the History of Art* that she edited with Katharine Jex-Blake.[2] But popular memory recalls her quite differently: as the eccentric, name-dropping, and impossibly domineering doyenne who presided over the British School at Rome and

expatriate society in Rome and who – embarrassingly – took "tea with Mussolini." She now hardly rates a place in the academic pantheon. In invidious comparison with the likes of Arthur Evans, Lily Ross Taylor, Jane Harrison, or John Beazley, she no longer seems worth taking the trouble to remember.[3]

The aim of this essay is not a full-scale rehabilitation of Mrs. Strong; her published work can, and must, speak for itself.[4] I want instead to explore the origins of her involvement in the history of ancient art, before she became that legendary, and slightly ludicrous, presence in the British community in Rome. In scratching the surface of Mrs. Strong's (or rather Miss Sellers's, as she then was) career in the 1880s and 1890s, I shall be revealing the almost entirely forgotten involvement of Strong and her circle in those lively late-nineteenth century controversies around the work of Giovanni Morelli and its impact on the study of ancient art. Strong, it turns out, was a central figure in the "Morellian revolution" that fascinated London when English versions of his books were published: notably *Italian Masters* in 1883 (translating *Die Werke italienischer Meister*) and *Italian Painters* (*Kunstkritische Studien über italienische Malerei*) in 1892–1893.

This holds considerable significance in the historiography of ancient art, and must have an impact on the collusive genealogies through which (we) ancient art historians make sense of the history of our subject. For it is not the work of Mrs. Strong, but of Sir John Beazley that is almost universally assumed to be the main conduit through which the "Morellian method" (an indispensable tool, or the dead hand of connoisseurship, depending on your point of view) entered classical art history. And, as we shall see, numerous recent studies have attempted to trace the links between Beazley's methods in identifying individual artists among the vast – and for the most part unsigned – repertoire of Greek painted pottery and Morelli's argument that apparently trivial details in the treatment of ears, eyes, or hands are the surest guide to an artist's identity. In showing that Strong and her friends were engaged in intense discussion of Morelli's work and its implications for classical art history years before Beazley (who was born in 1885) even looked at a Greek pot, and in pointing to a much more direct connection between Strong's writing and Morelli than has ever been demonstrated in the case of Beazley, I am not trying to

replace one fountain of influence and authority with another or simply to put Strong in Beazley's place. Rather I am prompting readers to wonder what the traditional exclusion of Mrs. Strong from the Morellian story tells us about how the history of classical art history has been constructed and what it tells us about how we decide who counts, or doesn't, as one of our intellectual ancestors.

## "All My Archaeology Was Taught Me by Germans."[5]

Mrs. Strong (1860–1943) was one of the first "professional" historians of classical art in Great Britain. She learnt her art history just as the subject was carving out a place for itself within the institutional structure of British academic life – just at the moment when a whole series of trade-offs and compromises between archaeology in the broadest sense imaginable, German-style *Kunstgeschichte*, and traditional Classics was resulting in something that could be called "classical art history." As this section will show, her early career was marked by several of the conflicting influences that she, and others, would in due course improvise into a discipline in its own right.

Miss Eugénie Sellers went up to Girton College in Cambridge to read Classics in 1879, aged nineteen. She had led a peripatetic childhood in Europe, with not much formal schooling. However clever and enthusiastic she may have been, she was almost certainly ill-prepared for the demands of the Classical Tripos – designed, as it had been, for young men who had been rigorously drilled in Latin and Greek (and in not much else) from a disconcertingly young age. Not surprisingly, she did very badly in her examinations (achieving only a mark in the "third division" of the "third class" – a pass, but one of the worst grades it was possible to be awarded). From Cambridge she moved first to schoolteaching, where success again eluded her (like many bad teachers, before and since, she was later to claim that her methods had been too radical); and then on to London, where she lived independently, supporting herself by tutoring and lecturing, while studying archaeology. [6]

At the very end of her career, in notes she was preparing for a never-to-be-written autobiography, she looked back at her archaeological training

and loudly trumpeted the support she had received from the Germans, whether in Munich or at the German Institute in Rome. "In Germany," she wrote, "and at the Institute I received fullest encouragement and help, contrasting painfully with the blank my effort had drawn in England, more especially from my own University of Cambridge."[7] This was partly true. During the late 1880s and 1890s she spent periods of several months in Munich working with Adolf Furtwängler and other luminaries on the German scene. It must have been a memorable immersion in a continental tradition of art history, as well as being a convenient excuse for her absence from England in the rougher patches of her up-and-down, on-off romance with Sandford Arthur Strong, whom she was eventually to marry in 1897. But her emphasis on German teaching alone was also a flagrantly unfair representation of the support she *had* (or might have) received at home.[8]

In fact, her time as a student in Cambridge was precisely the period when Classical Archaeology was inaugurated as a subject of study in the "Tripos" (as the Cambridge degree is still known). Between 1873 and 1885, Sidney Colvin, as Slade Professor of Art, regularly lectured on classical sculpture, while as Director of the Fitzwilliam Museum he was also instrumental in assembling from across Europe the hundreds of plaster casts of Greek and Roman sculpture that were to make up the brand-new Cambridge Museum of Classical Archaeology – formally opened in 1884 in the presence of royalty (another of Queen Victoria's grandchildren) and a variety of glitterati, including Lord (then Sir F.) Leighton, Lawrence Alma-Tadema, and Edward Poynter. These plaster casts played an integral part in the teaching of the new optional course in classical archaeology, introduced in 1879 thanks to the reforming zeal of those energetic late Victorians who wished to see the Cambridge Classical degree extended beyond mere exercises in language and translation. This new course was divided into four main parts: "the history of art, and the lives and works of artists"; "mythologies and religious beliefs"; "a special class or group of monuments, or the chorography, topography, and monuments of a special site or district"; "the art and handicraft, and the inscriptions, of the ancient Greeks and Romans." It was a characteristically nineteenth-century attempt to define the extent of "classical archaeology"; and it

was taught, lectured, and examined by a combination of amateur local talent who could claim some knowledge of at least part of the syllabus (J. G. Frazer, for example, is recorded as one of its first examiners) and a convenient, if pushy, new arrival on the Cambridge scene – the German-American art historian Charles Waldstein, with a degree from Columbia and a doctorate from Heidelberg.[9]

Eugénie Sellers chose not to stay on in Cambridge and take this new option (ready enough to leave, maybe, after her "third division, third class"). But in London she quickly became part of a social and intellectual circle at the forefront of debating the theory and method of classical archaeology and art history. Among her close friends was Sir Charles Newton (1816–1894), the Keeper of Greek and Roman Antiquities at the British Museum, the discoverer and restorer of the sculptures of the Mausoleum of Halicarnassus, and author of an extremely influential essay on the definition of archaeology. For Newton, archaeology was not simply exploration and excavation or the study of ancient art and architecture, but the study of *all* cultural and historical phenomena not transmitted by the printed word, from Christian iconography to the history of carpentry.[10] Something of his influence can be detected behind that wide-ranging first syllabus in classical archaeology at Cambridge, which (from our perspective) incongruously sets questions on Pheidias side by side with questions on the costume of the Flamen Dialis. And something of his influence will no doubt have rubbed off on Miss Sellers, too, whom Newton took to the theater and out to dinner, and conscripted into his amateur dramatic projects – while, at the same time, guiding her interests in ancient art and archaeology.[11]

But in London Sellers was even closer – quite *how* close is a matter of dispute – to two women, slightly older than herself, who had already made their mark in the history of art: Jane Ellen Harrison (1850–1928) and Vernon Lee (1856–1935). Jane Harrison is usually fitted into our subject classifications as a historian of Greek religion, but in late Victorian terms she was very much an "archaeologist" as Newton (she, and Cambridge) would have defined it. Even in our terms almost all her work, including her two most famous studies of religious history – *Prolegomena to the Study of Greek Religion* and *Themis* – is founded on the study of visual

images. Like Sellers, she had read Classics in Cambridge (at Newnham, not Girton), and then after a spot of unsuccessful schoolteaching, had also moved to London to work on art and archaeology and to support herself by teaching. Sellers was one of her pupils, doubling as Harrison's business manager and secretary (organizing some of her increasingly popular celebrity lectures); and for a short while at least they shared a flat. To judge from surviving teaching exercises given by Harrison to other pupils during this period, Sellers would have been expected to interrogate the iconography of ancient (almost exclusively Greek) art. At the top of Harrison's agenda in the 1880s and 1890s was the "decoding" of both sculpture and vase painting, and critical comparison between different visual media in the exploration of myth and its significance. As she repeatedly said in her course outlines, as well as the prefaces of her books, Harrison's approach was founded on the simple idea that art *means* something.[12]

"Vernon Lee" (her real name was Violet Paget) was a quite different influence again. One of the most outrageous intellectual celebrities of the late nineteenth and early twentieth centuries, she was an infamous art critic, novelist, and fashionable lesbian, the author of more than forty books, who kept a home base with the expatriate community in Florence but toured Europe as much as her self-proclaimed poverty could afford. She first met Sellers at a dinner party at Charles Newton's in 1886, and, despite occasional ruptures, they remained friends until Lee's death in 1935. (They, too, shared a London flat for some part of the 1880s, but fell out – significantly, I guess – over the cleaning arrangements.) Lee's own approach to art history is extremely hard to pin down. But in the period when she was first getting to know Sellers, she was making a good deal of noise about the psychological aspects of perception, and about gender and art – notably in her novel *Miss Brown*, which was a sharp, and no doubt richly deserved, critique of the Pre-Raphaelites' exploitation of their models.[13]

The flavor of the high-octane debates between these women (with Newton hovering in the background) emerges from surviving letters between Sellers and Lee on the subject of Harrison's early book (published in 1885), *Introductory Studies in Greek Art*. This was essentially the text of

the public lectures she gave in the British Museum, introducing a general audience to its classical collections. For Lee's taste, its approach to art history was an appallingly aesthetic, cloying Platonic ideality – a far cry, we must even now admit, from the radical irrationalism of Harrison's later work, or even from the hardheaded iconographic exercises she was setting her private students at the time. A complex tale of misunderstanding, bad faith, and convenient amnesia emerges from the correspondence. Lee, it seems, had written to Newton as soon as the book was published, to tell him what she thought and to ask him to pass her comments on to Miss Harrison. Newton, on his part, had decided, consciously or unconsciously, to forget this request; so when Lee first met Sellers across Charles Newton's dinner table, she harangued her (for she was presumably well known to be Harrison's sidekick) on the evils of the book and followed this up with letters to Sellers accusing Harrison of "having no instinct for art of any kind." Sellers kept her own counsel for a while, but finally plunged in to defend her teacher: "For years," she eventually wrote to Lee, "even after my 'discovery' of the Elgin Marbles I was a terrible materialist – and pictures and statues seemed to me pleasant things to look at, and that was about all. It is to Miss Harrison's teaching solely at first that I owe having even thought that their mission might be quite other than to amuse me."[14] That, from the woman who fifty years later was to claim that her art-historical training had been entirely German.

In 1897 Sellers, at last, married Arthur Strong, Professor of Arabic at University College London, and simultaneously Librarian of the House of Lords and for the Duke of Devonshire at Chatsworth. By then she had spent fifteen years at the cutting edges of different styles of German and British archaeology. After just seven years of marriage, her husband died (from the modishly diagnosed "pernicious anaemia"), and widowhood marked a defining break in her career. It gave her a new title, "Mrs. Arthur Strong, widow," and in 1909 it launched her into a new job, when she was installed as Assistant Director and Librarian of the fledgling British School at Rome. This period of her life is not the subject of this essay. Suffice it to note that, at first, she made an outstandingly successful pair with the much more retiring Director, Thomas Ashby: he went out, in best boy-scout tradition, plodding over the Roman Campagna, inventing

what we would now call archaeological "field-survey," while she effectively ran the institution and gave it a public face. But shortly after (and maybe not unconnected with) Ashby's marriage in 1921, relations broke down. By the early 1920s their quarrels were so dreadful and disruptive to the School that both Ashby and Strong were effectively sacked – in her case, under the cover of the honorable "retirement" that was so effusively celebrated, and wistfully regretted, at the glamorous dinner at the Hotel Cecil. Nevertheless, she remained in Rome for the rest of her life, an increasingly strident advocate of *Romanità* (with or without Mussolini) and of the claims of Roman art and culture against Greek. She died there in 1943.[15]

It was a long and prolific career. Her published books and articles over more than half a century offer endless temptation for the modern historiographer in search of the competing influences and allegiances lying behind her work; they trail a series of quite different versions of what is to count as "classical art history" and its proper concerns. As she herself announced, the formative role of German scholarship (and of Furtwängler in particular) is clear enough. She produced a series of translations of German-language works on archaeology and art history (including Karl Schuchhardt's *Schliemann's Excavations* in 1891, Furtwängler's *Meisterwerke* in 1895, and Franz Wickhoff's *Roman Art* in 1900), and she heralded her major book *Roman Sculpture from Augustus to Constantine* (1907) as part of a dialogue with Wickhoff, Riegl, and Strzygowski. But, unsurprisingly perhaps, it is hard not to detect also a characteristically British side. The insistence in *Apotheosis and After Life* (1915), for example, on the interconnection of visual representation and religion could come almost directly from Jane Harrison and the cultural anthropology embedded in the classical archaeology of Newton and Cambridge.[16] There are plenty of puzzles, too. The most tantalizing mystery is what lay behind the radical shift from her early studies of Greek art to her later fanatical (and sometimes, frankly, irritating) championship of all things Roman. Speculation – on her growing attachment to Italy, her latent Catholicism, private quarrels with leading hellenists, or increasingly Fascist leanings – remains just that.[17]

In the rest of this essay I shall be focussing on one of her earliest books, on its context and reception: *Masterpieces of Greek Sculpture*, published in

1895 as a translation of Adolf Furtwängler's *Meisterwerke* of 1893.[18] This book was renowned, and controversial, for being the most systematic attempt ever to identify (and reconstruct) the Classical Greek originals that supposedly lay behind the Greco-Roman "copies" that filled the museums of the West. Today Furtwängler's project seems dangerously unfashionable, a derided ancestor of that whole brand of *Kopienkritik* that willfully elevates the search for the lost (Greek) prototype above the (Roman) materiality of the objects we actually have. And Eugénie Sellers's role in producing an English translation (albeit as Furtwängler's personally chosen translator[19]) usually remains unremarked, a classic case of the invisibility of the translator's service industry within the hierarchy of academic glory. I hope to show that Sellers's contribution was much more active than that stereotype allows; that her re-presentation of Furtwängler in English to a British audience, and at the same time the explicitly theoretical framing that she gave to his work, have a much wider significance than we have come to assume – particularly in the context of the "Morellian revolution."

## Lermolieff Mania

It is impossible to imagine that anyone operating within the literary and artistic circles of late Victorian London would have been able to steer entirely clear of the controversy surrounding the work of Giovanni Morelli (1816–1891). A doctor by training and a leading politician in newly unified, late nineteenth-century Italy, Morelli's third – and most remarkable – string was art history. In a series of engagingly witty, and dangerously outspoken, books first published in German (under the parodically Russian pseudonym "Ivan Lermolieff"), he challenged the attribution of many of the most famous paintings in the most famous galleries of Europe. Ridiculing the low standards of connoisseurship that underlay the identification of so many "Titians," "Raphaels," and "Botticellis," he argued that attribution should be based on a much greater attention to the *detail* – and particularly to those apparently unimportant details such as ear lobes, fingernails, or eyelids which (he claimed) betrayed the characteristic style of their artist more reliably than anything else. It was part of the spirit of

the enterprise to spare his victims (including many of the leading European collectors, museum curators, and art critics) no blushes, to perch as a gadfly on their whole discipline and mock their pretentious certainties. "A director of a gallery or a professor," he wrote in one of his prefaces, "is apt to think it due to his high office that he should lay down the law to others and to feel himself debarred from admitting that he has anything more to learn or that he may have committed mistakes."[20] It should come as no surprise then that his German readership was split between vociferously admiring and, equally vociferously, deploring his method and his rhetoric; no surprise either that an English-speaking readership was ready to join in the fun and the outrage.[21]

The first translation of Morelli in English appeared in 1883: *Italian Masters in German Galleries* translated by Louise M. Richter, the mother of Gisela and the wife of the art historian Jean Paul Richter. He was one of Morelli's closest friends, and the advertisement for the book assured its readers that Mrs. Richter had "naturally profited by her husband's supervision."[22] *Italian Masters* was followed in 1892–1893 by *Italian Painters* translated by Constance Jocelyn Ffoulkes, with a long introduction by Sir Henry Layard (the famous Babylonian archaeologist who had more than a side interest in Renaissance painting).[23] Both these books caused an enormous stir among the chattering classes of London. They were reviewed by all the upmarket papers and magazines, which were split between, on the one hand, admiration for Morelli's introduction of a healthy bit of science into art history, and, on the other, utter abomination for Morelli's tone, methods, arguments, and spurious novelty. The Morellian method may now be regularly treated as something quintessentially late Victorian, as an intellectual revolution no less embedded in the discursive practices of the late nineteenth century than Sherlock Holmes or Freudian analysis. This violent disagreement about its merits is a salutory reminder that other quintessential late Victorians did not necessarily like what he had to say.

On the favorable side, Cosmo Monkhouse – then a prominent critic, now best remembered, if at all, as the author of the catchiest limericks in the English language – reviewed Mrs. Richter's translation of "a justly celebrated work" in the *Academy*: "I am not one of those," he wrote,

"who think that Sig Morelli's dream of a real science of art will ever be realised. . . . But the writings of Sig Morelli cannot fail to promote the study of Old Masters in a more rational spirit and on a sounder system."[24] The anonymous reviewer in the *Times* of the 1892–1893 translation chimed in on very similar terms: "to a profound knowledge of the history and technique of Italian art, Morelli has added a critical faculty as sagacious as it was delicate and discriminating, and a rare gift of caustic expression."[25] But the majority of comments went the other way and were fired off in all directions (and with a good smattering of misogyny). Many critics found Morelli himself quite insufferable: "He has a ready pen and, apparently, a large collection of photographs," remarked the reviewer of Mrs. Richter's translation in the *Athenaeum*; "His self-confidence is unbounded, and a lively animus gives energy to the sharp remarks in which his pages abound, and which are not least insulting when they are veiled by mock humility and the affectation of deference. There is a good deal that is feminine in the bitterness of Signor Morelli."[26] The *Times* likewise lamented the "tedious polemics" of this first book, in an art-historical world that (believe it or not) was said to be distinguished by the "absence of acrimonious personalities."[27] Others denounced the whole method – or said it was nothing new anyway: "The methods . . . were not invented by our author," ran an anonymous review in the *Athenaeum*, "although to read the praises lavished on him and his criticism, one would suppose they were unknown until he expounded them. . . . Is it possible that Sir Henry Layard can imagine that this had never been done before?"[28] One of the nastiest attacks was printed in the most influential magazine of them all. Side by side with articles on "The demoralisation of Russia" and "The new yachting," the *Fortnightly Review* for 1891 carried a piece by Wilhelm von Bode, the Director of the Berlin Museum (which Morelli had, of course, figuratively, ransacked). It pilloried the Lermolieff mania sweeping Germany ("an altogether strange epidemic is raging among us now"), ridiculed the author as a "quack doctor" and, worse still, as a "Romanised Swiss" and let out some squeals of righteous indignation: "[He] makes fun of us Germans on nearly every page of his books, he has formed a sect of German and half-German believers who endeavour to propagate his

teaching by embittering the lives of us, directors of picture galleries, with the usual amenity of sectarians."[29]

Eugénie Sellers had an even closer contact with the Morellian debate than the average avid reader of the *Fortnightly* (which she, no doubt, also was). Through Vernon Lee she had met one of the other great Morellians, Bernard Berenson, and she often stayed in Italy with him and his lover Mary Costelloe. A letter of 1896 describes the three of them in Italy, Morelli in hand, "re-writing the picture galleries": "the young man is far from stupid," the observer conceded, "but it is an unfortunate position to be in: the teacher and prophet of two admiring spinsters, one of whom is a widow."[30] (By widow he must mean Costelloe – though in fact she had abandoned her husband, still far from dead, in England.) Nor was this Sellers's first introduction to Morelli. A year earlier, Arthur Strong had sent her a letter while she was abroad, mixing romantic sweet-talk with snatches of bibliographic advice: "Morelli you probably have with you," he wrote.[31] But, in fact, as early as 1893, Sellers had been exploring the "Morellian method" on her own, and she was to incorporate the results in her "translation" of Furtwängler's *Meisterwerke*.

## The Troopers of Cortés

On July 13, 1893, Vernon Lee, in London, wrote a letter to her mother in Florence about her growing friendship with the beautiful young archaeologist, Miss Sellers: "Miss Sellers is doing such interesting work," she gushed. "She is applying to antique sculpture the method lately invented by Morelli for painting – namely accurate and minute study of single forms and methods of representation of each master. A man gets dominated by certain forms, or manners of vision, quite as much as by a technique, and it becomes an infallible means of identification. Thus Polyclite and Myron seek to represent hair in quite a different way."[32] Sellers was actually working on the so-called Aberdeen Head in the British Museum, which she was trying to prove (as others had already guessed) was an original piece by Praxiteles. Her method was to compare the details of the piece in the British Museum ("the form of the eyeball, and the modelling of both upper and lower lids . . . the little furrow indicated between the eyebrow

and the eyelid") with those of the Hermes from Olympia, "the one authenticated work from the hand of Praxiteles." The similarities were consistent and striking. "The head," she claimed, "could only be by the master [Praxiteles] himself," though probably (as she judged from "the use of the drill for the corners of the mouth") from "the artist's later period."[33]

A careful account of her researches on the Aberdeen Head was included in her translation of *Meisterwerke* in 1895, distinguished from Furtwängler's text by brackets, a slightly smaller typeface, and the pair of discreet initials "E. S." at the end of the section. It now merges almost imperceptibly with Furtwängler's long account of Praxitelean copies, and it is hardly recorded or remembered among Mrs. Strong's contributions to the history of classical art. It should hint, however, that we are dealing here with a more active role on her part than the title "translator" might suggest. And it is a more active role that she herself signals in what she calls her "*Editor*'s Preface" (italics mine), where she lists the alterations she has made to Furtwängler's original: strategic omissions, "disengag[ing] the author's arguments from all such controversial matter as might cumber or obscure them," and a substantial increase in the number of plates.[34] The careful explanation of the method she chose in dealing with the Aberdeen Head (including a use of photographic comparisons characteristic of Morelli) should also hint at a Morellian background to her own, if not to Furtwängler's, work.

Neither Furtwängler's *Meisterwerke* nor Sellers's edited translation is usually discussed in Morellian terms. Modern historiographers of our discipline have certainly not gone back to Furtwängler or his translator in their search for the "Morellian moment" in classical art history. This is partly no doubt because there is no mention of Morelli's name anywhere (so far as I have spotted) in either German or English editions of the book; and Morelli is only rarely listed next to J. J. Winckelmann and Heinrich Brunn among the intellectual ancestors behind Furtwängler's work.[35] But that cannot be the end of the story; because Sellers's translation as a whole, over and above the single case of the Aberdeen Head, was certainly seen in Morellian terms by contemporary reviewers.

In one of those classic examples of late Victorian literary corruption, Vernon Lee managed to get hold of her friend's *Masterpieces* to review in

the *Academy* in 1895. After plenty of compliments to "Miss Sellers' splendid English edition," she proceeded to situate Furtwängler's work in the historiography of ancient art from Winckelmann and Visconti through to Morelli: "Its genial quality depends . . . upon the application however tacit to Greek sculpture of the morphological method first formulated with regard to painting by the late Giovanni Morelli." This assertion is modified somewhat later in the review, when she suggests (as some of Morelli's critics had done more stridently) that his method was not quite as new as it might seem, since close observation of detail was already embedded in traditional art-historical practice. Far from a revolutionary change, she wrote, "the Morellian method as practised by Prof Furtwängler is after all only the systematic development of the method unconsciously applied to art by all who are really fitted to deal with it. . . ."[36]

Vernon Lee, we must conclude, had read *Masterpieces of Greek Sculpture* rather more attentively than most of its more recent readers; and she had not been deflected by the simple absence of a name. For in writing in these terms, she was, in fact, glossing the carefully encoded judgement on Morelli and his method that stands out (once you have seen it) at the end of Sellers's editorial introduction to *Masterpieces*:

> Lastly, it is hoped that this book, as it exhibits a picture, will also discover a process. Of the exact nature of that process it would hardly be necessary to speak, but for the fact that the copiousness and brilliancy of the achievements of a single critic in the more popular field of Italian art have thrown us in England into a state of naïve commotion akin to that of the ancient Mexicans, when, having never seen a horse, they mistook the troopers of Cortés for a new species of animal. For, as the critic in question never appears without his hobby, the two coalesce, as it were, in our imagination, until we think and speak of that which is nothing but the course and condition of all fruitful inquiry as if it were the honorific appendage of a particular name and the abnormal product of a particular field. On the contrary the present book is from first to last an example of the inductive method, which . . . is, in principle at least, as old as Winckelmann.[37]

For us, this is a desperately allusive passage, but the point she is making should have been clear enough to those who had lived through the

Morellian controversies of the 1880s and 1890s. Sellers's argument (which was to be followed closely by Lee) is an elegant compromise in the face of a long-running dispute: The Morellian method is brilliant but in its essentials as old as the discipline of art history itself; it is certainly not the unheard-of radicalism that so astounded, upset, or impressed the naive English public, nor is it usefully seen as the invention of a single man and applicable only to the attribution of Renaissance painters; "we" classical art historians have been "Morellian" since Winckelmann. Explicitly, then, all but for the use of his name, Sellers presented her translation of Furtwängler against the background of Morelli, and the book was received, understood, and critiqued in those terms.

That, inevitably, raises the question of how far Furtwängler's original was already itself conceived in Morellian terms, or whether such "Morellianism" was a theoretical and methodological gloss developed in the course of the reception and translation of the book. It is impossible to be certain. It may seem inconceivable that Furtwängler could have been writing in the midst of the "Lermolieff mania" that struck late nineteenth-century Germany without at least seeing its implications for his own work; and various scholars have assumed that Morelli must have been an influence, at some level, in the formulation of *Meisterwerke*. There is, however, no evidence that this was so, either in the book itself, or – so far as I have discovered – in Furtwängler's other published works.[38] It all depends, of course, on what we mean by "influence." If we mean by that all those myriad, complex, and unfathomable ways that ideas enter the intellectual atmosphere, in a shifting terrain of allegiance and reaction, contestation and collusion, then Furtwängler *must* be seen against a Morellian background – as must anyone else writing on art history in Germany and England through the last decades of the nineteeth century. But in a narrower sense, "influence" is a term of art (and of politics and ideology) in the construction of academic and intellectual genealogies. It is a way of theorizing and explaining patterns in the transmission of ideas, approaches, and arguments. As such it depends on *explicitation* – whether in the form of a first-person narrative ("It was after reading Gombrich, that *I* . . .") or, more commonly, in third-person, retrospective claims to make links of affiliation between one scholar and another ("It was after

reading Gombrich, that *he* . . ."). My suggestion is that the explicitation of the Morellian theory in *Meisterwerke* came from its theoretically informed readers (translators included); that Furtwängler became a Morellian *by reception*, a process very much guided by Sellers and her circle.

For in addition to the loaded reference to the "troopers of Cortés" in the introduction to *Masterpieces*, a notable review of the original German edition by Bernard Berenson makes similar Morellian links. Berenson and his lover Mary Costelloe were, as we have seen, close friends of Sellers: she stayed with them in Florence; they toured the art galleries with Morelli in hand; they quarrelled, on and off, about art theory, Vernon Lee, scholarly ambition, and a good deal more (the flames fanned in due course by Arthur Strong, who was one of Berenson's most vitriolic critics).[39] At one point in this rather breathless relationship, Berenson refused to review Sellers's translation of Furtwängler, as Costelloe had to explain in a letter: "[H]e has given up all idea of reviewing the Furtwängler, as it isn't his *Fach*, and the method appears to be not quite the same as his own."[40] But, whatever the difference between his own approach and Furtwängler's, it had not prevented his reviewing the original German *Meisterwerke* in the *Revue critique* of 1894. This long review has a curious history. It was actually published under the name of Salomon Reinach, but there can be no doubt from family letters and journals that Berenson was the author (aided by Costelloe) and that Reinach was the translator who turned it into French.[41] (What inadvertence, mischief, or malice led to Reinach's name alone appearing under the piece, we simply do not know.) The review starts with tactful compliments and gratifying sound-bites ("the most important book to have appeared on Greek art," "vast erudition" – and reasonably priced, too); it then proceeds through more than fifteen pages of detailed and critical summary, chapter by chapter, until it sums up with some rather more guarded judgements. "At root, Furtwängler's method is not as new as it appears. It is the proper consequence of the reproduction of photographs and casts, and the increasing ease with which we can travel. Burger in France, Bode in Germany and Morelli in Italy have proceeded in the same way in their work on modern painting."[42] Again, an explicit link, forged by the reviewer at least, between Furtwängler and Morellian theory.

But there is a sting in the tail. As we have already noted, Bode was one of the fiercest critics ever of the whole Morellian enterprise, and he would have been stunned to find himself sharing the same sentence in the *Revue critique*. If Berenson is not simply talking provocative nonsense, in what sense did he mean to put them together? Presumably, as his reference to photographs, casts, and easy travel implies, he has in mind the much more scrupulous attention to (comparative) detail that such technical innovations allow. "Morelli" here has become a slogan for *looking hard* and *comparing*, rather than for the precise forms of connoisseurship ("the cult of the fragment" in Edgar Wind's words[43]) that so enraged Bode. So, too, in Eugénie Sellers's preface, where the idea that Winckelmann was a Morellian *avant la lettre* only makes sense if "Morelli" had become a freely available catchword for theorizing (or adding a theoretical gloss to) any close attention to detail. This loose sense of the word may play its part, as my Coda will show, in the current preoccupation with the "Morellianism" of John Beazley.

## Coda: Beazley and Morelli

When classical art history in the late twentieth century turned with increasing interest to its own history and ancestors, one of its favorite subjects was John Davidson Beazley (1885–1970), Professor of Classical Archaeology at Oxford between 1925 and 1956. Beazley's visionary achievement (for others, his fatal obsession) was the "identification" of literally hundreds of painters of Athenian painted pottery, his attribution of much of the vast and largely unsigned corpus of black- and red-figure vases to individual artists. It was a feat of connoisseurship that almost all recent writers have connected directly to Morelli: Beazley took over Morelli's method (with a possible sprinkling of Berenson as well) to home in on those apparently trivial details of the human form that would give away the artist's individual character. Such claims have regularly been backed up by powerful citations from Beazley that echo Morellian concerns ("I would draw attention to . . . the indication of the trapezius between neck and shoulder") and illustrated with an impressive series of Greek painted ear lobes, chariot wheels, and nipples.[44] More

ambitious theorists (notably Jàs Elsner and Richard Neer[45]) have used these foundations to launch more radical speculation on the nature and implications of Morellian connoisseurship within classical art history – cleverly conscripting into the argument en route, Sherlock Holmes (rather over-worked), British imperialism, and Ferdinand de Saussure.

Nevertheless an uncomfortable silence tends to surround the question of whether Beazley had actually read or used Morelli's work either at first hand or through some intermediary such as Berenson. Donna Kurtz, one of the most vigorous champions of Beazley's Morellian inspiration, is also one of the few to admit (albeit in passing and with some puzzlement) that Beazley nowhere mentions Morelli, or Berenson: "We can only conjecture," she writes, "why he did not mention the names in print. . . . Perhaps he wished to avoid associations which could place him in a compromising position. Perhaps he wished to avoid the type of criticism that had been levelled at Morelli, Berenson and others." She also quotes Bernard Ashmole, a pupil of Beazley, as saying, "You will hardly believe it, but not only do I never remember Jacky mentioning either Morelli or Berenson, but I cannot recall his ever having spoken of his own methods or of the importance of comparing details of drawing on one vase with those on another. . . . His lectures . . . consisted in a detailed study of a series of them [sc. vases], one by one, not as you might have expected, of technical or stylistic details, but for the subjects, the way these were arranged and interpreted by the painter, and the quality and expressiveness of the drawing. . . . Little, except in a quite general way, about attributions."[46]

None of this might matter very much. If we allow "influence" to be attributed retrospectively, as part of the process of constructing intellectual genealogies, then we could surely allow Beazley to be "Morellian" by reception – just as Furtwängler was. Yet, scratch the surface of Beazley's Morellianism, and it becomes a good deal less convincing than it seems at first sight. It is not simply that there is nothing in Beazley's writing that documents any such specific influence. More significant is the loaded selection of quotations and drawings that have enabled Beazley to be presented as a look-alike Morelli. True, Beazley's work includes a whole series of references to the handling of apparently insignificant anatomical

details (clavicles, deltoids, wrists, navels, and so on), and taken together they give the desired impression. But this is only one element (as Ashmole's account of his lectures also implies) of a much more general and wide-ranging attention to detail, or hard looking, which marks Beazley's work in many ways and at different levels. Beazley does not consistently take the characteristic Morellian turn of "attribution by fragment, and solely by fragment"; there is much more to Beazley's attributions than that.[47]

The powerful modern myth of the Morellian Beazley is, I suggest, the product of a seductively neat fit between, on the one hand, a major figure in the history of art history whose intellectual origins we wish to identify (after all, what kind of historiographers would we be, if we could not even tie Beazley into the geneaology of scholarship?) and, on the other, a slogan that from its very origins has been conscripted to provide a theoretical foundation for many sorts of "detailed looking." In these terms, Beazley was no more Morellian than (as Eugénie Sellers had it) Winckelmann was. And it is in this myth that we can find a good part of the reason for the exclusion of Mrs. Strong from our own debates about Morelli and his influence within classical art history. There are, no doubt, many factors at work here: Mrs. Strong's general fall from grace in the history of our subject; her attempts to use Morelli on sculpture rather than on his defining medium of painting; her later definition as the fanatical supporter of *Romanità* (Mussolini included). But the crucial question – why is Beazley remembered as the Morellian when Strong (who explicitly engaged with Morellian theory) is not? – already contains the seeds of its own answer. Mrs. Strong is not remembered precisely because Beazley is. The history of scholarship likes its geneaologies (dangerously) simple.

## NOTES

*This paper originated in the CAA 2000 panel "Same As It Never Was," and was rewritten (to focus more directly on the Morellian connection) for "Who's Who? The Historiography of Classical Art in the Twentieth Century," a conference at the Courtauld Institute of Art, organized by Sorcha Carey and Vicky Coltman in May 2000. The relevance of the "troopers of Cortés" in my title will become clear later in the essay. The following abbreviations have been used throughout: Beard, *Jane Harrison*:

M. Beard, *The Invention of Jane Harrison* (Cambridge, Mass., 2000); Thomson, *Mrs Arthur Strong*: G. S. Thomson, *Mrs Arthur Strong: A Memoir* (London, 1949); Furtwängler, *Masterpieces*: A. Furtwängler, trans. and ed. E. Sellers, *Masterpieces of Greek Sculpture: A Series of Essays on the History of Art* (London, 1895).

1. This occasion, including the speeches given, is discussed by Thomson, *Mrs Arthur Strong* 9–11; Beard, *Jane Harrison* 14–16 (drawing on documents in the archive of Girton College, Cambridge: Strong Papers). "Retirement" is a euphemism for (nearly) dismissal; see below, p. 155.

2. E. (Mrs. Arthur) Strong, *Roman Sculpture from Augustus to Constantine* (London, 1907); K. Jex-Blake and E. Sellers, eds., *The Elder Pliny's Chapters on the History of Art* (London, 1896).

3. See, most recently, R. Hodges, *Visions of Rome: Thomas Ashby, Archaeologist* (London, 2000) xiv, 72–76. She was not, of course, universally derided at the time; and Thomson (*Mrs Arthur Strong* 72–74) could roll out a whole series of enthusiastic tributes to her social success at the British School and elsewhere. How far the awkward circumstances of her departure from the School (discussed below), or the shared recollections of her increasingly eccentric old age, are responsible for her current image is unclear. But for most British students in Rome today, she is the rather silly old ghost who haunts the library (looking for young men). Like it or not, Zefferelli's film, *Tea with Mussolini*, captures something of the flavor of Strong's community in Italy in the period of, and immediately before, World War II.

4. And it will be helped no doubt by Stephen Dyson's forthcoming biography of Strong, which will offer a sober reassessment of Strong's background and connections, as well as her contribution to Roman archaeology and art history.

5. J. Harrison, *Reminiscences of a Student's Life* (London, 1925) 64; a claim that was as untrue for her, as we shall see it was for Strong.

6. See Thomson, *Mrs Arthur Strong* 13–46; Beard, *Jane Harrison* 18–21.

7. Girton College, Cambridge: Strong Papers.

8. See Thomson, *Mrs Arthur Strong* 26–35, 40–41; Beard, *Jane Harrison* 31, 65–66. To credit all archaeological knowledge to Germany had, of course, a symbolic value beyond literal truth: a construction of an intellectual genealogy that owed nothing (and intentionally so) to the structures of English academic life.

9. See M. Beard, "Casts and Cast-Offs: The Origins of the Museum of Classical Archaeology," *Proceedings of the Cambridge Philological Society* 39 (1993) 1–29; "The Invention (and Re-Invention) of 'Group D': An Archaeology of the Classical Tripos, 1879–1984," in C. Stray, ed., *Classics in 19th and 20th Century Cambridge: Curriculum, Culture and Community* (Cambridge Philological Society, Supplement 24; Cambridge, 1999) 95–134.

10. See, especially, C. T. Newton, "On the Study of Archaeology," in his *Essays on Art and Archaeology* (London, 1880) 1–38 (originally given as a lecture in 1850). On Newton's role more generally, see B. F. Cook, "Sir Charles Newton KCB (1816–1894)" in I. Jenkins and G. B. Waywell, eds., *Sculptors and Sculpture of Caria and the Dodecanese* (London, 1997) 10–29.

11. Note the grudging admission from her autobiographical notes: "In London I did find sympathy and some encouragement when good fortune brought me in contact with Sir Charles Newton" (Girton College, Cambridge: Strong Papers). On the (semi-?) flirtatious relationship between Sellers and Newton (quite at variance with the dour picture of Newton usually painted), see Beard, *Jane Harrison* 41, 52–53, 61, 185 n. 26.

12. The relationship between Sellers and Harrison is one of the main themes of Beard, *Jane Harrison*; see esp. 30–97.

13. Lee's career is plotted by P. Gunn, *Vernon Lee: Violet Paget, 1856–1935* (London, 1964); her relations with Sellers by Beard, *Jane Harrison* 88–94.

14. Sellers to Lee, January 16, 1887 (dated 1886) (Miller Library, Colby College: Vernon Lee Papers); details of the background to the dispute are given in a draft letter, Sellers to Lee, October 20, 1886 (Girton College, Cambridge: Strong Papers).

15. For an overview of her later career, see Thomson, *Mrs Arthur Strong* 47–114; Beard, *Jane Harrison* 23–29. Ashby's side is given by Hodges, *Visions of Rome* (supra n. 3) 69–82.

16. English scholars, Strong wrote, "have a tendency to underrate the role played in the formation of religious ideas by the visible form given to deities." Art, she emphasized, did not merely illustrate religious claims; in a sense it was religion: *Apotheosis and After Life: Three Lectures on Certain Phases of Art and Religion in the Roman Empire* (London, 1915) 75.

17. See Beard, *Jane Harrison* 27–28, 179 n. 37.

18. Furtwängler, *Masterpieces,* translating *Meisterwerke der griechischen Plastik. Kunstgeschichtliche Untersuchungen* (Leipzig and Berlin, 1893).

19. So a letter in Girton College would imply: Furtwängler to Sellers, March 14, 1894 (Strong Papers); see Beard, *Jane Harrison* 177 n. 20.

20. *Italian Painters* (infra n. 23) II, 7.

21. Morelli's career and influence is usefully reviewed by R. Wollheim, *On Art and the Mind* (Cambridge, Mass., 1974) 177–201 ("Giovanni Morelli and the Origins of Scientific Connoisseurship"); and with different emphasis by C. Ginzburg, "Morelli, Freud and Sherlock Holmes: Clues and the Scientific Method," *History Workshop Journal* 9 (1980) 5–36, repr. in U. Eco and T. Sebeok, eds., *The Sign of Three* (Bloomington, 1983) 81–118.

22. *Italian Masters in German Galleries* (London, 1883), translating *Die Werke italienischer Meister in den Galerien von München, Dresden und Berlin. Ein kritischer Versuch* (Leipzig, 1880). The impact of this family background on Gisela Richter's methods in her dating of Greek kouroi hardly needs pointing out, even if her own autobiography, *My Memoirs: Recollections of an Archaeologist's Life* (Rome, 1972), is not forthcoming on the topic. The subject is discussed in I. E. M. Edlund, A. M. McCann, and C. R. Sherman, "Gisela Marie Auguste Richter (1882–1972): Scholar of Classical Art and Museum Archaeologist," in C. R. Sherman and A. M. Holcomb, eds., *Women as Interpreters of the Visual Arts, 1820–1979* (*Contributions in Women's Studies* 18; Westport and London, 1981) 276–279.

23. *Italian Painters: Critical Studies of Their Works* (2 vols.; London, 1892–1893), translating *Kunstkritische Studien über italienische Malerei* (3 vols.; Leipzig, 1890–1893). Layard was also, almost certainly, the author of an anonymous tribute to Morelli ("Giovanni Morelli: The Patriot and Critic") in the *Quarterly Review* 173 (July 1891) 235–252.

24. The *Academy* November 24, 1883, 353–354. Written by, or attributed to, Monkhouse are such classic limericks as "the smile on the face of the tiger" and "bigamy, Sir, is a crime."

25. The *Times* (London), April 21, 1892, 4.

26. The *Athenaeum*, March 29, 1884, 415–416.

27. The *Times* (London), December 26, 1883, 10.

28. The *Athenaeum*, August 5, 1893, 197–198.

29. "The Berlin Renaissance Museum," *Fortnightly Review* 50 (1891) 506–515 (esp. 509).

30. H. Brewster to E. Smyth, May 16, 1896 (reprinted in E. Smyth, *What Happened Next* [London, 1940] 139).

31. A. Strong to Sellers, April 23, 1895 (Girton College Archive: Strong Papers).

32. V. Lee, *Letters*, ed. I. Cooper Willis (London, 1937) 351–352 (July 13, 1893).

33. Furtwängler, *Masterpieces* 346–347.

34. Furtwängler, *Masterpieces* xi–xii.

35. The only sustained attempt I know to draw direct connection between Furtwängler and Morelli is P. Rouet, *Approaches to the Study of Attic Vases: Beazley and Pottier* (Oxford, 2001) 37–40; see also infra, n. 38.

36. The *Academy*, March 9, 1895, 221–222.

37. Furtwängler, *Masterpieces* xiv.

38. S. L. Marchand, *Down from Olympus: Archaeology and Philhellenism in Germany, 1750–1970* (Princeton, 1996) 105–106, juxtaposes Morelli and Furtwängler, but can only document his claims to have been influenced by Semper's *Der Stil* and Darwin's *The Expression of Emotion in Animals and Man*. J. Boardman, *The History of Greek Vases* (London, 2001) 131, refers, in passing, to Furtwängler's having "practised [the Morellian method] in Classical art history...on sculpture, not vase painting." See also supra n. 35. Neither A. E. Furtwängler's entry "Adolf Furtwängler" (in W. W. Briggs and W. M. Calder, eds., *Classical Scholarship: A Biographical Encyclopaedia* [New York and London, 1990], 84–92), nor R. Lullies's short essay (in R. Lullies and W. Schiering, eds., *Archäologenbildnisse: Porträts und Kurzbiographien von Klassischen Archäologen deutscher Sprache* [Mainz, 1988] 110–111) gives any further clue. The modern allure of Furtwängler, such as there is, derives from his archaeologically precise (and far from Morellian) catalogues of vases: "Furtwängler's...catalogue of the vases in Berlin was a landmark: eschewing old-fashioned narratives, Furtwängler listed 4221 vases and classified them by fabric, period and shape" (I. Morris, "Archaeologies of Greece," in I. Morris, ed., *Classical Greece: Ancient Histories and Modern Archaeologies* [Cambridge, 1994] 28). I have been unable to consult archival material on Furtwängler, except his letters to Sellers in Girton College, Cambridge.

39. The complex interrelationships are charted by E. Samuels, *Bernard Berenson: The Making of a Connoisseur* (Cambridge, Mass., 1979) e.g., 259–260, 271–272 (for the notorious quarrel between Berenson and Lee, 283–266, 288–289); and B. Strachey and J. Samuels, eds., *Mary Berenson: A Self-Portrait from her Letters and Diaries* (London, 1983), e.g., 67, 79.

40. Costelloe to Sellers, 22 February, 1895 (Girton College Archive: Strong Papers).

41. Samuels, *Bernard Berenson* (supra n. 39) 206–207; though Reinach himself certainly points to Furtwängler's "Morellianism" in "Adolphe Furtwängler," *Chronique des arts* (1907) 309–311.

42. *Revue critique* 6 (1894) 97–116.

43. *Art and Anarchy* (London, 1963) 42.

44. See, for example, D. Kurtz, "Beazley and the Connoisseurship of Greek Vases," in *Greek Vases in the J. Paul Getty Museum* (J. Paul Getty Museum. Occasional Papers on Antiquities 3, 1985) 237–250; M. Robertson, "Adopting an Approach I," in T. Rasmussen and N. Spivey, eds., *Looking at Greek Vases* (Cambridge 1991) 2.

45. J. Elsner, "Significant Details: Systems, Certainties and the Art-historian as Detective" (review of D. Kurtz, ed., *Greek Vases: Lectures by J. D. Beazley*), *Antiquity* 64 (1990) 950–952; R. Neer, "Beazley and the Language of Connoisseurship," *Hephaistos* 15 (1997) 7–30.

46. Kurtz, "Beazley and the Connoisseurship of Greek Vases" (supra n. 44) 243–244 (Ashmole was responding to the opinion of Joan Evans that Beazley's attributions were "Berensonian"). Rouet, *Approaches* (supra n. 35) 60 can point to a mention of Morelli's name in a letter from Beazley to N. Plaoutine; and (81) to a photograph sent by Beazley to Berenson.

47. Two early reviews make an explicit link between Beazley and Berenson/Morelli. A review of Beazley's *Attic Red-Figured Vases in American Museums* (Cambridge, Mass., 1918) by H. Stuart Jones in the *Times Literary Supplement*, August 21, 1919, 444–445, calls Beazley the "Berenson of the study of Attic red-figured vases." And an anonymous review of Beazley's *Lewes House Collection of Ancient Gems* (Oxford, 1920) in the *Classical Review* 34 (1920) 116–117 (believed by Boardman, *History* [supra n. 38] 132, to be by A. Gow) warns readers that, notwithstanding the author's well-known work in ancient vases, the "artistic personalities of various gem engravers" are not reconstructed; "minute scale and high finish together make the application of Morellian methods to gems extremely difficult." But in both cases Beazley's general project in the identification of artists, rather than any precise theory, may be the reviewer's point.

# 8

## Jargon, Authenticity, and the Nature of Cultural History-Writing: *Not Out of Africa* and the *Black Athena* Debate

JOANNE MONTEAGLE STEARNS
For Sheldon R. Brivic

At the same time, in the feeling of meaninglessness which is the high-bourgeois expression of real need, the permanent threat of destruction is assimilated by consciousness. What this consciousness dreads it turns in such a way that the threat seems to be an innate part of it, and thus it weakens that element of the threat which can no longer be grasped in human terms. The fact that on all sides meaning of every kind seems to be impotent against evil, that the latter yields no meaning at all, and that the assertion of meaning may even promote evil, is registered as a lack of metaphysical content. . . . The falseness of this reinterpretation, using a mode of cultural criticism with which the stingy pathos of the authentics joins in, regularly becomes visible in a particular fact: the fact that past ages – whichever one prefers – ranging from Biedermeier to Pelasgic, appear as the ages of immanent meaning. Such reinterpretation follows an inclination to set back the clock politically and socially, to bring to an end the dynamism inherent in a society which still, through the administrative measures of the most powerful cliques, appears to be all too open.[1]

Theodor W. Adorno

The subject of this essay concerns the so-called nature of history; specifically, it concerns the following question: whether history – however it is construed – can be represented accurately, truthfully, or authentically by history writing, or historiography. Though I invoke a number of disparate authors (from J. J. Winkelmann to Matthew Arnold to W. E. B. DuBois) in an attempt to illustrate various facets of this historiographic

problem, my discussion is mediated through three principal works: Mary R. Lefkowitz's *Not Out of Africa: How Afrocentrism Became an Excuse to Teach Myth as History*; Martin Bernal's *Black Athena: The Afroasiatic Roots of Classical Civilization* I. *The Fabrication of Ancient Greece 1785–1985*; and Theodor Wiesengrund Adorno's *The Jargon of Authenticity* (which hovers over my essay by virtue of Adorno's notion of *authenticity, Eigentlichkeit*, as I apply it here).[2]

What unites (and divides) Lefkowitz, Bernal, and Adorno is a common concern with analyzing the so-called nature of language, particularly as used in history and historiography. This ramifies into a desire to differentiate *authentic* ("real," "true," or "unfalsified") from *inauthentic* ("fictive," "artful," "mythical," or "falsified") language, especially as practiced in the (mine)fields of modern (and postmodern) history and historiography.[3] This seems to be so in the case of Mary Lefkowitz, whom I quote below in a passage dealing with the question of whether Cleopatra was black:

> But evidently [Joel A.] Rogers was not concerned with discovering what Shakespeare actually meant [when he called Cleopatra "tawny" and "black"]. He was interested in finding references . . . . to "prove" his points; all his assertions are backed up by some kind of partial evidence. Selective use of evidence is a characteristic of propagandistic history; so is blinkered vision, the tendency simply to ignore or omit evidence that might contradict what the propagandist is trying to prove. Surviving portraits of Cleopatra do not suggest that she was a person of African descent. Rogers, however, says that there is no *authentic* portrait of Cleopatra in existence (there are in fact several).[4] [my emphasis]

It seems clear to me that in this passage, Lefkowitz interrogates Rogers not so much out of "racist motives" – a charge, she writes, often leveled against her – but out of a wish to ascertain the historiographic accuracy (or inaccuracy) of his truth-claim.[5] It seems just as clear to me that Lefkowitz appears to rely (perhaps unconsciously) on a particular, culturally based notion of historical truth, or "authenticity" ("*Eigentlichkeit*") – specifically, that propounded by Leopold von Ranke (1795–1886), and epitomized in his famous dictum, which I quote: "To history has been assigned the task of judging the past, of instructing the world of today

for the benefit of future years. The present attempt does not claim such an exalted function; it merely wants to state [in later versions, to show] what actually (*eigentlich*) happened."[6]

How Ranke's idea of historiographic "authenticity" (i.e., "*Eigentlichkeit*") affects this essay can be inferred by recalling that, when the modern notion of history *as a science* was being articulated, the ideal of "scholarly objectivity" (*wissenschaftliche Objektivität*) was seen to be embodied in Leopold von Ranke. Although a political conservative, and closely associated with Prussian *Staatengeschichte* (political history), Ranke nevertheless felt his own history writing to be "impartial," that is to say, above partisan struggle ("*unpartheilich*") – a quality, we recall, Ranke believed should inhere in all historiography, or, I might say, in historiography purporting to tell (or show) the truth as it "really, actually, or authentically happened."[7]

Each work with which this essay deals – *The Jargon of Authenticity, Not Out of Africa*, and *Black Athena* – bears Ranke's stamp. And this despite, or perhaps because of, the fact that Ranke's construal of historical "authenticity" was so imprecise, veering between, on the one hand, an empirical model of historiography and, on the other, a version that could be called poetic, mystical, or mythical (an ambiguity embodied, according to Gilbert, in Ranke's decision to revise the wording of his now-famous injunction).[8] This ambiguity, I think, should remind us that historiography is not, perhaps, the autonomous discipline Ranke (and many of his descendants) imagine it to be – a reminder, I suspect, that is implicit in Adorno's skeptical treatment of the term "authenticity" ("*Eigentlichkeit*"). With this in mind, I turn to the *Black Athena* Debate.

## Culture and History: Fiction or Fact?

Because this essay is concerned with words and their use in the construction or the writing of history, I shall begin with definitions. History I distinguish from historiography. The former I construe to mean an event or series of events, that is, a process occurring in time; the latter, to connote an event or sequence of events as formulated, grasped, or

comprehended by a writer, that is, the historiographer, whose task it is to condense into words what appears to have happened.

German historiography distinguishes this difference by the words *Geschichte* and *Geschichtsschreibung*, referring respectively to *what happened* and *what is said to have happened*. This distinction is important not only in the writing or the representation of history generally but also in the *Black Athena* debate specifically. In the latter case it is important because *Not Out of Africa* and other related works by the classicist Mary R. Lefkowitz level charges of historical falsification against *Black Athena I* and *II*, and against many of those who follow this historiographic model and who are characterized variously by Lefkowitz as using history or historiography for purposes of *propaganda* and *indoctrination*.[9]

I believe Lefkowitz weakens her arguments by calling on her opponents, or critics, to define their words precisely while not doing the same herself. That is, she proceeds as if the meaning of terms like the ones mentioned above as well as others she invokes repeatedly, often on a single page – for example, "fact," "evidence," "truth," "falsehood," "myth," and even "history") – were self-evident (or, borrowing her words, linguistically "transparent.")[10] It is true that Lefkowitz does distinguish so-called *factual* (or *authentic*) history "based on discussion of evidence" from history she believes to be fabricated or "fictive."[11] But neither in *Not Out of Africa* nor in her article in the *New Republic* out of which it grew, nor in the version of that article that prefaces her anthology, *Black Athena Revisited*, does Lefkowitz acknowledge the existence of or engage in discursive debate with the vast body of historiographic criticism that has accumulated in the last two centuries around the terms "history" and "myth," not to mention other terms, or words, she also uses uncritically – as, for example, "genealogy" and "philosophy."[12] Thus, it is not in the interest of quibbling but to avoid the fallacy of ambiguity or of appearing to speak a "private language" that I attempt to be as precise as possible in the delineations I draw.[13]

Turning now to the title of this essay, I note, there, references to names, terms, and events I have drawn together for the purpose of depicting an event that I construe as being less about the *authentic* representation of the past than about the necessarily ideological nature of history and

history-writing today. The event I portray in this essay is a debate about the nature of historiography that is taking place in the late modern phase of Afro-Atlantic culture, a term I employ to depict a world, or locale, that is more particular, more specific than that conveyed in the phrase *Western* or even *Anglo-American* culture.[14]

This event, or sequence of events, is one I see condensed in the name *Black Athena*, by which name I mean (1) the title of a two-volume (soon to be three-volume) work written by Martin Bernal, i.e., *Black Athena*; (2) the polemic against *Black Athena* initiated largely by Mary Lefkowitz, whose opening parry, "Not Out of Africa," appeared in the February 1992 issue of *New Republic*, which marketed her essay with a cover worthy of William Randolph Hearst (four years later the cover photograph would re-appear, virtually unchanged, on the dust jacket of her book [Fig. 1]); and (3) a genealogical title or designation, in which genealogy is construed not only in the dictionary sense of a record or account of the ancestry and descent of a person, family, or group, or descent from an original form or progenitor, but also in the sense used by Friedrich Nietzsche: that is, genealogy construed as the competing metaphors by or through which historiographers attempt to express the nature of historical truth.[15]

All this is to say that I follow modern (here, meaning post-Nietzschean) models of historiography in so far as I view *Black Athena* from the particular standpoint of historiography understood as the genealogy of ideas. From this perspective, the debate seems to me to embody a play, or contest, of metaphors. Centering on *Black Athena*, this struggle has been waged in the arena of historiography around the topic of history, specifically, around concerns regarding the essence, or the essential or authentic nature (indeed, the *authenticity*) of history, historiography, and historical truth in the global (that is, the multicultural) world today. This, however, is not to imply that the *Black Athena* debate is just about something called *real* – or *authentic* – history (as opposed to so-called fictive or pseudohistory); or that it is just about antiquarian subject matter having a "dead reality independent of the inquiry," to quote G. R. Elton; or that the debate is just about "what happened in the past," or about the "duty and obligation" to "preserve the memory of history in as scientific a manner as possible," to quote Lefkowitz.[16] It is to affirm, rather, that

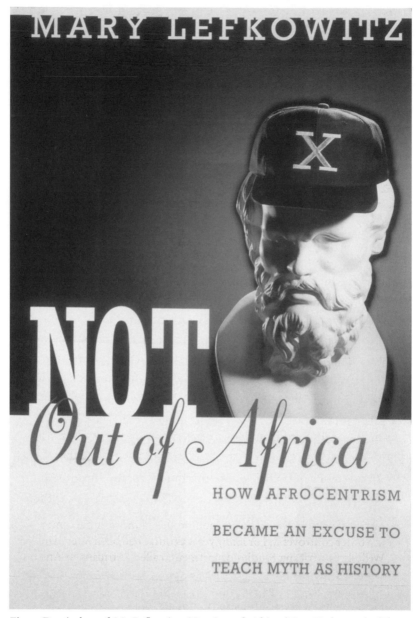

**Fig. 1.** Dustjacket of M. Lefkowitz, *Not Out of Africa* (New York, 1996). (Photo courtesy of J. Holloway ©.)

the *Black Athena* debate is ideological in the "good" way, which is to say that *Black Athena* is about interests and power and the power of words in the construction of political and cultural life generally; which is to suggest, further, and against Lefkowitz, that the historiographic topic, *Black Athena*, can be viewed positively as being about rhetoric and about the symbolic power of words in the historical life not only of the past but also of the present and of the future.[17]

To take this position sets me apart from a critic like Mary Lefkowitz, who is the Andrew W. Mellon Professor in Humanities at Wellesley College and a distinguished classical scholar whose books include *Lives of the Greek Poets* (1981) and *Women in Greek Myth* (1986) as well as the exhaustive anthology mentioned above, co-edited with Guy MacLean Rogers, *Black Athena Revisited*. The latter work contains articles by nineteen scholars rebutting various aspects of Bernal's thesis. The question might arise why I focus on Lefkowitz's polemic rather than on other, more dispassionate treatments of the subject (such as the ones included in *Black Athena Revisited*). The reason, as I indicated previously, is that Lefkowitz is arguably the most vocal and most public critic of the model of historiography practiced by Martin Bernal in *Black Athena*, and that it is she who may be seen to have launched what Stephen Howe of Oxford University called in 1998 "[t]he longest and most detailed assault on Afrocentrism to appear thus far."[18]

As might be inferred from Howe's metaphor, that which I am calling a play, a contest and, elsewhere, a debate has been depicted otherwise by Lefkowitz, who portrays herself as the standard-bearer in an event that she depicts, metaphorically, as war:

> My article in the *New Republic* soon propelled me into the center of a bitter controversy. For many years a course had been offered in Wellesley's Africana Studies department, called "Africans in Antiquity." I had always thought that the course was about historical Africa. But now as a result of my research, I realized instead that the ancient "Africans" in its subject matter were such figures as Socrates and Cleopatra, and that among the "facts" of "African" ancient history were the same bogus claims about Greek philosophy that I had previously uncovered. Because I had discussed why

these ideas were wrong, I found myself fighting on the front lines
of one of the most hotly contested theaters in the Culture Wars,
both at home and on a national level.[19]

This citation illustrates Lefkowitz's tendency, mentioned earlier, to use
words imprecisely, that is, to use words as if their denotation were uni-
versally "transparent," or free of connotative effects.[20] I note her habit of
placing so-called scare-quotes around words the construal of which she
finds suspicious – suspicious, that is, when used in non-traditional ways,
or by those she considers opponents.[21] Had she scrutinized her own use
of language as assiduously as she does others,' the reader would not be left
to guess how she construes, for example, the terms "history" and "Culture
Wars" (or how, elsewhere, she construes the mode of historiography she
terms "*cultural* history-writing").[22]

In the next few paragraphs I want to discuss Lefkowitz's use of these
terms, and to illustrate, further, how her apparent imprecision in termi-
nology could lead a so-called common reader to imagine that the apparent
semantic confusion at work in her language might be seen to infect the
historiographic task she sets herself in *Not Out of Africa* and other related
writings. The point of this exercise is not to ridicule Lefkowitz; rather, it is
to show that historiographic fallacies inhere even in "history" that deems
itself (and is deemed by others to be) *authentic,* i.e., "factual," "rational-
ist," "scientific," and "dispassionate" (to invoke some of the evaluative
terms Lefkowitz uses in differentiating praiseworthy (*eigentlich*) histo-
riography from the blameworthy (myth-making) type practiced, in her
view, by "*cultural* historians" (among them, Afrocentrists)[23] (emphasis,
as well as quotation marks, in the original).

I begin with the author's use of the term "*cultural* history-writing,"
the historiographic *roots* (or routes) of which Lefkowitz defines precisely
neither in her book nor in the *New Republic* article on which *Not Out of
Africa* was based. A type of historiography pioneered by Jacob Burckhardt
(1817–1898), *Kulturgeschichte* opposed (and opposes) positivist, empiri-
cist, or, in short, Rankean models of historiography purporting to repre-
sent "facts" (or *realia)* objectively – that is, in isolation from larger politi-
cal, social, and economic interests.[24] In other words, *Kulturgeschichte* has
its own history (or histories). Moreover, its methodological assumptions

are modern – not pre-modern or post-modern (i.e., mythologizing), as Lefkowitz seems to imply. That is to say that the cultural historian, i.e., the historiographer who writes history from a cultural point of view, follows a tradition that was articulated in the mid-nineteenth century, and which still proceeds from the assumption that the historiographic enterprise cannot arrogate to itself a privileged claim – namely, the truth-claim that *real* (or *authentic)* History – *proper* history with a capital "H" – is a genus distinguished by the fact of having been composed by historiographers who occupy, or seek to occupy, an impartial, disinterested, or Archimedean point outside culture; the standpoint, presumably, Mary Lefkowitz invokes when she speaks of "traditional historical writing."[25]

That, for example, Lefkowitz never invokes the *genealogy* or historio-graphic genesis, of cultural history-writing is alluded to by Howe, who writes:

> Lefkowitz proclaims an interest in the sociology of knowledge, and promises more than once to explain *why* Afrocentrism has had such appeal to some students and intellectuals. This, how-ever, she never does. Her discussion of intellectual climates and traditions is brief and crude. She appears to associate Afrocentrism with postmodernist, textualist or relativist approaches to histori-cal study, with the view of "history as a form of fiction" (xiv) and confusingly describes such stances as "cultural history" (50) – by which is usually meant the history of culture, but which she uses to mean history written from the viewpoint of cultural particu-larism – and "new historicism" (50) – a term normally denoting the approach of such literary scholars as Stephen Greenblatt, but for Lefkowitz apparently meaning "mythicized history."[26]

To illustrate Howe's point, and to provide a concrete example of Lefkowitz's confusing view of what differentiates impartial from partial history writing, and dispassionate analysis from partisan historiography composed in the interests of "identity politics" (i.e., "*cultural* history writing"), I quote from *Not Out of Africa.*[27] I preface this quotation by suggesting that Lefkowitz's view of the history of art is "fanciful," to borrow one of her pejoratives, since there is not, to my knowledge, any art historian who would classify Rembrandt van Rijn as a Renaissance artist, Rembrandt (1606–1669) having been born about three-quarters of

a century after the date the (Italian) Renaissance is conventionally seen to have "ended" (that is, with the Sack of Rome in 1527), and Rembrandt's work being, along with that of Peter Paul Rubens (1577–1640), the conventional exemplar not of Renaissance but of Baroque art.[28]

Turning to Lefkowitz, we read:

> The inevitable result of *cultural* history-writing, unless it is done with the greatest of caution, is a portrait of the past painted with broad strokes and bright colors of our own choosing. It is almost as if we removed all the Rembrandts from the museum and replaced them with Mondrians in order to study the history of the Renaissance. We are left with a vivid history of the concerns of our own society. We can now see in the past not the issues that the people living at that time considered important, whatever these might have been, but a biased history written to the dictates of dead white European males, and a literature largely insensitive to the needs and aspirations of women and cultural minorities. Academics ought to have seen right from the start that this "new historicism" has some serious shortcomings. But in fact most of us are just beginning to emerge from the fog far enough to see where history-without-facts can lead us, which is right back to fictive history of the kind developed to serve the Third Reich. It is not coincidental that ours is the era not just of Holocaust denial but of denial that the ancient Greeks were ancient Greeks and creators of their own intellectual heritage.[29]

In the next paragraph Lefkowitz distinguishes between that which she terms (evidently bad) "*cultural* history-writing" and (evidently good) "traditional history writing." The latter, praiseworthy variety is based, according to Lefkowitz, on "discussion of evidence."[30] It would appear that Lefkowitz agrees with G. R. Elton, who wrote that the practice of history is based on two fundamental questions, namely, "exactly what evidence is there, and exactly what does it mean?"[31] But Lefkowitz does not mention Elton's, or any similar discussions, and she does not acknowledge the fact that the nature of historical evidence has given rise to evidentiary debates precisely because there is no recording angel of history (whose narrative could be guaranteed, in the fullness of time, to be perfectly factual, objective, and disinterested). By simply asserting the necessity of "evidence" in the writing of so-called factual history, Lefkowitz risks

falling into a variety of historical fallacy termed by David Hackett Fischer "the fallacy of the hypostatized proof," which, as summarized by Perrell F. Payne, Jr., "consists of identifying the received theory about $X$ ... with $X$ itself, and hence rejecting some variant theory of $X$ on the grounds that it does not do justice to the nature of $X$."[32]

In other words, better parsing of the historiographic term "evidence" might have allowed Lefkowitz to offer an informed critical analysis such as Alan Munslow provides:

> The empirical method presupposes what historians know about the past begins with the evidence.... What it is that is distinctive about the historian's intellectual training originates with the way in which the sources of the past are mined as evidence for the nature of change over time. It is usually claimed that evidence provides the bond between history and the past. Epistemologically the strength of that bond is to be found in the closest possible correspondence between events ... and their description.... Without evidence, therefore, history would be just fiction. This is the issue. Can we write proper, or non-fictional history if we re-conceive the nature of this bond?
> But it is not just a matter of how the historian uses his/her (chosen) evidence (or how his/her culture uses the historian). At the far more profound level of epistemic uncertainty it may be that insisting evidence is *the* foundation to history is a flawed assumption. No matter how extensively and constantly we hedge our epistemological bets about the evidence by reiterating its capacity to mislead the unskilled, we invariably fall back on our belief in the power of inference to the best explanation as if the incantation will work magic. Instead of realizing the shortcomings of our skills and the failings of the inferential method by asking where the meaning does emerge between the single factual statement and the monographic interpretation, we persist with the idea that the more evidence we have and the more we refine the questions we address to it, the closer we must be getting to the truth. This [is a] dogged refusal to face up to our flawed methodology.[33]

But because Lefkowitz does not argue her evidence but simply asserts it – as when she writes, "Selective use of evidence is a characteristic of propagandistic history; so is blinkered vision, the tendency simply to ignore or omit evidence that might contradict what the propagandist

is trying to prove" – the reader must infer *ex silentio* the nature of the model that Lefkowitz praises as "traditional history writing."[34] Lefkowitz, however, does offer one clue to her historiographic model in "Ancient History, Modern Myths," the *New Republic* essay that launched what Stephen Howe called her "assault" on *Black Athena*, when she notes, "Modern historians are understandably frustrated when they try to use Herodotus to discover 'what really happened.' . . ."[35]

I have discussed the significance of Ranke's description of the historian's task – to reconstruct history "as it really was," or "as it actually happened" (*wie es eigentlich gewesen*).[36] Here, let me recapitulate my point, though from a different angle. In adjectival and adverbial form the German adjective "*eigentlich*" denotes something that is real, actual, true, or original (as in the phrase, "*im eigentlichen Sinne des Wortes*," "in the true sense of the word"); as a noun, in philosophical, epistemological, or ontological discourse, "*Eigentlichkeit*" is construed to mean an entity the nature of which is real or true – that is, "authentic." And when Adorno, in *Jargon der Eigentlichkeit*, targets that term, I think he is targeting implicitly the historians' fallacy of the Archimedean viewpoint – the belief, mentioned above, that there actually can be a transcendental perspective the attainment of which permits the reconstruction of a true, factual, real, or authentic picture of the past, free (or nearly free) of the subjective concerns and cultural interests of the writing subject.

The obduracy of Adorno's style makes it difficult to paraphrase his thought or even to epitomize an individual work, *Jargon of Authenticity* included. Suffice it to say that Adorno, an exile from Nazi Germany, was as vexed as Lefkowitz by the propagandistic use of language, and no doubt would have concurred with her assessment that "[t]he events of this century have shown that it is dangerous to allow propaganda to usurp historical truth."[37] Adorno, however, probably would have concurred neither with Lefkowitz's simplistic view of the nature of that which she designates "propagandistic" historiography nor with her equation of it with "blinkered vision" and "the tendency . . . to ignore or omit evidence that might contradict what the propagandist is trying to prove."[38]

Indeed, Adorno might have characterized both the author's invocation of "Culture Wars" and her self-portrait as a warrior as propagandistic, in

so far as Lefkowitz could be seen as using words, or language, in a manner Adorno calls "mythologizing" or "ennobling."[39] By Adorno's account, Lefkowitz may be seen to be engaged in barbarism or plundering, by virtue of the fact that she tears a phrase (for example, *Kulturkampf*) out of its historical context (nineteenth-century Prussian cultural history) and radically revises it in the service of contemporary culture and politics. Language deprived of its historiographic *roots*, Adorno categorized as jargon – that is, technical (or non-reflective) chatter: babbled words, disguised as *nomina nobilia*, propagated for mass consumption.[40]

Adorno might also have noted the absent scrutiny of the historiographically charged term "propaganda," which Lefkowitz deploys so vehemently in *Not Out of Africa*. Here, I shall linger for a moment over the word, since it bears on issues this essay pursues, including the historiography of certain tropes, or metaphors, of culture, civilization, and barbarism we have yet to consider.[41] Terence H. Qualter, author of *Propaganda and Psychological Warfare*, has noted that the seventeenth-century term originated in a Catholic Church responsible for missionary activities in the New World and for defending the faith in the Old. In this older sense propaganda was a fairly neutral term denoting the dissemination, or propagation, of what was seen as true information. But in Protestant England, Qualter notes, the promotion of Catholicism had a sinister taint, which is one reason why "in English, to a greater degree than in other European languages, the word 'propaganda' has a pejorative connotation that makes its objective analysis extremely difficult."[42] Qualter also notes that although in World War I Britain did have a Department for Propaganda in Foreign Countries, "it soon became policy to grant the enemy exclusive use of the term. Against their 'propaganda' we would spread 'information and truth'. Today propaganda is still largely thought of as a device for undermining the credibility of opponents. Their arguments, discredited by the propaganda label, don't merit reasoned rebuttal. They can simply be dismissed as, by definition, dishonest and invalid."[43]

There are two further qualities connected with the connotation of propaganda that touch on Lefkowitz's view of history writing generally, and propagandistic history writing in particular. First there is the fact, noted by Qualter, that in liberal democracies the notion of propaganda

is inflected by the idealistic belief in "a perfect political world in which choices are made by the rational evaluation of objective, unpressured information."[44] (From this perspective, Lefkowitz's historiographic judgments may be seen to be motivated by an admirable if naïve idealism.)[45]

A second point Qualter makes I shall quote at length, since it bears on Lefkowitz's discrimination of traditional (in Rankean terms, "*eigentlich*") historiography from the other (or "*uneigentlich*") type:

> Most popular definitions focus on the attempt to distinguish the "truth" which we uphold from the "falsehoods" or propaganda of the other side. It is invariably a futile exercise, for truth and falsehood are not the objective dichotomies many believe them to be. For the most part, assertions of fact offered in all good faith are assertions of opinions or beliefs about facts, which others, with equally good faith, might dispute. Further, "the facts" are rarely the same as "the truth." Much depends on the knowledge of speaker and audience. An incorrect statement made by someone sincerely believing it to be true is not a lie. An objectively true statement, made with the intention to deceive, by someone who believed it to be false, may well be. There is a further difficulty in that one may adhere strictly to the facts and still be a liar. In proffering only some of the facts, in ignoring uncomfortable counterfacts, in exaggerating or downplaying the significance of facts, or in asserting as unique attributes of one side facts that are common to both, one may totally distort or deceive while not saying anything that is actually untrue.[46]

## History or Metaphor: Roots or Routes?

On this note I turn to the concluding section of this essay. Here, I examine how an organic metaphor of growth and decline, inherited from ancient rhetorical models, was used by German historiographers at the end of the eighteenth century and was refined in the nineteenth by both German and English cultural historians. I pursue some of the routes traveled by this organic metaphor – that is, the metaphor of culture or civilization; or, put otherwise, the metaphor of barbarism or decline – and, in addition, some of the forms it assumed in the historiography of Johann Joachim Winckelmann (1717–1768), Matthew Arnold (1822–1888), and W. E. B.

DuBois (1868–1963), among others. Although I will be discussing histo-
rians (or, speaking anachronistically, cultural critics) who lie outside the
chronological perimeters of the *Black Athena* debate, nevertheless, the
questions they raised, and the sometimes agonized solutions they found,
impinge on us still today.

I turn now to the issue of whether *history* can be said to have an *authen-
tic nature* and, following from that, whether the *nature* of history may not
be clarified better (that is, more usefully) by studying the historiography
of culture and ideas than by searching for history "as it *actually* was." I
conclude my study with a discussion of W. E. B. DuBois and his now
"classical" revision of the mythological heroine, Atalanta, into a meta-
phorical figure, "black young Atalanta," and I suggest that the freedom
to revise "classical" models might be, ironically, the freedom to which
modernity has been condemned.[47] Perhaps, one might say, borrowing
(or "revising") further, that after the death of God, in an age when ev-
erything is permitted, perhaps now, in post-modernity, it is "Man's Fate"
to read – and to read on the same day – T. S. Eliot and Ernst Nolte, each
invoking vision and revision.

"Any attempt to question the authenticity of ancient Greek civilization
is of direct concern even to people who ordinarily have little interest in
the remote past," states Mary Lefkowitz.[48] An enemy of New Historicism,
Lefkowitz disputes the contention that history always reflects the point
of view of the writing subject. Believing that it is "from the Greeks, and
not from the any other ancient society, that we derive our interest in his-
tory and our belief that events in the past have relevance for the present,"
Lefkowitz brings an almost patristic zeal to the study of the "classical"
past.[49] Recalling Berlinerblau's aptly titled study of the *Black Athena* de-
bate, *Heresy in the University*, we might suggest that Lefkowitz views
non-traditional modes of historiography about as favorably as Tertullian
viewed Marcion's (d. ca. A.D. 154.) revision of the Bible, which incited
Tertullian to hammer out the five volume polemic, *Adversus Marcionem*
(ca. A.D. 203–208).[50]

Lefkowitz, as we have seen, excoriates modes of historiography such as
the Afrocentric that seek to revise the metaphors or narratives shaping the
identity of the postcolonial subject. Martin Bernal's *Black Athena* is one

such revision (which, as in the case of other multicultural and Afrocentric reinscriptions, Lefkowitz condemns as historical falsification). Although she does not use the term *Historikerstreit*, Lefkowitz does appear to view many who practice revised models of historiographic inquiry – among whom, for example, she includes, fairly, Leonard Jeffries and, unfairly, practitioners of New Historicism – as akin to Nazi mythographers.[51] Whether or not, for example, Cleopatra may have been of mixed blood, and whether, by the standards embodied in the so-called one-drop rule or traceable amount rule, Cleopatra could be called black – "The nation's answer to the question 'Who is black?' has long been that a black is any person with *any* known African black ancestry," notes Frank Davis in *Who Is Black? One Nation's Definitions* – such arguments Lefkowitz seems either to ignore, or to be ignorant of.[52]

Whether or not she acknowledges racialist modes of re-writing history, Lefkowitz nevertheless seems eager to resist other, less contentious, modes of historiographic renovation. Thus, she resists the renaming, or, in Kimberly Benston's words, the "(un)naming" of cherished (mythical or symbolic) figures – (black) Athena, for example.[53] When Cheryl Johnson-Odim (whom Lefkowitz quotes, disapprovingly) asks, "Why should the Egyptians not stand for the rest of Africa? What we are really talking about here is symbolism. . . . And is it not the same kind of symbolism that Greece has for the many European peoples to whom . . . the Greeks felt no kinship?" Mary Lefkowitz answers: "[S]he [Odim] has made an argument that will find cultural acceptance. But once symbolism is taken as a mode of historical proof, the way is open for other groups . . . to argue for a different symbolism. Only a few of the people teaching . . . today seem to have not forgotten that not long ago symbolic myths of ethnic supremacy were responsible for the deaths of whole populations."[54]

Lefkowitz's concern to preserve a factual picture of the "Classical" past recalls an observation Adorno made in *The Jargon of Authenticity*, which I quote in my epigraph. Speaking of particular models of cultural criticism that invoke a so-called authentic past, he wrote: "The falseness of this reinterpretation, using a mode of cultural criticism with which the stingy pathos of the authentic joins in, regularly becomes visible in a particular fact: the fact that past ages – whichever one prefers – ranging

from Biedermeier to Pelasgic, appear as the ages of immanent meaning. Such reinterpretation follows an inclination to set back the clock politically and socially, to bring to an end the dynamism inherent in a society which still . . . appears to be all too open."[55]

Adorno also noted, elsewhere, how the drive to authenticate allies the cultural critic with the appraising collector no less than with the art critic. I would extend this observation to the historiographer as well. "In general," wrote Adorno, "cultural criticism recalls the gesture of bargaining, of the expert questioning the authenticity of a painting or classifying it among the Master's lesser works. One devaluates in order to get more."[56]

We may recall Bernard Berenson, the historian (of art) who advised art dealers.[57] Like Winckelmann before him, Berenson sought to discriminate between representations he considered authentic and ones he did not. The distinguished historian of art, Sir Kenneth Clark, was Berenson's intern, and in his popular book and television series *Civilisation: A Personal View*, Clark distinguished between a state he called "civilization" and one he called "barbarism."[58]

There, Clark invokes the Apollo Belvedere as a metaphor of "Classical" civilization. He contrasts the Apollo to an African ceremonial mask (Fig. 2). The mask, a Fang work from West Africa (Gabon), Clark identifies (in the book, *Civilisation*) with barbarism; interestingly, he does not use this metaphor in the television series, in which it is Norse *culture* that he associated with *barbarism* (my emphasis). In the book Clark writes:

> Whatever its merits as work of art, I don't think there is any doubt that the Apollo embodies a higher state of civilisation than the mask. They both represent spirits, messengers from another world – that is to say, from a world of our own imagining. To the Negro imagination it is a world of fear and darkness, ready to inflict horrible punishment for the smallest infringement of a taboo. To the Hellenistic imagination it is a world of light and confidence, in which gods are like ourselves, only more beautiful, and descend to earth in order to teach men reason and the laws of harmony.[59]

The metaphor Clark applies to these artifacts reflects one inherited from Matthew Arnold (1822–1888), who, in *Culture and Anarchy* (1869), discriminated between two opposing perspectives (or, as we might say,

**Fig. 2.** K. Clark, *Civilisation: A Personal View* (1969; New York and Evanston, 1970) 2, figs. 2 and 3.

*Weltanschauungen*) – namely, "Hebraism" and "Hellenism." "As one passes," wrote Arnold, "from Hellenism to Hebraism . . . one feels inclined to rub one's eyes and ask oneself whether man is indeed a gentle and simple being, showing the traces of a noble and divine nature; or an unhappy chained captive, labouring with groanings that cannot be uttered."[60] For Arnold, the "Hebraic" worldview conjured up darkness – the face of tribalism, the deformed site of partial vision that he (and others) associated with the so-called Nonconformists, e.g., with the Methodists, with the Irish, and with other disestablishmentarians standing outside the Church of England; the "Hellenic," on the other hand, signified "aerial ease and radiancy," the disinterestedness of cultured vision, the vision of one who "[sees] things as they really are."[61]

Is this historiographic constellation refracted on the cover of *Not Out of Africa*, which is virtually identical to the *New Republic* cover designed by Jim Holloway (Fig. 1)?[62] Backlit by lurid day-glo color, the "Classical" bust sits, or rather floats, at a de-centered angle, a hat invoking Malcolm X perched incongruously atop its head. Vulgar, the image suggests, among other things, that Malcolm's bequest amounts, today, to tribal

paraphernalia. One recalls the judgment made by Arthur Schlesinger (historian of the so-called consensus school), whose polemic, *The Disuniting of America* (1991), Lefkowitz cites in *Not Out of Africa*.[63] There, Schlesinger may be seen as revising (consciously or not) Arnold's metaphor when he depicts multiculturalism as "invit[ing] the fragmentation of the national community into a quarrelsome spatter of enclaves, ghettos and tribes."[64]

Here I turn to Johann Joachim Winckelmann, whose metaphor of the "Classical" norm is inscribed, arguably, in the historiographic project of every writer examined in this essay. Winckelmann, in *Reflections on the Imitation of the Greek Works in Painting and Sculpture* (1755), took an organic metaphor of rise and decline – a metaphor inherited from antique models of oratory – and crafted it into a figure of the generation and degeneration of history and culture from ancient Greece to modern Prussia. I will dwell for a moment on one rhetorician who was particularly important to Winckelmann (and hence to us), namely, Dionysius of Halicarnassus (ca. 60–8 B.C.), whose treatise, *On the Ancient Orators*, contrasted an "Attic" to an "Asiatic" style of oratory: "Just so, in every city, even – worst of all – in the highly cultivated, the old, native Attic Muse was in disgrace, cast out from her inheritance, while another, sprung from some Asian sewer the other day . . . claimed the right to govern the cities of Hellas, and, in her ignorance and madness, to drive out her sane, philosophical rival."[65]

Around this antithesis of a "good" Attic and a "bad" Asiatic, Winckelmann crafted his historiographic vision. "Greek art," he wrote, "like Greek poetry, has . . . five [principal] periods. For as every action or event has five parts, and, as it were, stages – namely, beginning, progress, state of rest, decrease, and end . . . so it is with the succession of time in art."[66] To these periods Winckelmann appended names (or historiographic labels): the Older Style; the Grand, Lofty, or High Style; the Beautiful Style; and the Style of the Imitators or Eclectics.

These names were not purely descriptive, that is, they were not value-free. For example, the Grand or High Style Winckelmann associated with Pheidian Greece, a period he believed to have been one of stability. The Style of the Imitators, on the other hand, he associated with what we now call Hellenistic Greece, that is, Greece in the period following the death

of Alexander the Great in 323 B.C. Characterizing this period as one of "rebellions and bloody wars," Winckelmann condemned it as a stage (or age) of decline, the stage (or age) in which, on his model, the "Attic" heritage was decimated.[67]

In Winckelmann's historiography and the historiography of his inheritors, these stages – these *names* – became imbued with the aura of the sacred (as well as with the cursedness of the profane). That which was, after all, only a name – the Grand, the Eclectic, the Attic, the Asiatic – came to appear as if it were more than a name. It came to appear as if natural. When Adorno invokes the names Biedermeier and Pelasgus, he is targeting a mythology of language that wraps words like "civilization" (or, I might add, [black] "Athena") in an aura of artificial presence, "like oranges in tissue paper," as Adorno writes.[68]

Adorno makes a point about the illegitimate authority of names (or historiographic markers) by invoking two "noble nouns," or names, which are also ignoble (*ignobilis*, of unknown, obscure, humble, or base origin). One is a mythical king who came eponymously to codify a distinction between aboriginal Greeks and other Greeks called Hellenes; the second, a fictitious poet (Gottlieb Biedermeier) created in the pages of the satirical weekly *Fliegende Blätter*, whose name came to signify a style of art associated with the repressive regime of Prince Metternich. Both are historiographic *nomina*; both impart, to the periods they "describe," the semblance of unified being, in short – the semblance of reality.

These historiographic labels give order to the flux of time and bestow ponderability on the imponderable. One way they do this is by personifying (or animating) the inanimate. John Ruskin subsumed this mnemonic device under the term "pathetic fallacy," noting that this rhetorical trope "produce[s] . . . a falseness in all our impressions of external things."[69] Quoting a poem that invokes the "cruel, crawling foam," Ruskin wrote: "The foam is not cruel, neither does it crawl." Here, one might note that as the foam does not crawl, neither does time rise or decline. Rather, an epoch resembles a rebus, in Jacques Derrida's sense of the word: "[The] great stake of literary discourse," he writes, "is the patient, stealthy, quasi-animal or vegetable, tireless, monumental, derisory transformation of a name, a rebus, into a thing or name of a thing."[70]

*Black Athena* is a name – that is, the contested name or title of a book subtitled *The Afroasiatic Roots of Classical Civilization*. Bernal's *Black Athena* may be seen as a project of re-mapping, an enterprise which, in re-tracing Athena's provenance to black Africa (or Egypt), seeks, fundamentally, to re-route the metaphor through which we, as cultural subjects, perceive our historical, or historiographic, "roots" – that is, our heritage, our genealogy, ourselves. The question of whether this re-mapping constitutes a "re-naming" of the past, or an "(un)naming" – that is to say, a "nullification" in the legal sense – lies, I think, at the heart of the *Black Athena* debate (as it does in the debate about America's racial heritage generally).[71] Such issues, writ large, Kimberly Benston addresses in "I Yam What I Am: The Topos of (Un)naming in Afro-American Literature."[72] There, he ponders "un-naming" as a metaphorical strategy for revising historically (or historiographically) imposed definitions – definitions, we might add, that may be seen "to substantiate, perpetuate, and legitimate" what the legal scholar A. Leon Higginbotham calls "Precepts of Inferiority."[73]

I turn now to W. E. B. DuBois, who may be said to have "re-named" – or to have "(un)named" – the classical heroine Atalanta by invoking her as "swarthy Atalanta" in *Souls of Black Folk* (1903), of which Henry Louis Gates has written: "I would venture to say, no other text, save possibly the King James Bible, has had a more fundamental impact on the shaping of the Afro-American literary tradition."[74] Conflating a number of metaphors through this revision – among them, race and racing, Atlanta (where he was teaching at the time he wrote *Souls*) and Atalanta – DuBois, whose undergraduate degree was in Classics, may be seen to be altering (if not falsifying) classical tradition, putting into practice historiographic principles he learned while at the University of Berlin (1892–1894), working toward a doctorate (in sociology) with teachers such as Heinrich von Treitschke and Gustav von Schmoller.[75]

DuBois' revision appears in "On the Wings of Atalanta" (chapter 5, *Souls of Black Folk*). There, he alters the picture of Atalanta that Ovid borrowed from Greek antiquity, and re-presented in *Metamorphoses*, Book 10. But whose picture did DuBois alter? Did he read an edition published between 1853 and 1876 in Leipzig and Berlin, perhaps while he

was attending the University of Berlin; or the *Metamorphoses: Englished, Mythologized, and Represented in Figures* by George Sandys (1578–1644); or perhaps Arthur Golding's famous translation (1567), on which Shakespeare apparently relied and which, according to a modern critic, turned "the sophisticated Roman [Ovid] into a ruddy country gentleman with tremendous gusto . . . an ear for racy speech, and a gift for energetic doggerel?"[76]

At any rate, in Golding we read of an Atalanta who appears "whyght as snowe" yet also of "ruddy" hue: "A redness mixt with whyght yppon her tender body cam, As when a scarlet curtaine streyned ageinst a playstred wall/Dooth cast like shadowe, making it seeme ruddye therewithal" (10. 693–695).[77] Similarly – and here we may rely on Lefkowitz's discussion in her chapter, "Myths of African Origins," of the "black" (and, elsewhere, "tawny") Cleopatra depicted by Shakespeare – we read in DuBois: "Perhaps Atlanta was not christened for the winged maiden of dull Boeotia; you know the tale, – how *swarthy* Atalanta tall and wild, would marry only him who out-raced her"; and, three pages later, "In the Black World, the Preacher and Teacher embodied once the ideals of this people – the strife for another and a juster world, the vague dream of righteousness, the mystery of knowing; but today the danger is that these ideals, with their simple beauty and weird inspiration, will suddenly sink to a question of cash and a lust for gold. Here stands this *black* young Atalanta, girding herself for the race that must be run; and if her eyes be still toward the hills and sky . . . then we may look for noble running; but what if some ruthless or wily or even thoughtless Hippomenes lay golden apples before her?" (my emphasis).[78]

At Harvard, DuBois's mentor was William James, the pioneer of pragmatic philosophy whose influence on both DuBois himself and his work seems to have been deep. D. Levering Lewis describes James as he might have appeared to DuBois at Harvard in the 1890s: "The empirical and psychological essentials of the Jamesian philosophy were already unmistakeable, although the term 'pragmatism' was a few years away from general currency. It was a lumping of philosophical temperaments into 'tough-minded' and 'tender-minded' categories, the testing of the 'cash value' of ideas by demanding to know what concrete difference their

being true makes in the real world, and an insistence that society must accommodate the plural, unsettling, competing interests of individuals."[79] In a sense, then, DuBois was continuing (Jamesian) tradition – the traditional practice of revising the past in the interests of the present (and the future) – when he re-worked Ovid's Atalanta of "ivory-white skin" (*terga eburnea*) into the modern Atalanta, "swarthy" and "black."[80] But shall we follow Lefkowitz and then classify DuBois' re-inscription as "revisionist" historiography, written in the service of "identity politics?"[81] Should we view DuBois – the "father" of Afrocentric history and of the mode of historiography represented by *Black Athena* – as engaging in what one might term an act of textual nullification, an act that by Lefkowitz's account might be seen to be at worst nihilist and at best instrumentalist, a pragmatic construction of truth?

Professor Lefkowitz has written, "Afrocentrism poses a threat to the rationalist tradition."[82] But might one not suggest that Lefkowitz's historiographic perspective is no more rational or irrational than those held by any of the historiographers represented in this essay, all of whom might practice a mode of history writing characterized by Jacques Derrida as "white mythology," and that he construes as follows: "White mythology reassembles and reflects the culture of the West: the white man takes his own mythology, Indo-European mythology, his own *logos*, that is, the *mythos* of his idiom, for the universal form of that he must still wish to call Reason."[83]

Aristotle, in the *Rhetorica*, may be seen as implying that metaphor allows us to see the world in new ways, by giving a name to the unfamiliar.[84] This essay has attempted to trace certain ways of "worldmaking" enacted by historiographic imagination. Focussing on Mary Lefkowitz's vexed representation of "traditional history writing," particularly as proffered in *Not Out of Africa: How Afrocentrism Became an Excuse to Teach Myth as History*, I have attempted to show how perspectival error – the "optical illusion," in Burckhardt's words, endemic to historiography – inheres in the very *nature* of history. Here it is perhaps well to remember that Winckelmann's justly famous evocation of classical civilization – as he confronted it (or did not confront it) – is, at heart, revisionist.[85] Indeed, one might not err in characterizing as "historical

falsification" Winckelmann's description of the priest Laocoon, since Winckelmann invokes the latter – whose expression is one of violent, contorted suffering – in words (*"eine edle Einfalt und eine stille Größe"*) that might be taken as referring to a different monument entirely.[86] Yet, one might suggest that it is this historiographic illusion – this product of *Phantasia*, of Winckelmann's imagination (based, one might say, not on history "as it really was" [*"wie es eigentlich gewesen"*], but on history as he wanted it to be) – that inspired Goethe, Schiller, Herder, Hegel, Schopenhauer, Marx, Burckhardt, Nietzsche . . . the list is virtually endless.

In conclusion, I quote a modern scholar who has written this of Winckelmann: "With respect to even the most basic historical concerns – that is, questions of what happened, and when, and where – to a surprising extent modern research . . . follows lines suggested by Winckelmann."[87] Whether "history" is better or worse by virtue of, for one, Winckelmann's historiographic "fabrication" (to recall Martin Bernal's thematic subtitle, *Black Athena* I: *"The Fabrication of Ancient Greece 1785–1985"*)"; and whether such "fabrications"(or acts of imagination) render the subject more or less "authentic" – that, I think, depends on the viewpoint of the individual.

### NOTES

1. "Zugleich wird im Gefühl von Sinnlosigkeit die spätbügerliche Gestalt realer Not, die permanente Drohung des Untergangs, vom Bewußtsein verarbeitet. Es wendet, wovor ihm graut, derart, als wäre es ihm eingeboren, und schwächt so ab, was an der Drohung menschlich überhaupt nicht mehr zuzueignen ist. Daß Sinn, welcher auch immer, allerorten ohnmächtig scheint gegen das Unheil; daß keiner ihm abzugewinnen ist und daß seine Beteuerung es womöglich noch befördert, wird als Mangel an metaphysischem Gehalt, . . . Das Lügenhafte der Verschiebung durch eine Art Kulturkritik, in welche das verkniffene Pathos der Eigentlichen regelmäßig einstimmt, wird sichtbar daran, daß Vergangenheiten, die je nach Geschmack vom Biedermeier bis zu den Pelasgern reichen, als Zeitalter anwesenden Sinnes figurieren, getreu der Neigung, auch politisch und sozial die Uhr zurückzustellen, durch Verwaltungsmaßnahmen mächstigster Cliquen die Dynamik einer anscheinend noch allzu offenen Gesellschaft zu beenden, die ihr innewohnt." T. Adorno, *Jargon der Eigentlichkeit. Zur deutschen Ideologie* (Frankfurt am Main, 1964): repr. in *Gesammelte Schriften* 6 (Frankfurt am Main 1973) 413–526 (hereafter cited as *Eigentlichkeit*); quotation from p. 437. The

translation is that of K. Tarnowsky and F. Will, trans., *The Jargon of Authenticity* (Evanston, 1973) 36 (hereafter cited as *Authenticity*).

2.  *Not Out of Africa: How Afrocentrism Became an Excuse to Teach Myth as History* (1996; New York, 1997) (hereafter cited as *Not Out of Africa*); M. Lefkowitz, "Ancient History, Modern Myths," in *Black Athena Revisited* ed. M. Lefkowitz and G. M. Rogers (Chapel Hill and London, 1996) 3–23 (repr. of "Not Out of Africa," *New Republic* [10 February, 1992] 29–36, hereafter cited as "Ancient History"; M. Bernal, *Black Athena: The Afroasiatic Roots of Classical Civilization* I. *The Fabrication of Ancient Greece 1785–1985* (1987; repr. London and New Brunswick, 1994); II. *The Archaeological and Documentary Evidence* (New Brunswick and London, 1991) (hereafter cited as *Black Athena I* and *Black Athena II*). I have relied almost exclusively on *Black Athena I*, since *Black Athena II* is beyond my range of expertise; Adorno, *Authenticity/Eigentlichkeit*.

    In this essay *italics* are used to signal: (1) book titles; (2) foreign words; (3) words the usage or construal of which I want to emphasize.

3.  See Lefkowitz, *Not Out of Africa* xvi: "This book thus has both a negative and a positive purpose. The negative purpose is to show that the Afrocentric myth of ancient history is a myth, and not history. The positive purpose is to encourage people to learn as much about ancient Egypt and ancient Greece as possible. The ancient Egypt described by Afrocentrists is a fiction. I would like our children and college students to learn about the real ancient Egypt and the real ancient Africa, and not about the historical fiction invented by Europeans."

4.  Lefkowitz, *Not Out of Africa* 39–40.

5.  Lefkowitz, *Not Out of Africa* xii.

6.  F. Gilbert, *History: Politics or Culture? Reflections on Ranke and Burckhardt* (Princeton, 1990) 19; L. Ranke, *Geschichten der romanischen und germanischen Völker von 1494 bis 1514. Sämmtliche Werke* 33–34 (Leipzig, 1874), vii: "Man hat der Historie das Amt, die Vergangenheit zu richten, die Mitwelt zum Nutzen zukünftiger Jahre zu belehren, beigemessen: so hoher Aemter unterwindet sich gegenwärtiger Versuch nicht: er will bloss zeigen, wie es eigentlich gewesen."

7.  G. G. Iggers, *The German Conception of History: The National Tradition of Historical Thought from Herder to the Present* (1968; rev. ed., Hanover, 1983) 77.

8.  Gilbert (supra n. 6).

9.  Lefkowitz, *Not Out of Out Africa* 39 and passim; 3 and passim.

10. Lefkowitz, *Not Out of Africa* xv and passim; xiii and passim; 27 and passim; 8 and passim; 3 and passim; 26. See also Lefkowitz, "Ancient History." Lefkowitz's uninflected use of these terms is also evident in her article, the foundation for her extended argument in *Not Out of Africa*.

11. Lefkowitz, *Not Out of Africa* 50 and passim. For Lefkowitz's use of scare-quotes, see infra p. 178.

12. In "Myths of African Origins," chapter 2 of *Not Out of Africa*, Lefkowitz uses the word "genealogy" and includes two family trees: 17; 19, 37. On Nietzsche's definition of the term in the content of historiography, see infra n. 15; Bernal does mention Nietzsche: *Black Athena I*, 213, 293, 339. For Lefkowitz's uncritical use of "philosophy": *Not Out of Africa* 9 and passim; "Ancient History" 3 and passim.

Genealogy also assumes some importance in the *Black Athena* debate by virtue of Bernal's own genealogy, his father being John Desmond Bernal (1901–1971), a physicist, X-ray crystallographer, promoter of "proletarian science, member of the Cambridge Scientists Anti-War Group during World War II, a friend of Picasso, and a polemicist against 'the unreason of "Aryan science"'": C. Hitchens, *Times Literary Supplement* 5029 (20 September, 1999) 3–4 (review of B. Swann and F. Aprahamian, *J. D. Bernal: A Life in Science and Politics* [London 1999]. Finally, although the issue of names figures prominently in Lefkowitz's polemic against *Black Athena I* and *II*, she does not cite the critical work of J. Searle, "Proper Names," or S. Kripke, "Naming and Necessity," to cite but two works on that vexed term, both in A. Martinich, *The Philosophy of Language* (New York and Oxford, 1996) 249–255, 255–271.

13.   I am not using "private language" in the sense formulated by Wittgenstein: see Hans-Johann Glock, *A Wittgenstein Dictionary* (Oxford and Malden 1996) 309–315, s.v. "Private language argument."

14.   On the term Afro-Atlantic, see K. A. Appiah and H. L. Gates, Jr., eds., *Africana. The Encyclopedia of the African and African-American Experience* (New York 1999) s.v. "Afro-Atlantic," 42.

15.   Bernal (supra n. 2); Lefkowitz (supra n. 2). For a concise definition of Nietzsche's historiographic concept of "genealogy," see R. Geuss, *History and Illusion in Politics* (Cambridge, 2001) 6–7: "In *Zur Genealogie der Moral* Nietzsche develops an approach to history which he calls 'genealogy'.... Nietzsche thought that Socrates had put us on the wrong track by suggesting that it was important to try to get formal definitions of those human phenomena that were of the greatest concern to us. It was ... possible, ... Nietzsche thought, to seek for definitions of abstract items or of features of the natural world. Thus terms like 'triangle' . . . or 'gene' could be defined. The reason this was possible ... was precisely that such terms designated items which were not part of history. A triangle was a triangle in fifth-century Greece or in nineteenth-century Tasmania.... Human history, though, was concerned ... not with entities such as these, but with objects such as Christianity, punishment, conscience, and morality, which were historically inherently *variable* configurations of powers, functions, structures, and beliefs. These 'objects' were bearers of multiple 'meanings' at any given time, and the constellation of the meanings associated with any of them was constantly shifting. Incarceration in the twelfth century has a different role, function, and meaning from incarceration in the penal systems of the nineteenth century. Freedom meant something different for Luther, Epictetus, and Herzen. Third-century Christianity was not the same as eighteenth-century Christianity. 'Christianity' – the concept and the reality – is what a succession of humans have made it by virtue of acting in certain ways. In acting people have different goals, changing values, variable interests, and these differences come to be reflected in the shifting meaning of the term. Was Christianity 'really' or 'essentially' Christ's first-century Jewish way of living, the doctrine of Paul, or the decrees on the nature of the Trinity made by a certain church council...? Was

Manicheanism a form of Christianity? Was the Inquisition 'Christian'? Was Cistercian architecture particularly Christian? How about the architecture of the Austrian baroque? Or Hagia Sophia (now a mosque)?"

16. G. Elton, *The Practice of History* (1968; repr. New York and Sydney, 1967) 73–74; Lefkowitz, *Not Out of Africa* 193.

17. Lefkowitz, *Not Out of Africa* 8–9: "Will students of one ethnicity deny the existence of other 'ethnic truths,' with dire consequences akin to the ethnic conflicts in the former Yugoslavia? Perhaps they will be assured that the differences do not matter because all history is a form of rhetoric, and narratives of the past can be constructed virtually at will." 52: "Once symbolism is taken as a mode of historical proof, the way is open for other groups to argue for a different symbolism." Elton, *Practice* (supra n. 16) 87.

18. S. Howe, *Afrocentrism: Mythical Pasts and Imagined Homes* (London and New York, 1998) 9.

19. Lefkowitz, *Not Out of Africa* xii.

20. See supra p. 174 and n. 10 for Lefkowitz's use of "transparent."

21. Lefkowitz, *Not Out of Africa* xii and passim J. Berlinerblau speaks of her "undialogic" approach to opponents' arguments: *Heresy in the University: The Black Athena Controversy and the Responsibilities of American Intellectuals* (New Brunswick and London, 1999) 8–9.

22. Lefkowitz, *Not Out of Africa* 49 and passim.

23. Lefkowitz, *Not Out of Africa* 50 and passim; 179, n. 8 and passim; 86, 4. The word "dispassionate" appears in a quotation from A. Schlesinger, Jr. , *The Disuniting of America: Reflections on a Multicultural Society* (1991; repr. New York, 1992) 99.

24. Burckhardt's clearest delineation of the mode of historiography he called "*Kulturgeschichte*" appears in J. Oeri, ed., *Griechische Kulturgeschichte* (4 vols.; 1898; repr. Darmstadt, 1930) I, 5; for the (abridged) English edition, see *The Greeks and Greek Civilization*, trans. S. Stern, ed. O. Murray (New York, 1998) 5. Many who negatively reviewed Burckhardt's study of Greek cultural history used terms similar to ones deployed by Lefkowitz (and others) against New Historicism, Afrocentrism, etc. For example, an anonymous reviewer complained about Burckhardt's (mis)reading of historical sources (i.e., his *Quellenforschung*) and compared *Griechische Kulturgeschichte* (or its effect on the reader) to an "artwork" – that is, a skilled work of imagination rather than a work of historical scholarship ("Das Werk wirkt zunächst vor Allem als Kunstwerk"): review of Oeri's edition in *Literarisches Centralblatt für Deutschland*, ed. E. Barncke, 11 February, 1899, 198; going one step further, Wilamowitz declared that "*Griechische Kulturgeschichte...* does not exist for scholarship": U. Wilamowitz-Moellendorff, *Griechische Tragödie* II (Berlin, 1899) 7, cited in *Greeks* xxxiv.

25. Lefkowitz, *Not Out of Africa* 50.

26. Howe, *Afrocentrism* (supra n. 18) 10.

27. Lefkowitz, *Not Out of Africa* 46, 49.

28. For "fancy," see Lefkowitz, "Ancient History" 22 and passim.

29. Lefkowitz, *Not Out of Africa* 49–50.

30.  Lefkowitz, *Not Out of Africa* 50.
31.  Elton, *Practice* (supra n. 16) 87.
32.  D. Fischer, *Historians' Fallacies: Toward a Logic of Historical Thought* (New York, 1970) 55–56; P. F. Payne, Jr. "A Note on a Fallacy," *Journal of Philosophy* 55 (1958) 125.
33.  Alan Munslow, *The Routledge Companion to Historical Studies* (London and New York, 2000) 92–95, s.v. "Evidence."
34.  Lefkowitz, *Not Out of Africa* 39.
35.  Lefkowitz, "Ancient History" 11–12.
36.  Supra p. 173 and passim.
37.  Lefkowitz, *Not Out of Africa* 155. Adorno wrote many essays on the Nazis, Nazi politics, and the Holocaust; one could almost say that everything he wrote after 1933 involved these subjects. Particularly relevant in terms of this discussion, however, is "*Was bedeutet: Aufarbeitung der Vergangenheit*" in *Gesammlte Schriften* 10.2 (Frankfurt am Main, 1977) 555–572: There, Adorno questions the ability of language to renovate, clear up, or, in vaguely Freudian usage, recover from ("*aufarbeiten*") history or the past – particularly a traumatic past – in any *authentic* way. For Jacob Burckhardt's use of "*aufarbeiten*," see infra n. 75.
38.  Lefkowitz, *Not Out of Africa* 39.
39.  Adorno, *Authenticity/Eigentlichkeit* 42/441 and passim.
40.  Adorno, *Authenticity/Eigentlichkeit* 43–44/442: "Language mythology and reification become mixed with that element which identifies language as antimythological and rational. The jargon becomes practicable along the whole scale, reaching from sermon to advertisement.... The words of the jargon [of authenticity] and those like Jägermeister, Alte Klosterfrau, Schänke, are all of a piece. They exploit the happiness promised by that which had to pass on to the shadows. Blood is drawn from that which has its appearance of concreteness only after the fact, by virtue of its downfall. At least in terms of their function, the words, nailed into fixity and covered with a luminous layer of insulation, remind us of the positivistic counters. They are useful for effect-connotations, without regard to the pathos of uniqueness which they usurp, and which has its origin on the market, on that market for which what is rare has exchange value." ("Sprachmythologie und Verdinglichung vermischen sich mit dem, worin Sprache antimythologisch und rational ist. Der Jargon wird praktikabel auf der ganzen Skala von der Predigt bis zur Reklame.... Die Jargonworte und solche wie Jägermeister, Alte Klosterfrau, Schänke bilden eine Reihe. Ausgeschlactet wird das Glücksversprechen dessen, was hinab mußte; das Blut dem abgezapft, was einzig um seines Untergangs willen nachträglich als Konkretes schimmert. Die reglos festgenagelten und mit einer leuchtenden Isolierschicht übermalten Worte errinnern zumindest der Funktion nach an die positivischischen Spielmarken; geeignet für beliebige Wirkungszusammenhänge, unbekümmert um das Pathos von Einzigkeit, das sie sich anmaßen und das selbst herstammt vom Markt, dem das Seltene ein Tauschwert ist.")
41.  For the purposes of this essay I construe culture and civilization synonymously, though Geuss construes them differently, at least in their German

sense: See R. Geuss, *Morality, Culture, and History: Essays on German Philosophy* (Cambridge, 1999), especially "Kultur, Bildung, Geist" 29–51.

42.  T. Qualter, s.v. "propaganda," in W. Outhwaite and T. Bottomore, eds., *Blackwell Dictionary of Twentieth-Century Thought* (2nd ed., 1993; repr. London and Malden, 1998) 517–518; see also T. H. Qualter, *Propaganda and Psychological Warfare* (New York, 1962), especially chapter 1, "The Theory of Propaganda" 3–31.

43.  Qualter, "Propaganda" (supra n. 42) 517.

44.  Qualter, "Propaganda" (supra n. 42) 517.

45.  See Lefkowitz, "Ancient History" 5: "I know that I run the risk, in the aftermath of Foucault and poststructuralism, of seeming naive in my belief that some kind of objectivity is possible. . . ."

46.  Qualter, "Propaganda" (supra n. 42) 517.

47.  W. E. B. DuBois, *The Souls of Black Folk* (1903; repr. New York, Toronto, London, 1989) 57 (herafter cited as DuBois, *Souls*).

48.  Lefkowitz, *Not Out of Africa* 6.

49.  Lefkowitz, *Not Out of Africa* 6.

50.  Berlinerblau, *Heresy* (supra n. 21); on Marcion, see E. Ferguson, ed., *Encyclopedia of Early Christianity* (New York and London 1990) 568–569, s.v. "Marcion."

51.  Lefkowitz, *Not Out of Africa* 172–173 and passim; 50; ibid. See Lefkowitz, "Ancient History" 22 on "political myths" as "justification for the Holocaust."

52.  F. Davis, *Who Is Black? One Nation's Definitions* (University Park, 1991) 4–5.

53.  See Benston (infra n. 72).

54.  C. Johnson-Odim, "The Debate Over Black Athena," *Journal of Women's History* 4 (Winter 1993) 84–89, 86; Lefkowitz, *Not Out of Africa* 52.

55.  Adorno, *Authenticity* 36.

56.  T. Adorno, "Cultural Criticism and Society," in *Prisms*, trans. and ed. S. and S. Weber (Cambridge, Mass., 1992) 17–35, 22; see *Kulturkritik und Gesellschaft, Gesammlte Schriften* 10.1 (Frankfurt am Main, 1977) 11–30, 15: "Das Modell des Kulturkritikers ist der abschätzende Sammler kaum weniger als der Kunstkritiker. Kulturkritik erinnert allgemein an den Gestus des Herunterhandelns, etwa wie der Experte einem Bild die Echtheit bestreitet oder es unter die minderen Werke des Meisters einreiht. Man setzt herab, um mehr zu bekommen."

57.  On Berenson, see C. L. R. James, "What is Art?" in *The C. L. R. James Reader*, ed. A. Grimshaw (London and New York, 1999). James, a Trinidadian writer and historian, was also the author of *The Black Jacobins; Toussaint l'Ouverture and the San Domingo Revolution* (2nd ed., rev.; New York, 1963).

58.  K. Clark, *Civilisation: A Personal View by Kenneth Clark* [videorecording], written and narrated K. Clark, dir., M. Gill (British Broadcasting Corporation, 1969; Chicago: Home Vision Arts, 1999) 13 vols.; K. Clark, *Civilisation: A Personal View* (1969; repr. New York, 1992) 2.

59.  Clark, *Civilisation* (supra n. 58) 2.

60.  M. Arnold, *Culture and Anarchy*, ed. J. Wilson (1869; repr. Cambridge, New York, and Melbourne, 1990) 136.

61. Arnold, *Culture and Anarchy* (supra n. 60) 134.
62. The second paperback edition has a less offensive cover: see M. Lefkowitz, *Not Out of Africa* (New York, 1997).
63. Lefkowitz, *Not Out of Africa* 4; see supra n. 23.
64. Schlesinger, *The Disuniting of America* (supra. n. 23) 82.
65. Dionysius of Halicarnassus *Orat. Vett.*, preface 1, trans. D. Russell; for this passage, see A. A. Donohue, "Winckelmann's History of Art and Polyclitus," in W. Moon, ed., *Polykleitos, the Doryphoros, and Tradition* (Madison, 1995) 337.
66. Winckelmann, in G. H. Lodge, trans., *The History of Ancient Art, Translated from the German of Johann Winckelmann* (London, 1881) II, 116–117; see also Mark D. Fullerton's essay in this volume.
67. Trans. Lodge (supra n. 66) II, 240; for this passage, see Donohue (supra n. 65) 348 n. 34.
68. Adorno, *Authenticity/Eigentlichkeit* 43/442: "Der Nimbus, in welchen die Worte verpackt werden wie Orangen in Seidenpapier, nimmt die Sprachmythologie in eigene Regie, als vertraute man ihrer Strahlkraft doch nicht ganz. . . ."
69. J. Ruskin, in C. H. Holman and W. Harmon, eds., *A Handbook to Literature* (5th ed. 1936; repr. New York, 1986), 347.
70. J. Derrida, in J. Culler, *On Deconstruction – Theory and Criticism after Structuralism* (Ithaca, 1982), 192.
71. For the literature on nullification, see R. Delgado and J. Stefanic, eds., *Critical Race Theory: The Cutting Edge* (Philadelphia, 2000), especially P. Butler, "Racially Based Jury Nullification: Black Power in the Criminal Justice System," 194–204, and J. Rosen, "The Bloods and the Crits," 584–589.
72. K. W. Benston, "I Yam What I am: The Topos of Un(naming) in Afro-American Literature," in H. L. Gates, ed., *Black Literature and Literary Theory* (New York, 1984) 151–172.
73. A. L. Higginbotham, Jr., *Shades of Freedom: Racial Politics and Presumptions of the American Legal Process* (New York and Oxford, 1996) 3, 7–17 and passim.
74. DuBois, *Souls* 57; H. L. Gates, Jr., "Introduction: Darkly, as Through a Veil," in DuBois, *Souls* vii–xxix, xiv.
75. See D. L. Lewis, *W. E. B. DuBois: Biography of a Race, 1868–1919* (New York, 1993), especially 79–150 (chapters 5 and 6, "The Age of Miracles: 'At but not of Harvard,' " and "Lehrjahre,"). When considering DuBois's re-working of classical tradition, it is interesting to note that Burckhardt, like DuBois, studied under von Schmoller. Burckhardt, regarded as the so-called father of cultural history, was also the author of the now canonical work *Civilization of the Renaissance in Italy* (1860), which proposed that the Renaissance did not come into being, as it were, primarily through the "imitation" (*imitatio*) or even the "emulation" (*emulatio*) of Greco-Roman culture, but rather from what one might call, following Lefkowitz's usage, a complete and "systematic" re-working (*aufarbeiten*) of the "classical" heritage. See J. Burckhardt, *Civilization of the Renaissance in Italy*, trans. S. G. F. Middlemore (1860; repr. London and New York, 1998); L. Goldscheider, ed., *Kultur der Renaissance in Italien* (Phaidon, n.d.).

76. Ovid, *Metamorphoses: Die Metamorphosen, erklaert von Moriz Haupt* (2 vols. 2nd vol. ed. K. P. O. Korn; Leipzig and Berlin, 1853–1876); *Ovid's Metamorphoses: Englished, Mythologized, and Represented in Figures by George Sandys*, ed. K. K. Hulley and S. T. Vandersall (Lincoln, 1970); *Ovid's Metamorphoses: The Arthur Golding Translation 1567*, ed. J. F. Nims (Philadelphia, 2000); J. Bate, "Shakespeare's Ovid," in Nims, xli–l, xliii.

77. Nims, *Ovid's Metamorphoses* (supra n. 76) 267–268.

78. Lefkowitz, *Not Out of Africa* "Myths of African Origins" 38–39; DuBois, *Souls* 54, 57.

79. Lewis, *W. E. B. DuBois* (supra n. 75) 87.

80. Ovid, *Metamorphoses* II.10.592, trans. F. J. Miller (London and New York, 1926) 106.

81. Lefkowitz, *Not Out of Africa* 46; she does not discuss DuBois.

82. See M. Lefkowitz, "Afrocentrism Poses a Threat to the Rationalist Tradition," *Chronicle of Higher Education,* May 6, 1992, A 52.

83. J. Derrida, "White Mythology," in *Margins of Philosophy*, trans. A. Bass (Chicago, 1982) 213. cf. Lefkowitz, *Not Out of Africa* 153–154. Her use of metaphors such as clear, clarity, and blinkered vision do call to mind Derrida's idea of "transparent" history, by which he seems to mean not only the rationalist, philological version of historiography (with its tradition of emending – or, in Derrida's terms, erasing or *eracing* errors) but also the historiographic metaphor of the palimpsest, a metaphor Lefkowitz herself invokes when quoting Orwell: "In *Nineteen Eighty-Four* George Orwell described a nightmare world in which 'all history was a palimpsest, scraped clean and reinscribed exactly as often as was necessary'". Compare what Lord Acton wrote of Leopold von Ranke: "[He] is the representative of the age which instituted the modern study of history. He taught it to be critical, *colorless,* and to be new" (my emphasis); as Hughes-Warrington suggests, to be "colourless," in Acton's sense, was something positive – it suggested "hiding one's views and sticking to the facts in the process of preserving, organizing and critically examining evidence"; in M. Hughes-Warrington, *Fifty Key Thinkers on History* (London and New York, 2000) 256, s.v. "Leopold von Ranke."

84. Aristotle, *Rhetorica* III. 1410 b; trans. W. R. Roberts in W. D. Ross, ed., *The Works of Aristotle Translated into English* XI (Oxford, 1924); cited in R.A. Lanham, *A Handbook of Rhetorical Terms* (2nd ed.; Berkeley, Los Angeles, Oxford, 1991) 100–101, s.v. "metaphor."

85. Donohue, "Winckelmann's History of Art" (supra n. 65) 349 n. 51.

86. J. J. Winckelmann, *Gedancken über die Nachahmung der Griechischen Wercke in der Mahlerey und Bildhauer-Kunst,* E. Heyer and R. C. Norton eds., trans., *Reflections on the Imitation of Greek Works in Painting and Sculpture* (LaSalle, 1987) 33.

87. Donohue, "Winckelmann's History of Art" (supra n. 65) 327.

# Index

Aberdeen Head, 159–160

academies of art, 63–65, 73–74, 82
  ranking of arts and artists, 64–65

Adorno, Theodor W., 171, 173, 182–183, 186–187, 190; *see also* authenticity, jargon

Aegina, Athenian attack on, 119–122

Aeschylus, 133, 136

Afrocentrism, 177, 178, 185, 186, 193

Akesas, 69, 74

Akragas (artist), 69

Akragas (Sicily), 48

Alkamenes, 55

allusion, 111

alphabetical lists of artists, 55–56

Alster, Bendt, 30

*Altertumswissenschaft*, 4

amber, 69, 71

anecdotes, in historiography of art, 53–54, 56, 62

Apelles, 61, 69, 74

*apobatai*, 77

Apollo Belvedere, 187, 188

archaeology, and study of ancient art, 3–4

Archaic period, 93, 96

Archaic style, 93–94, 97, 102, 106, 108

archaism, 103, 107, 108

archaistic style, 93, 94, 97, 106–107

archaistic works, 106, 107
  Athena, Albani collection, 97
  Athena from Herculaneum, 94–96
  Athena on Panathenaic amphoras, 106
  four-gods relief by Kallimachos, 97
  relief of Citharoedus type, 97

archaizing style, 93, 94

architecture, 74, 82

Aristotle, 50, 57, 193

Arnold, Matthew, 171, 184, 187–189

art; *see also* historiography of art
  African, 187
  as private property, 52
  category of, 72
  classical, study of, 2–5, 75–76, 78, 151, 152, 155
  classifications in, 64–65
  concept of, in Pliny the Elder, 48–58
  display of, 52–53, 56, 57, 63, 104, 105
  evolution in, concept of, 48–51, 54–57, 59–64; *see also* metaphors, style, stylistic development
  functions of, 52–58, 72–73, 79, 48–53, 56, 108
  in Rome, 52–53
  materials for, 50–51, 52, 69–84
  Mesopotamian, interpretation of, 14–15, 19–21
  Roman, 53, 57, 97, 102, 104, 108, 111–112

# Index

"Art for art's sake," 75–76, 88 n. 38
artists, 69, 74, 97–98, 101
  alphabetical lists of, 55–56
  anecdotes about, 53–54, 56, 62
  biographies of, 59–62, 63
  chronological treatment of, 53–55, 57,
    63, 64–65
  classifications of, 54–58, 59–61, 64–65
  contributions of, 59–62
  fame of, 52, 54
  floruit of, 54
  lists of famous, 52, 54–55
  names of, 101, 102
  originality of, 64
  role of, 50
  signatures of, 99, 101
Ashby, Thomas, 154–155
Ashmole, Bernard, 165, 166
Astarte, and Adonis, cult of, 25
Atalanta, 185, 191–193
Athena, archaistic, from Herculaneum,
  94–96
Athens, Acropolis Museum
  kore 589, 120, 121
  kore 675, 120, 122
Athens, National Museum: grave stele of
  Hegeso, 78
*augumento*, 59
authenticity, 187
  Adorno's conception of, 172, 173, 182,
    186–187; *see also Eigentlichkeit*
  in history-writing, 171, 172, 173, 178
*avaritia*, 51

Babel, Towers of, 13
Babylon
  imagined immorality of, 6, 23
  sacred prostitution in Herodotus, 23
Baden, Torkel, 63–65
  and academic categories, 64–65
  and Danish Academy of Fine Arts, 63,
    65
  classification of artists, 64–65
  history of Greek painting, 63–65
  moralizing themes in, 64–65

  paintings from Herculaneum, 63–64
  use of Pliny as model, 63–65
  use of Winckelmann as model, 65
Baïf, Lazare de, 124–125
Beazley, Sir John Davidson, 149,
  and Morellian method, 164–166
Becatti, Giovanni, 107
Becker, Wilhelm Adolf, 139, 144 n. 43,
  145 n. 56
Belvedere torso, 99, 101
Benston, Kimberly, 186, 191
Berenson, Bernard, 148, 159, 163, 164, 187
Berlin Museum, 158
Berlin, University of, 191, 192
Berlin, Vorderasiatisches Museum
  Middle Assyrian lead relief from
    Assur, 15, 18
  Old Babylonian terracotta plaque, 15,
    16
  Old Babylonian terracotta mold, 15,
    17
Berlinerblau, Jacques, 185
Bernal, Martin, 172, 175, 177, 185, 191, 194
Bernazzano Milanese, 62
Bianchi Bandinelli, Ranucchio, 115 n. 46
Bible, attitudes toward sexual behavior
  in, 21–23, 26, 31
Biedermeier, 171, 187, 190
*Black Athena* debate, 171, 173, 174, 177,
  191
Böckh, August, 4
Bode, Wilhelm von, 158, 163–164
Boëthos, 69
Böttiger, Carl August, 130–131, 139
Brendel, Otto J., 115–116 n. 46
British School at Rome, 148, 154–155
bronze
  Corinthian, 52–53, 57, 58
  *statuaria ars*, 55
  statuary in, 49, 52–58, 62, 71, 72, 74,
    109–110
Brooks, Beatrice, 24–25
Brunn, Heinrich, 100–102, 160
Bulle, Heinrich, 106
Burckhardt, Jacob, 178, 193, 194

# Index

# Index

# Index

Gombrich, E. H., 62–63
Gruber, Mayer, 16

Hamilton, Sir William, collection of, 81
Hancarville, Baron (Pierre François
    Hugues), 81
*harimtu*, 32–33
Harrison, Jane Ellen, 149, 152, 154, 155
Harvard University, 192
Hauser, Friedrich, 100–102, 106
Havelock, Christine, 107
Hebraism, Matthew Arnold's concept
    of, 188
Hebrews, moral conceptions of, 22
Hegeso, grave stele of, 78
Helbig, Wolfgang, 132
Helikon (artist), 69
Hellenism, Matthew Arnold's concept
    of, 188
Hellenistic art, 57, 98–101, 102, 104
Hellenistic period, 54, 78, 93, 111,
    189–190
Helst, Bartholomeus van der, 63
Herculaneum, paintings from, 63–64
Herculaneum, Villa of the Papyri
    archaistic Athena from, 94–96
    bronze bust of Doryphoros from, 101
Herodotus, 71, 182
    account of sacred prostitution in
        Babylon, 23–24, 31
    accounts of Mesopotamian culture,
        21, 25
    on Greek clothing, 119–123, 136
hierodule, 13, 28, 35 n. 5
hierogamy, *see* marriage, sacred
Higginbotham, A. Leon, 191
*himation*, 119, 124, 131–132
historicism, in Winckelmann, 98, 99,
    189–190
*Historikerstreit*, 186
historiography, 171, 173, 174
    distinguished from history, 173
    empirical, 178, 181
    modern, 174, 175
    positivist, 178

postmodern, 112, 172, 179
    revisionist, 193
historiography of art; *see also*
    metaphors, style, stylistic
    development
    academic principles of, 63–65
    alphabetical lists of artists, 55–56, 64
    anecdotes in, 53–54, 56, 62
    art and nature, competition of, 61
    Baden, Torkel, 63–65
    chronological schemes, 54–55, 57
    decadence, concept of, 59, 63, 78, 93,
        99
    decline, concept of, 54, 57 92, 93, 99,
        100
    ecological themes in, in Pliny, 51
    evolutionary schemes in, 54–58,
        62–63
    fame, as criterion in, 54, 55–56, 64–65
    floruits in, 54
    hierarchical structures in, 51, 52
    imitation, concept of, 59–62, 82, 93,
        98, 101
    improvement, concept of, 51, 54–56,
        57–58, 59–62, 63, 82, 59–62
    innovations, concept of, 53–55, 56–57,
        59–61, 63–64
    moralizing themes in, 49–51, 57,
        63–64
    nature, as model for art, 54, 56, 59–62,
        63–64
    origins of art, 53, 63
    perfection, concept of, 55, 56, 57,
        59–64
    political themes in, 56, 76, 78, 79, 82,
        171–194
    post-antique art, 59–63, 67–68 n. 28
    progress in art, idea of, 51, 54–58,
        59–64, 81
    revival, concept of, 54, 57, 59, 99
history, 173, 174, 178–179
    as a science, 173
    authentic, 172, 174, 175, 179, 185,
    distinguished from historiography,
        173–174

**207**

# Index

# Index

Lévesque, Pierre-Charles, 63, 67–68 n. 28
Lewis, D. Levering, 192
liberty, idea of, in Winckelmann, 98, 99
Lippold, Georg, 105–106
literary sources in study of classical art, 102
Locri, terracotta plaques from, 78–80
London, British Museum, 152, 154, 159
   Aberdeen Head 159–160
   agate from Epirus, 81
love poetry, Mesopotamian, 29–31
Löwy, Emanuel, 9
*luxuria*, 51
luxury, 51, 58, 69–84; *see also luxuria, tryphe*
Lysippos, 55, 57, 62, 69, 102

magic, Mesopotamian domestic, 15
Malcolm X, 188–189
marriage, sacred
   theory of, 14, 20, 24, 27–31
   types of, 27–30
Masaccio, 62
masterpiece, 102, 106
materials for art; *see also* amber, bronze, ivory, medium, stone
   hierarchy of, 50–51
   minerals, 51, 52–53
   precious, 69–84
Mattusch, Carol C., 110
Medici Venus, 101
medium; *see also* materials for art
   categorization of artifacts by, 73
   style independent of, 81
Melian Aphrodite, 104
Mentor (artist), 69
Mesopotamia
   art, misinterpretation of, 14–15
metaphors; *see also* stylistic development
   childhood, 60
   in Aristotle, 193
   of barbarism, 183, 184, 187
   of civilization, 183, 184, 187
   of culture, 183, 184

   of genealogy, 191
   of war, 177–178
   organic, of growth, perfection, and decline in art, 59–60, 92, 94, 97, 184, 189
   sexual, Near Eastern, 21, 25, 30
Michelangelo Buonarroti, 61
minor arts, category of, 72
Mnesarchos, 69
Monkhouse, Cosmo, 157–158
Montfaucon, Bernard de, 125–127
Moortgat, Anton, 24, 27
Morelli, Giovanni, 149, 156–159, 160
Morellian method, 149, 151, 156–159, 160–164
Morgan Ivory, 79
Müller, Karl Otfried, 131–132, 139
multiculturalism, 175, 189
*mundus*, 50
Munslow, Alan, 181
Myron, 55, 159
Mys, 69
myth, 172, 174, 179, 183, 193

*Nachahmer*, 96; *see also* Winckelmann
*nadītu*, 25, 26
names, 190, 196 n. 12
Naples, Museo Nazionale
   archaistic Athena from Herculaneum, 94–96
   bronze bust of Doryphoros from Herculaneum, 101
   Farnese Herakles, 101
naturalism, development of, in Greek art, 54–57, 80–81
nature
   as model for art, 54, 59–62, 63–64
   concept of, in Baden, 63–64
   concept of, in Pliny, 50–58
   imitation of, linked with artistic progress, 56, 59, 63–64
   in Vasari, 59, 60–62
Neo-Attic production, 100–101, 106, 107
Nero, 53, 56, 58
New Historicism, 179, 185, 186

# Index

Newton, Sir Charles, 152, 153–154
New York, Metropolitan Museum of
    Art: Morgan Ivory, 79
Nietzsche, Friedrich, 175, 194
Nippur, Inanna Temple, archives, 31
Nochlin, Linda, 19
Nolte, Ernst, 185
nudes, Mesopotamian, interpretation
    of, 19
nu.gig, 28, 35 n. 5

objectivity, 173
Orientalism, 13–14, 19–22
original, in study of sculpture, 102, 103,
    105, 108
originality in art, 64, 110
Orléans, Duc d', collection of, 74, 75
Ottoman Empire, effect of, on Near
    Eastern studies, 21
Ovid, *Metamorphoses*, 191–193

Paget, Violet, *see* Vernon Lee
painting, 51, 54, 63–65, 71, 74, 81, 82
*palla*, 125, 133
Palladium, costume of, 130–131
*pallium*, 125, 132
Panainos, 63
Panathenaic amphoras, 77, 106
Paris, Musée du Louvre: Melian
    Aphrodite, 104
Parrhasios, 69
Parrot, André, 14
Parthenon, 69, 70, 77, 78, 126
pathetic fallacy, 190
patriarchy
    effect of concepts on Near Eastern
        studies, 21–22, 27, 35
    in Mesopotamia, 33
Pausanias, 70, 73
Payne, Perrell F., Jr., 181
Pelasgic, 171, 187, 190
*peplos*, 118–147
    as Dorian garment, 118, 129, 131–133
    as expression of Hellenic identity, 133
    as Near Eastern borrowing, 125, 132

construction of, 118, 119, 124–131, 134,
    136–139
etymology of, 130, 132–133
historicity of, 136, 138–140
Homeric, 124, 132, 134
identified in early scholarship, 124–128
in Roman representations, 127
in texts, 123–124, 133, 136
*katà stêthos*, 132, 133
of Athena, 118
overfold of, 129
*peplophoroi*, 122
perfection in art, *see* historiography of
    art, metaphors, style
*perfezione*, 59
Perillus, 48–49
periodization, *see* style
*peronai*, 119
Phalaris, 48–49
Pheidias, 54, 55, 63, 69, 98, 101, 102, 152
*phiale mesomphalos*, from Duvanli,
    76–77
Phocaea, abandonment of, 71
Pindar, 70
pins, 119; 133, 134–135, 138–139; *see also*
    *fibulae, peronai*
plaques, terracotta
    from Locri, 78–80
    Old Babylonian, 15, 16, 17, 31
Pliny the Elder, 48–68, 70, 72
    alphabetical lists, 55–56
    anecdotes, 48–49, 53–54, 55–56, 109
    art, concept of, 48–57
    artist, concept of, 50–51
    as compiler, 49
    audience of, 50
    character of, 49
    chronology, 54, 57
    cosmology of, 50
    decline, idea of, 54, 57, 58
    developmental schemes, 54–57, 58
    ecological themes, 51
    evolutionary schemes, 54–57, 58
    fame, as organizational principle, 52,
        54, 56

# Index

Rome
  art in, 52–54
  display of art in, 52–56
  German Institute, 151
  Museo Capitolino: archaistic relief by
    Kallimachos, 97
  Villa Albani (Torlonia): archaistic
    Athena, 97
Ruskin, John, 75, 190

Said, Edward, 22
Salmasius, Claudius (Claude Saumaise),
    125, 129
šamḫatu, 32
Samos Museum: ivory figure from lyre,
    72, 73
Schlegel, Friedrich von, 129, 131
Schlesinger, Arthur, 189
Schmidt, Eduard, 106, 107
Schmoller, Gustav von, 191
Schuchhardt, Karl, 155
Segesta, plate at, 73
sexual activity, in Mesopotamia, 32–34
sexual rites, Mesopotamian, theory of,
    13, 14, 15, 34; see also marriage,
    sacred; prostitution
Shakespeare, 192
signatures of artists, 99, 101
silver, works in, 51, 71, 72–73
similitudo, 57
simplicity, attributed to Greek art,
    75–76
Sofia Archaeological Museum: silver
    plaque, 72
Sophocles, 132
Spanheim, Ezechiel, 127–128
Staatengeschichte, 173
Stämme, Greek, 123, 129, 131; see also
    Dorians, Ionians
statuaria ars, 55
Stead, W. T., 6
stone, objects in
  in art historiography, 69, 71
  in Pliny, 51
Stosch, Philipp von, collection of, 74

Strabo, 31
Strong, Eugénie Sellers (Mrs. Arthur
    Strong)
  advocate of Romanità, 155
  and Morellian method, 159–166
  association with German scholars,
    150–151, 155,
  association with Mussolini, 149, 155,
    166
  education of, 150–152
  marriage of, 151, 154
  reputation of, 148, 149–150, 166
  retirement from British School at
    Rome, 148, 155
  translator of Adolf Furtwängler, 156,
    160–163
Strong, Sandford Arthur, 151, 154
Strongylion, 53–54
Strzygowski, Josef, 155
Studniczka, Franz, 132–140
style; see also historiography of art,
    stylistic development
  Archaic, 93–94, 97, 102, 106, 108
  archaistic, 93, 94, 97, 106–107
  Attic and Asiatic, in oratory, 189–190
  Classical, 93–94, 97, 100, 101, 102,
    108
  classicizing, 93, 97, 109, 111
  idealism, 54, 57
  periodization, 110
  periodization in Vasari, 59–63
  periodization in Winckelmann,
    96–100, 189–190
  reiterative, 102
  retrospective, 92–117
  terminology of, 92–96, 103
stylistic development, 92–94; see also
    historiography of art, imitation,
    metaphors, style
  decline in art, concept of, 54, 57, 58,
    78, 92, 93, 99, 100
  naturalism, 54, 56, 59, 80–81, 92; see
    also nature
  paradigms of, 69
  progress in, 51, 54–56, 59–62, 81

212

# Index